Live from
Cape Canaveral

50 Years in Space by

the Only Reporter There

Live from
CAPE CANAVERAL

Jay Barbree

Smithsonian Books

Collins
An Imprint of HarperCollinsPublishers

HarperCollins books may be purchased for educational, business, or sales promotional use. For information please write: Special Markets Department, Harper-Collins Publishers Inc., 10 East 53rd Street, New York, NY 10022.

FIRST EDITION

Designed by Cassandra J. Pappas

The Library of Congress Cataloging In Publication Data has been applied for.

ISBN: 9780061233920
ISBN-10: 0061233927

07 08 09 10 11 ID/RRD 10 9 8 7 6 5 4 3 2 1

This book is for. . .

The damnedest aviation and space writer I've ever seen. . .

MARTIN CAIDIN

SEPTEMBER 14, 1927—MARCH 24, 1997

Acknowledgments

Science advisor. . .
Physicist Gene McCall, Ph.D.
Chief Scientist, Air Force Space Command,
Senior Scientist, Los Alamos National Laboratory,
Senior Advisor to Chief of Staff, U.S. Air Force. (Ret.)
Researchers. . .
The voices of Launch Control
Apollo's Jack King
Space Shuttle's Hugh Harris
And
The voice of the astronauts
Bob Button

This book is written from the files and memories of Jay Barbree and the
following storytellers. . .

Astronaut Buzz Aldrin
Ted Anderson
Astronaut Neil Armstrong
Tom Baer
Jo Barbree
Dan Beckmann

Sam Beddingfield
Howard Benedict
Jay Blackman
Mary Bubb
Bruce Buckingham
Dee Dee Caidin

Martin Caidin

Steve Capus

Astronaut Scott Carpenter

Mark Cleary

Stefano Coledan

Colonel Bill Coleman

Hartwell Conklin

Tom Costello

Walter Cronkite

Kristen Dahlgren

Marcia Dunn

George English

Dixon Gannett

Cosmonaut Yuri Gagarin

Astronaut John Glenn

Herb Gold

Phil Griffin

Lt. Colonel Ken Grine

Kay Grinter

Robert Hager

Todd Halvorson

Bill Hardwood

Bob Harrington

Cora Harris

Eddie Harrison

Jim Hartz

Science Writer A. R. Hogan

Dale Holzen

Lang Houston

Paul Irvin

Bill Johnson

Larry Kasulka

Jim Kitchell

Gene Kranz

Henri Landwirth

Bill Larson

Cosmonaut Alexei Leonov

Laurel Lichtenberger

Lisa Malone

Marvin Matthiesen

Leslie McCall

Lt. General Forest McCartney

Javier Morgado

Frieda Morris

David Mould

Rob Navias

John Neilon

Al Neuharth

Ray Nugent

James O'Berg

Thomas J. O'Malley

Amber Philman

Jim Rathmann

Mike Rein

John Rivard

Les Roberson

Jessica Rye

Astronaut Wally Schirra

Astronaut Winston Scott

Astronaut Alan Shepard

Dan Shepherd

Astronaut Deke Slayton

Roy Tharpe

Cosmonaut Gherman Titov

Russ Tornabene

Manny Virata

Russ Ward

Ken Warren

Fritz Widick

Billy Wiggins

Bilynda Wiggins

George Wilson

Astronaut Al Worden

Contents

Preface

Jay Barbree was present at the creation of the space age. As he likes to tell it, he was on a date in his home state of Georgia the night the Russian satellite *Sputnik* passed over the United States.

I don't know what happened to his date, but I do know Jay decided at that moment to make the space age his life's work. He moved to Cape Canaveral, Florida, and began a lifelong love affair with the space program, quickly developing a reputation as the reporter who knew the personalities, the technology, the politics, the triumphs, and the tragedies of this daring enterprise than any other.

Now, fifty years after *Sputnik 1*, Barbree gives us a vivid, first-hand account of how the race into space changed the world. It is a monumentally important story, and no one is better equipped to tell it from the ground up.

Barbree is the only reporter to have covered every mission flown by astronauts. He was there the day *Apollo 1* burned, the day *Challenger* exploded shortly after takeoff, the day *Columbia* broke up in the skies over Texas.

In his own way, Jay Barbree has been to the moon and back, the space station and back. He's also been on the verge of death and brought back to life. Training for the Journalist-in-Space Project, Jay suffered

"sudden death" while jogging on the sands of Cocoa Beach. He made a heroic recovery and returned to what he loved best: reporting on the space program.

Live from Cape Canaveral is his up-close and personal account of a half-century of space exploration. It tells the stories of the courage and genius of the pioneers. But it also describes the mistakes, the feuds, the wild times, and the indelible impression left by these men and women who allowed us to escape the bonds of Earth and fly into the unknown.

A thousand years from now, historians will mark this time as the beginning of the greatest age of exploration ever. Jay Barbree takes you on that first giant step for mankind.

TOM BROKAW
August 24, 2006

Live from
Cape Canaveral

Sputnik

In 1957, Cape Canaveral was the most vital and most intensely exciting place in the country. It offered cutting-edge technology in a time of nineteen-cent-a-gallon gasoline, nickel Cokes, two-bit drive-in movies, and the hit of the television season *Leave It To Beaver*. It was a time when doors went unlocked, when virgins married, when divorce ruined your social standing, and when folks spent their lives working for the same company with the promise of lifelong retirement checks.

In 1957 few that walked this planet reflected on the fact they were actually inhabitants of a mortal spaceship eight thousand miles in diameter, circling one of the universe's 10,000,000,000,000,000,000,000,000 (ten to the twenty-fourth) stars at 67,062 miles per hour.

However, two groups of men and women—given the era, it was mostly men—were actually consumed, day and night, by the realities that we were all astronauts living on spaceship Earth. One group worked in the United States at Alabama's Redstone arsenal; the other busied itself in a Soviet hamlet called Baikonur on the steppes of Kazakhstan.

Like the American group, the Russians developed and worked on machines to lift nuclear warheads and stuff off our planet, and on the evening of October 4, 1957, one of their creations, a large white rocket

Cape Canaveral. In the 1950s and 1960s, dozens of rockets and missiles were launched from this real *Disney World. (NASA).*

called R–7, was being fueled for what some would call the single most important event of the twentieth century. Nearby, inside a steel-lined concrete bunker, an intense middle-aged man named Sergei Korolev was at work. His job, as the chief rocket engineer for the USSR, was to orchestrate the stop-and-go countdown. But unlike his American counterpart, Wernher von Braun, Korolev had the full blessing and support of his country's communist government.

While Korolev had been chasing the goal of space flight at breakneck speed, Dr. von Braun had been pleading with President Dwight David Eisenhower to let him launch an Earth satellite. Only the year before, von Braun had moved his rocket and satellite to its launch pad without permission. He was going to launch it anyway, pretending that the satellite accidentally went into orbit. But Lieutenant Colonel Asa Gibbs, Cape Canaveral's commander, ordered the satellite launcher returned to its hangar. Colonel Gibbs cared more about his ass and making full colonel than he did history.

Now, with von Braun's rocket in storage, Sergei Korolev's R–7 was fueled, and his launch team was ready to send a satellite into orbit and send Russia into the history books.

"Gotovnosty dyesyat minut."

Ten minutes.

Steel braces that held the rocket in place were folded down, and the last power cables between Earth and the rocket fell away.

"Tri. . .

"Dva. . .

"Odin . . ."

"Zashiganive!"

IGNITION!

Flame created a monstrous sea of fire. It ripped into steel and concrete and blew away the night. It sent orange daylight rolling across the steppes of Kazakhstan, quickly followed by a thunderous train of sound that shook all that stood within its path.

As Sputnik, *Earth's first artificial satellite,*
was sent into orbit on October 4, 1957.
(NASA).
(this is dummy caption)

R-7 climbed from its self-created daylight on legs of flaming thrust and soon appeared as if it were an elongated star racing across a black sky. It fled from view and left darkness to once again swallow its launch pad as it became just another distant star over the Aral Sea.

While others strained to see the final flicker of the rocket, Korolev was interested only in the readouts. He sat transfixed by the tracking information streaming into the control room. The data were perfect. He was intently interested in each engine's shutdown. Separation of each stage had to be clean. And when the world's first man-made satellite slipped into Earth orbit, he permitted himself to rejoice with the others.

It would be called *Sputnik* (fellow traveler), and ninety-six minutes later, it completed its first trip around our planet, streaking over its still-steaming launch pad, broadcasting a lusty *beep-beep-beep*.

A dream had been realized.

Wild celebrations exploded across the Soviet Union.

In the NBC newsroom in New York, editor Bill Fitzgerald had just finished writing his next scheduled newscast when the wire-service machines began clanging. The persistent noise rattled most everything. Fitzgerald ran to the main Associated Press wire and began reading.

BULLETIN

London, October 4th (AP)

Moscow radio said tonight that the Soviet Union has launched an Earth satellite.

The satellite, silver in color, weighs 184 pounds and is reported to be the size of a basketball.

Moscow radio said it is circling the globe every 96 minutes, reaching as far out as 569 miles as it zips along at more than 17,000 miles per hour.

Fitzgerald froze. He didn't want to believe his fully written newscast had just been flushed down the toilet.

"Damn!" he cursed in protest before hurrying across the newsroom and bursting into Morgan Beatty's office. "Mo, we've gotta update," he shouted. "One of the damn Russian missiles got away from them, and they lost a basketball or something in space."

Beatty, a World War II correspondent, never came unglued in battles and he wasn't about to be upset by an agitated editor. "Give me that," he demanded, snatching the wire copy from Fitzgerald's hand.

Beatty's eyes widened as he read. "Jesus Christ, Bill, you know what this is? The Russians have put a satellite in Earth orbit! They've been talking about it, and damn it, they've really done it!"

Fitzgerald took a deep breath. "Okay, what do we do, Mo?"

The veteran newscaster didn't hesitate. "We've got to get this on the air, now!"

Sputnik came around the world, streaking northeast over the Gulf of Mexico and Alabama. Its current orbit took it south of Huntsville, where the U.S. Army's rocket team at the Redstone Arsenal was enjoying dinner and cocktails with some high-powered brass from Washington. One of the guests was Neil H. McElroy, who was soon to be the secretary of defense. Wernher von Braun was delighted. He judged McElroy as a man of action and when he replaced the current defense secretary, Charles E. Wilson, action would be what the army's rocket team would get. Dr. von Braun and his crew had been trying to punch a satellite into Earth orbit for months, but Wilson and President Eisenhower thought it was just so much nonsense and von Braun and his team had been left outside with their dreams.

But von Braun was as much a charmer as he was a genius in rocketry. He was tall, blond, and square-jawed, and that evening he had come with charts and slides and reams of data to brief McElroy on the potential of the army's rockets to bring American space flight to reality. McElroy listened with interest and understanding. Dr. von Braun was jubilant; he felt he was getting through. He was not aware *Sputnik* was about to wreck his carefully planned sales job.

"Dr. von Braun!"

Von Braun sprung about, to see his public affairs director running into the room.

"They've done it!" shouted Gordon Harris.

"They've done what?"

"The Russians . . ." Harris ran up to join the group. "They just announced over the radio that they have successfully put up a satellite!"

"What radio?" demanded von Braun.

"NBC." Harris sucked in air. "NBC was just on with a bulletin from Moscow radio. They've got the sounds from the satellite. The BBC has also—"

"What sounds?" von Braun interrupted.

"Beeps," Harris told him. "Just beeps. That's all. Beeps."

Von Braun turned and stared at McElroy. "We knew they were going to do it," he said with disgust. "They kept telling us, and we knew it, and I'll tell you something else, Mr. Secretary." A tremor of suppressed fury wrapped his words. "You know we're counting on *Vanguard*. The president counts on *Vanguard*. I'm telling you right now *Vanguard* is months away from making it."

A panel of scientists had recommended the development of a new rocket called *Vanguard*, arguing that a booster with nonmilitary applications, even though it was a product of the navy, would lend more dignity to a scientific project. Eisenhower went with it, ignoring the fact von Braun's army team was the only group in America with the experience and ability to launch a satellite, and McElroy gestured in protest. "Doctor, I'm not yet the new Secretary. I don't have the authority to—"

"But you will," von Braun broke in, his words raw with emotion. "You will be, and when you have the authority," he said sternly, "for God's sake turn us loose!"

The night of *Sputnik*, I was working for WALB radio and television in Albany, Georgia, where I was more interested in a Marilyn Monroe look-alike named Ann Summerford than in the world's first artificial

satellite. My best friend and coworker, Gene McCall, was dating Ann's sister, Leslie, and neither of us had the slightest hint what role *Sputnik* would play in our lives.

Gene, who would grow up to be a Princeton physicist and work on nuclear weapons as a senior scientist for the Los Alamos National Laboratory before becoming chief scientist of the Air Force Space Command, figured out *Sputnik*'s high five-hundred-mile-plus orbit would keep it and its trailing booster rocket lit by the sun as they passed over a dark Georgia. Theoretically, if we focused on the southwest sky at the precise moment, we just might see the tumbling booster. Of course the basketball-size *Sputnik* was too small to see, but we decided to take our chances with the booster, and we drove to a dark spot out of town and waited.

Minutes passed and as Gene had calculated, we saw a star moving. It raced over our heads and disappeared below the star-filled horizon. Its flight path appeared to change as it moved across the sky. But it didn't. It was Earth that moved. Like *Sputnik* itself, the booster rocket was in its own independent orbit, moving around the planet every ninety-six minutes on a firm track fixed by gravity. Earth was rotating beneath it at the rate of about eight hundred miles each hour at Albany's latitude. We knew we were seeing the future.

I did a report on *Sputnik* and began to imagine ways I might move to Cape Canaveral and cover the impending space race. I had no idea then that I would spend more than fifty years covering every space flight by astronauts and amassing the most detailed files of known and unknown facts of space history. I built sources and contacts not only in America but in Russia as well, and in the autumn of my career I would write this book—my lifetime's most important story. Besides, I had had a run-in with Albany's Knights of the Ku Klux Klan, which made relocating seem even more attractive. I wouldn't say I was run out of town but I sure as hell was out in front, leading the parade.

Only a month after *Sputnik 1*, the Russians did it again. *Sputnik 2* weighed 1,120 pounds and it soared more than a thousand miles

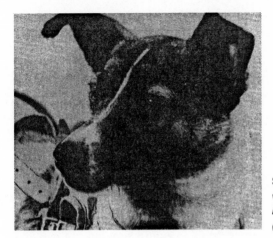

Sputnik 2 raced through orbit with Laika, seen here before being placed in the satellite. (Caidin Collection).

above Earth. The numbers were unbelievable to an American public struggling to understand what was going on. Where were our rockets? Where were our satellites? And what the hell was inside this thing? A dog?

Americans were livid. Was Washington burning and President Nero fiddling? Eisenhower got the message and he acted. Prematurely, but he acted, and a civilian team working on *Vanguard* rushed the unproven rocket to its launch pad. On top was a grapefruit-size satellite that weighed a laughable three pounds.

Dr. von Braun had warned that *Vanguard* wasn't ready, and had reminded Washington that his *Jupiter-C* was. But, again, he was ordered to keep his rocket in the hangar. No military launch. Civilian only, if you please. But you say the *Vanguard* is a navy rocket? Hush! Shut your mouth!

They may have wanted a civilian rocket, but they didn't want a civilian press. I was among the reporters and photographers pounding on the gates of Cape Canaveral. The military wouldn't budge. The media were kept outside on sand dunes nicknamed bird-watch hills, in boats, on any spot with a view of the slender rocket. For some of us, telephones were more important than great views, and no nearby phones went unused. Housewives rented theirs for extra cash. I found mine in a row of phone booths at the south gate of the Cape.

The day was December 6, 1957, and as the launch neared, an anxious hush fell over a hopeful America.

"T-minus 10 seconds and counting," the short-wave broadcast reported to the nearby Coast Guard.

"Seven, six, five, four, three, two, one . . ."

I was on the line with WALB, and when the countdown reached zero, my report began . . .

"There's ignition. We can see the flames . . . *Vanguard*'s engine is lit and it's burning . . . but wait . . . wait a moment . . . there's . . . no wait . . . there's no liftoff! It appears to be crumbling in its own fire . . . It's burning on its pad . . . *Vanguard* has crumbled into flames. It failed, ladies and gentlemen, *Vanguard* has failed."

It had risen only four feet off its pad, and four feet didn't count when you were reaching for orbit.

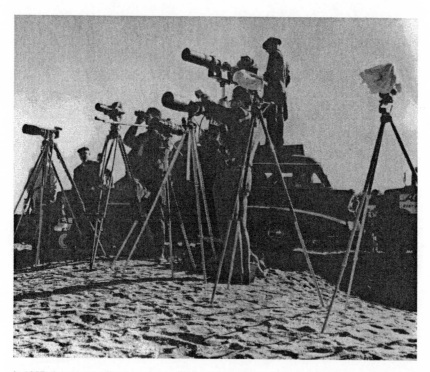

In 1957, the news media was not permitted on the air force's Cape Canaveral launch facility. These cameras were waiting for the first Vanguard satellite launch attempt. (Barbree Collection).

Out on the beach, a young CBS correspondent named Harry Reasoner and his producer, Charles von Fremd, had gained an advantage in the race to be first on the air. They had rented an oceanfront cottage with a view of the Vanguard launch pad. While cameraman Paul Rubenstein took his post on the beach, where the sightlines were better, Reasoner stood on the porch and peered through binoculars. Inside the little house, von Fremd's wife, Virginia, held a phone that was connected to the CBS newsroom in New York. Reasoner later wrote:

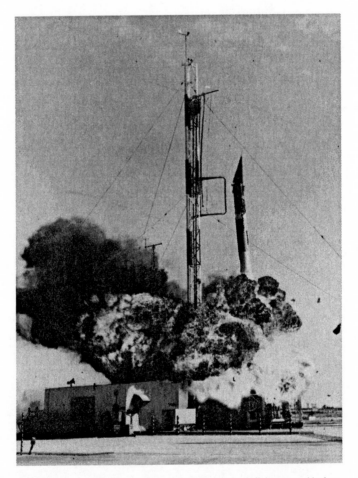

At t-minus zero, the first Vanguard *satellite lifts four feet off the ground before crumbling back on its pad, consumed by its own fires. (Neilon Collection).*

. . . I saw an unmistakable flash of flame and the pencil-thin white rocket began to move. "There she goes!" I shouted. "There she goes!" shouted Virginia into the phone. "There she goes!" shouted the CBS executive in New York, hanging up the phone and charging off to get the bulletin on the air.

We beat ABC and NBC certainly. There was only one problem. A tenth of a second after I shouted, "There she goes!" I shouted, "Hold it!" . . .

The tiny satellite was blasted off the top of the exploding rocket and bounced into hiding in the Cape's wilderness. Its small transmitter broadcast its lonely distress. To those listening, it was mournful—a string of unbroken beeps. Columnist Dorothy Kilgallen asked the most appropriate question on CBS's *What's My Line*: "Why doesn't someone go out there, find it, and kill it?"

It was a black day for a proud country, and space pioneer and storyteller John Neilon, who worked on Vanguard, recalled, "The project was instantly dubbed all sorts of uncomplimentary names like Rearguard, Flopnik, and one newspaper wrote ill-fated

Vanguard' as if that were the real name of the project." Neilon can laugh today. He added, "Some of our team with a sense of humor would answer the phone, 'Ill-Fated Vanguard Project!'"

The loss of Vanguard wounded our pride and destroyed our confidence, and most of us knew it was time for something to be done. The Russians were kicking us where we sat, and it was time for a stubborn White House to call in the cavalry—to call in the von Braun team.

Eisenhower did, and Redstone missile #29 was hauled out of storage and refitted. More reliable upper-stage rockets were added, and a thirty-one-pound satellite was mounted atop the stack with eighteen pounds of instruments designed to measure space radiation. Eisenhower and his White House crowd didn't want to be reminded that the rocket was the same damn Redstone that could have placed a satellite in orbit more than a year before *Sputnik*. The orders came down to change the name of the rocket, and *Jupiter-C* became *Juno 1*.

The media were finally invited on the Cape, and after three days of delays caused by high winds, *Juno 1* was ready for launch.

On January 31, 1958, at 10:45 P.M., test conductor Robert Moser pushed the launch button. After waiting more than two years to fly, *Redstone #29* was suddenly alive and its flames washed over the launch pad. Those lucky enough to be there cheered as broadcasters shouted to be heard above the rocket's growing roar.

Some around me cried shamelessly as I shouted my on-the-scene report and watched the first rocket with an American satellite climb higher and higher and faster and faster. I knew I was witnessing history. It was surreal with all the shouting, screaming, and joyful crying, and I continued to shout my report and watch the *Jupiter-C*'s flames grow smaller and smaller. Soon it was a star lost in a black sky filled with many, and I felt my own personal national pride. One of von Braun's stars, I reminded myself. As a boy, the young rocket master had promised himself he would go to the stars, and this night he was taking his first step on that journey.

The country did not yet have a network of tracking stations in place. Definite confirmation that the satellite was in orbit would have to wait until it had almost completed a trip around Earth as it raced over a tracking station in California. Dr. von Braun had calculated that it would take the satellite 106 minutes to pass over the California station. When it didn't, he began to pace.

Eight minutes later, an excited voice shouted, "They hear her, Wernher! They hear her!"

The satellite was in a slightly higher orbit than expected, accounting for its delay. Men and women hugged, and Wernher von Braun walked onto the stage of an adjoining auditorium filled with reporters.

"It was one of the great moments of my life," he said. "I only regret we weren't permitted to do it earlier."

A grateful and jubilant America was at von Braun's feet and his hometown, Huntsville, Alabama, rocked with a wild and furious celebration. Horns blared and cheering thousands danced and hugged each other in the streets. Retired defense secretary Charles E. Wilson, who had single-handedly stopped von Braun's efforts to reach Earth orbit, was hanged in effigy.

German-born Wernher von Braun became an instant American hero.

He was on the front pages of newspapers, on radio networks, on television talk shows and evening newscasts, and even on the prestigious cover of *Time*. The country's leading news magazine wrote: "Von Braun, 45, personifies man's drive to rise above the planet. Von Braun, in fact, has only one interest, the conquest of space, which he calls man's greatest adventure." Soon thereafter Eisenhower summoned von Braun to a white-tie dinner at the White House and presented him with the Distinguished Federal Civilian Service Award. Charles E. Wilson did not attend.

Wernher von Braun's satellite was named *Explorer 1*. It weighed only thirty-one pounds, but despite its size, it made science's first discovery by a satellite. Dr. James A. Van Allen's Geiger counter on board *Explorer 1* learned that Earth is surrounded by huge bands of high-energy radiation composed of particles trapped in our planet's magnetic field. Scientists honored Van Allen by naming the belts after him. Today, when humans travel in space they avoid these radiation belts discovered by *Explorer 1*, the little satellite that catapulted America into the space age, and into a fierce competition for national prestige with the Russians.

Just around the corner, the race to the moon was moved to the starting blocks.

The Early Days

There are some fishing villages that are cocooned in time, content to let progress pass them by. In the late 1950s one such community was Cocoa, Florida. It was like many other coastal towns of its vintage, moving with the effortless politeness that was its major contribution to its citizens—citizens who spent most of their days on the water, the docks, and the fishing piers.

"Salt Water Trout Capital of the World" was what Cocoa called itself, while progress lay barely ten miles to the northeast on a palmetto and scrub-brush sand spit jutting into the Atlantic that had been named Cape Canaveral by Spanish explorers five hundred years ago. A cutting-edge, high-tech laboratory sprouting missile and rocket gantries along the ocean's shore, it served as the anchor of a five-thousand-mile-long missile range of natural island tracking stations reaching to Ascension, a British island in the south Atlantic.

In the late 1950s and early '60s, Cocoa and its seaside sister community of Cocoa Beach suddenly became boomtowns—men and women with an average age of twenty-seven were arriving in airliners, in automobiles, and by train, some even by Greyhound. They were the engineers, the technicians, the scientists, and the hucksters coming to build America's spaceport, seeking membership in the newest and most elite

C.32—Waterfront along the Indian River Cocoa, Fla.

The easygoing town of Cocoa, Florida, hosted only a small, two-lane causeway to Cape Canaveral during the birth of America's spaceport. Irate missile and rocket workers demanded the U.S. Army Corps of Engineers keep the drawbridge closed to boat traffic during rush hour. *(Florida Historical Society).*

fraternity that would carry the Western world into the second half of the twentieth century.

I was one of them, shouting into a microphone a play-by-play broadcast as I chased runaway missiles and exploding rockets in the greatest show of technology the world had ever seen. I would tell our listeners that ballistic missiles did not simply blow up. They did not yield their life energy without a struggle. The flame began in spurts, from the arteries of fuel lines and the reservoir of tanks, and then in long, fiery streamers. Shards of the doomed rockets fell blazing toward an indifferent ocean.

This was Cape Canaveral in the early days, a world of missiles and rockets and of nights exploding violently as launch crews huddled within the protection of thick steel-and-concrete blockhouses, peering through periscopes, each shouting liftoff as more satellites followed *Explorer 1* and *Vanguard* into orbit, the successes making things happen. The defense budget was increased significantly, and military rocket pro-

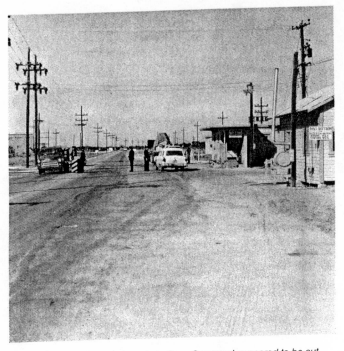

In the early days, the security gate to Cape Canaveral appeared to be out of The Grapes of Wrath. *The first missile launched flew perfectly, followed by many not so perfect. A Delta rocket explodes high above its pad while a Titan seems to escape before raining down in shards over the Atlantic. (USAF).*

grams were given more or less a blank check. Most forms of government-subsidized research began to grow. The nation's education system was overhauled, and federal dollars poured into the schools to help produce an unmatched generation of scientists and engineers who would become the heart of the American space reply to the Russians.

The Pentagon formed the Advanced Research Projects Agency (ARPA) to guard against further U.S. technological slippage.

And the National Aeronautics and Space Administration (NASA) was born.

America was on the move, and someone had to manage the new space effort. Who would lead? The army, navy, and air force all sought the assignment, as did the Pentagon's ARPA and the Atomic Energy Commission. But the White House focused on the National Advisory

Committee for Aeronautics (NACA), an inconspicuous group of scientists who oversaw federal flight-technology laboratories.

NACA possessed some of the best engineering talent in the country. Under civilian control, iy was too obscure to have been caught up in partisan politics, and most pleasing to all, it was a stranger to the red tape of government bureaucracy. This small but talented agency got the job of challenging Russia's lead in space.

Reborn as the National Aeronautics and Space Administration, the agency gathered under its umbrella NACA's five laboratories and eight thousand technicians; the California Institute of Technology's Jet Propulsion Laboratory; the navy's Vanguard project; and the army's four-thousand-strong rocket team headed by Dr. von Braun. But Congress insisted the Pentagon also maintain a separate space effort.

I had gone to work for NBC News on July 21, 1958, and was soon introduced to the network's executive producer in charge of space coverage. He was a tall, stout, grinning New Yorker named Jim Kitchell with a reputation for getting things done. First out of his mouth he told me to never work in New York or Washington and to build myself a small empire as the man who knew the answers to all questions about space flight. He added, "Never be a threat to any of your coworkers." I bought a Shetland pony, rode low, and stayed under everyone's radar, and I was soon known as the man with the space answers that did not want any New York or Washington job. Kitchell's suggestion proved to be the best advice I was to receive in my life.

The man from the city had personally gotten the media on the Cape's highly secret air force launch installation, and now he was getting ready for television's first-ever live coverage of a breaking news event. To make it work, Kitchell worked out an agreement with the air force, as well as one with our affiliate WFGA, Channel 12, in Jacksonville.

There was another young go-getter at WFGA named Herb Gold, and he and Jim became close friends. Herb had no clue what he was in for, and he was soon coaxed into dragging a live studio setup, cameras and all, 170 miles south through the rain.

Herb bought an old truck built for delivering pies, filled it with the equipment needed to transmit through microwave or coaxial cable to

the network, and loaded it with three-hundred-pound television cameras. He hauled the cameras to the Cape, and by jerry-rigging ropes and tackles and employing the biggest muscles around, Herb and crew then hauled them up the backside of an abandoned radar building overlooking the launch pads. A live television signal was fed through the "pie truck" to the network, and when a Thor-Able rocket headed for the vicinity of the moon on November 8, 1958, Jim Kitchell and Herb Gold and their scavengers had legendary broadcaster Roy Neal reporting live on the NBC television network. For the first time, a breaking news event arrived live on your home television set.

NBC had its live television breaking news report, and NASA was now a fact, but the "spook" boys around the Pentagon weren't happy. The Russians hurled large payloads in orbit and our puny satellites could only watch. The Advanced Research Projects Agency decided something had to be done, and they came up with a propaganda doozey. They decided to put a whole damn Atlas into orbit. The entire missile would be the satellite. Let's see the Russians top that!

The Atlas was, at the time, the country's intercontinental ballistic missile, and for it to hurl a warhead more than five thousand miles, the stage-and-a-half rocket had to achieve a speed just under orbital velocity. Engineers figured if they stripped an Atlas down to its socks, to what they called a "hot rod" rocket, it would go into orbit with the assist of Earth's easterly rotation. This meant Atlas had to be launched due east, out of the range of safety guidelines, but Major General Donald Yates, commander of the Air Force Eastern Test Range, told the White House he could handle that.

Only eighty-eight people were brought in on the plan. They had to strip *Atlas 10B* of everything not needed to fly, and they had to place a tape playback unit and a broadcast transmitter inside the missile. The tape was what we in the business call a closed loop. It would continually repeat a message recorded by President Eisenhower wishing all peoples peace on Earth from the world's largest satellite.

The scheme was given the name "Project Score," and *Atlas 10B* was

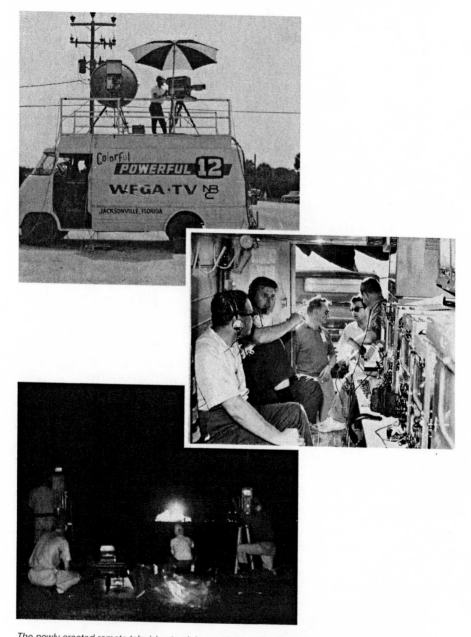

The newly created remote television truck is seen here at the Cape. Inside is executive producer Jim Kitchell (second from left). Correspondent Roy Neal (third from left) is seen talking to unit manager Dick Auerbach. The November 8, 1958, launch of the Thor-Able rocket to the vicinity of the moon is seen captured by NBC's cameras—the first live television of a breaking news event. (Gold Collection).

ready to fly on December 18, 1958. The mission was the most secret American launch ever, and the "spooks" were off and grinning.

Four days before the launch, I was in a stall in the men's room down the hall from General Yates's office when I heard a familiar voice. It was the general himself, talking to an ARPA man.

"Check the place out," Yates ordered.

The ARPA man scanned the men's room before bending over and looking under each stall's door. By then my feet were up around my ears.

"We're clear."

"Okay," the general said, adding, "My biggest concern is some damn reporter will find out about the launch."

"So what?" The spook sounded gleeful. "If he tells the world, and we fail, we'll simply deny it. He'll be left out on the proverbial limb."

"Right," Yates agreed, "but if we get Ike's message in orbit, then the President can announce it himself from the White House."

The two men finished and left. Now I was the one feeling smug. It was dumb luck for sure, but just what in hell were they talking about?

The next launch was *Atlas 10B*. That I knew. But they were talking about Ike's message from orbit. *10B* wasn't going to orbit anything! Or was it? I had been told how Atlas rockets almost achieve orbit each time they are launched on intercontinental ranges. Could that be it? Well, why in hell not? They could be orbiting something with *10B*. That was it! They could be orbiting a message from the President.

I rushed back to my office. A message from Jim Kitchell in New York waited. I returned his call and learned Jim was already on the story. We compared notes on what each of us knew, and I was quickly on my way to see a few solid sources. I had no idea only eighty-eight people nationwide were officially in the know, and I was greeted with blank faces. Then, good old RCA, NBC's parent company came through. The playback unit and transmitter were being put together by RCA, and my source played me the tape. I had it all. But as the "spook" had said, there was little I could do. We could film, record, and stand by. Nothing more.

I phoned Kitchell and he flew cameraman Bruce Powell down from

Chicago. Atlas *10B* roared from a freshly darkened Earth at 6:02 P.M. Eastern time, December 18, 1958.

And God! What a launch!

10B climbed into the darkness, the Atlas's thrust lighting the night as hundreds of launches had before. But then, a little more than a minute off the ground, the rocket was instantly out of sight. The line of shadow cast by Earth stretched far over our heads, and now *Atlas 10B* was rushing across a blue sky beyond our darkness. It was bathed in sunlight from a sun that had already disappeared beyond the Cape's horizon.

We stood frozen by what we saw. Rocket flames growing blood-red

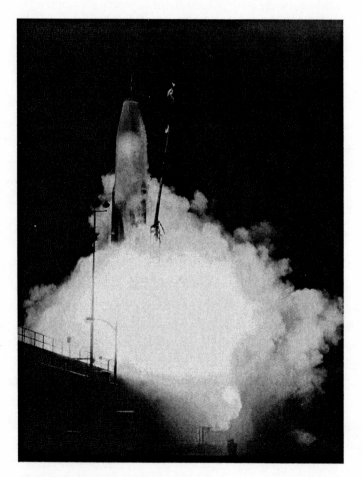

Atlas 10B *lifts off with Project Score. (USAF).*

followed by dazzling blues and greens and yellows, all creating a shimmering aurora in space. We were looking at a multicolored sky alive and dancing. It was as if the gods were welcoming Ike's message with their own shimmering Christmas tree.

No one had ever seen before or will ever see again this incredible sight. The temperature, the moisture in the air, and the light rays from a hidden sun were just right. The stunning colors and lights glimmered and lingered in the heavens, and official phones were ringing off their walls. Some thought the world was ending. Others thought the rocket had blown up.

Meanwhile, inside Range Control, those who were tracking the Atlas were watching the big rocket grab for all of Earth's rotational push. *10B* needed all the help it could get to make it into orbit. It was headed due east and off the safety charts. The range safety officer (RSO) was about to have a fit. He was reaching for the destruct button to blow the Atlas to harmless debris when he felt a hand grab his wrist. General Donald Yates stood over his shoulder with a firm grip. "Don't push that button, Captain," the general ordered. "I'll take full responsibility."

"But, Sir," the air force captain protested, "if we have a failure the missile could hit Africa."

"Big deal," the general bellowed. "A lot of jungle out there." Yates released his grip. "Don't touch that damn button, Captain. That's a direct order."

The range safety officer leaned back in his chair and began to sweat. General Yates held his breath, and an anxious White House awaited word.

Five minutes after *Atlas 10B*'s magnificent liftoff, the rocket sailed into Earth orbit and became the planet's largest and heaviest man-made satellite.

Other press members reported it as a routine launch. I didn't report anything. I grinned as NBC cameraman Powell sped away for his chartered plane to our Jacksonville affiliate. If the whole damn scheme worked, we'd have an NBC network report.

The air force returned the news media to Headquarters Building 425 at Patrick Air Force Base, where we had left our cars. Immediately, ev-

eryone was off the bus and off to the bars, believing the story was over.

Major Ken Grine, our air force escort, decided to stay in his office, and I decided to stay with him. We both knew why we were waiting, and two hours after *10B*'s launch, direct from the White House we had confirmation from the President himself.

"Tonight," Ike began, "An Atlas satellite was launched into orbit from Cape Canaveral. On board is this recorded message by me."

The President turned and pointed to the White House radio technician:

This is the President of the United States speaking. Through the marvels of scientific advance, my voice is coming to you from a satellite circling in outer space. My message is a simple one. Through this unique means I convey to you and all mankind America's wish for peace on Earth and good will to men everywhere.

NBC News was the only agency with film, and we enjoyed our little exclusive.

In 1958, launches at Cape Canaveral had become the hottest news in the country. NBC's Chet Huntley was America's number-one broadcaster, often at the Cape. From left to right: author Jay Barbree, Major Ken Grine, Chet Huntley, Bill Hill, Jim Kitchell, and Bruce Powell. (Barbree Collection).

Project Score reached orbit five months into my employ by NBC News, and by now I knew my way around the Cape and the military.

As a farm boy of sixteen without a home, I lied about my age and talked myself into the air force, where I spent four years in search of an education. After basic training in Texas, I was assigned to Scott Air Force Base in Illinois. There, I spent my off-duty time studying for my general equivalency diploma, and watching the fighters and bombers climb into the sky from Scott Field. Sometimes I would walk to the end of the runway and stand, drinking in the energy of an F–80 jet thundering over my head, tucking up its gear and fleeing into puffy white clouds.

I was in awe of flying machines, and I began spending much of my spare time at a nearby private airport. I had no money for flying lessons, but I would stand there and watch the pilots shout "Contact!" to the mechanics that would grab the wooden props and swing them down suddenly; each aircraft engine would fire with a stuttering cough. I loved to stand behind the ships when the pilots revved them up for a power check. The air blast whipped back, throwing up dust and flattening the grass, blowing strong in my face.

Soon, I was an airport fixture. I was the pilots' "go-fer." I gladly ran their errands and helped them with their planes, and they repaid me with local rides.

I'll never forget my first hop. The airplane was old, its fabric faded, splotched yellow, and the engine dripped oil. It smelled of gasoline in the air; it shook my teeth, but I didn't care. After a few weeks, the pilots let me handle the stick and rudder foot pedals in flight, adding instructions when possible.

Then there was the day the man with the red-and-white Stearman biplane landed at our field. I helped the pilot with the awesome ship, running behind the right wing and pushing on the struts. We got the machine refueled, and I answered all the pilot's questions, bringing him coffee and a couple of fresh doughnuts. And while he downed the cof-

fee, I stood on a box, cleaning the cockpit glass, polishing the gleaming red-and-white surface as the pilot watched in silence.

"Hey, buddy!" he shouted. "Would you like a ride?"

My grin was my answer and minutes later we were in the air, where, for the first time, I experienced aerobatics as earth and sky vanished and reappeared with startling rapidity. It began with me staring at a vertical horizon and realizing the edge of the world now stood on its end. But not for long, as the Stearman continued on over, rolling around the inside of an invisible barrel in the air, until the ground was up and the sky was down. I had just enough time to catch my breath when the nose went down and an invisible hand pushed me gently into my seat and glued me there as the nose came up, and up. The horizon disappeared again, and the engine screamed with the dive. Then the nose was coming up, higher and higher, and the engine began to protest. The sun flashed in my eyes, and I found myself on my back as the Stearman soared up and over in a beautiful loop.

As we flew on, my pleasure grew, and my eyes were glazed with delight by the time the biplane whispered onto the grass landing strip.

There could be no stopping me now. I lived and slept flying, and within a year I had my pilot's license along with my high school di-

The author as an eighteen-year-old pilot at Scott Air Force Base, Illinois. (Barbree Collection).

ploma, and I earned two years of college credits in night aviation classes. I was transferred to the Scott AFB Link Trainer Section, where I was appointed an air force instrument flight simulator instructor at the age of eighteen.

A couple of the other pilots in the Link Section and I bought an Aeronica Champion, and in the months to come, logged endless hours in the single-engine land aircraft. At that time I only saw my future in aviation, but I soon learned the pay wasn't promising, and I met a portly radio-station owner endowed with both a full bosom and a desire to possess my young body. Broadcast crept into my life, pushing flying aside, and once out of the air force, a living I had to make.

I kicked around a couple of radio stations before landing at WALB Radio & TV in Albany, Georgia, where, after three years, the "space bug" sunk its teeth in me and I was off to Cape Canaveral. I managed a little piece of bachelor's heaven in a studio apartment on the beach, and when it came to making friends, I was lucky. Some of them were even famous, but I suppose the one I liked to hang out with the most was a wild New Yorker named Martin Caidin. Caidin stepped aside for no man, and he was arguably the greatest aviation and space writer ever. He lived in New York but when he finished writing a book, Caidin would be off to the Cape, where we would raise hell and get in some serious flying.

We were an odd couple: he a wise-ass New Yorker, I a Georgia plowboy. We just seemed to piss off the right people, which I reasoned was because Caidin was an orphan and we'd both grown up without. When two people who never had much meet, well, there's instant trust.

Mostly, when Marty came down, we would go flying. He had bought a German World War II ME–108 fighter, and I remember one particular night when we were upstairs in calm air and the old Messerschmitt was rock steady, and we could see the Cape spread out before us; we could see where brilliant searchlights converged on an Atlas missile. It was too far away to make out details at first, but we could see the plume of escaping liquid-oxygen vapor flashing in the light.

America's new spaceport was an enchanted land of lights and colors, and as we flew closer, we could see along the northeast beach the four

massive gantry towers for Atlas, including the missile undergoing a fueling test on its pad, and the dark shapes where engineers and construction workers were rushing the completion of four complexes and their towers for the mighty Titan. And south of the Cape's point, there were the gantries for the family of intermediate-range ballistic missiles; Thor, Jupiter, Redstone, and Jupiter-C; and the new launch pads for Polaris.

I smiled. Before the week was finished, I would be covering the Polaris launch, the solid-fueled missile that would soon go to sea aboard nuclear submarines.

There were other areas too dark to identify, but from the air, I realized I was seeing the Cape as I had never seen it before. This was not merely a site where buttons were pushed and missiles screamed into the sky. It was a vast assembly, the workshop of a laboratory that stretched more than five thousand miles across the Atlantic. It was vibrant, expensive, terribly complicated, and dangerous, but most of all, vital to all of us.

Martin Caidin and Jay Barbree could often be seen flying this German World War II Messerschmitt ME–108 fighter over Florida. The German fighter with its original markings raised many eyebrows at local airports, and once Caiden had to make an emergency landing on U.S. 1, coming to a stop in front of a motel. He grinned and asked, "You have a room?" (Caidin Collection).

I rolled the Messerschmitt westward, cutting power and trimming the World War II fighter for a rapid descent. Three brilliant lights flashed and disappeared, first white, then green. They were the flasher beacons from Titusville's executive airport. I made a long, straight-in approach to the runway and the aircraft settled easily on the concrete.

I t was a beautiful Florida day for the first full-scale Polaris launch.

We reporters and photographers were taken to the roof of a vacated radar building overlooking the missile's launch pad.

The Polaris was a white-and-black stubby thing. Both of its stages were packed full of solid fuel—something like candle wax instead of liquid. That was because the fifteen-hundred-mile-range missiles, with more destructive power than all the bombs dropped in World War II, were to ride inside silos on board nuclear submarines.

The safety people had placed a standard, liquid-fuel missile's destruct package on board. The explosives were there to blow the Polaris to shreds if it acted up, but this was unknown to the experts; this destruct package couldn't get the job done. It needed about four times the explosives to blow the solid-fuel Polaris into harmless debris.

The countdown moved through its final seconds, and Polaris leapt from its pad, racing skyward much faster than its liquid-fuel brethren. Cheering onlookers were hooting and hollering as Polaris, unlike the liquid-fuel rockets, climbed on a solid stack of white smoke. It was a joy to see until—you guessed it—Polaris decided to go its own way.

Instantly, the range safety officer sent a radio signal to destroy the missile, to stop it from threatening life or property, but instead of blowing it into harmless burning trash, the underpowered destruct package simply separated the Polaris's two stages.

The first stage, the one that had been ignited at launch, continued to burn, and took a new course toward coastal towns.

Suddenly, a panicked voice began screaming over the Cape's squawk box, "All personnel on the Cape take cover!"

No member of the press moved. We stood staring into the sky. The

Polaris's unlit second stage appeared like a huge white barrel tumbling over and over, heading directly toward us.

The squawk box kept screaming for us to take cover, and our escort, Major Ken Grine, kept yelling, "Get the hell off this roof!"

At that very moment, a naval commander was bringing a tray of sandwiches up the stairs, unaware of what was happening.

"Come on, you guys," Grine yelled again. "It's my ass if you don't get off this roof."

Again, no one moved, and the major stamped his foot and took off running down the stairs, sending tray and sandwiches and naval commander tumbling to the ground. I quickly refocused my attention skyward to see the Polaris's second stage breaking apart. It was now in several pieces. A large chunk plunged into the roof of a car parked next to our building; it smashed the vehicle flat, including its tires. Other debris, most of it now burning, showered an area around us the size of a football field. One piece smacked into the roof in front of my feet.

The instant smell of burning tar got our attention, but we still didn't move. Associated Press photographer Jimmy Kerlin had his legs and arms wrapped around his tripod, shooting pictures of everything in sight.

The Polaris's first stage continued burning its way toward land. God, it could even hit Cocoa! Hundreds could soon be killed. Then, I moved. I ran down the stairs, demanding that Major Grine take us off the Cape so we could get to the impact site and report whatever happened.

Grine agreed. We quickly got on the bus and as we moved through the guarded gate, I jumped off on the safety of civilian soil. I ran for the same public phone booth where I had covered the Vanguard blowup. I was on the air within a minute, telling NBC network listeners what I knew; and when I completed my report I ran onto the highway, waving down the first car coming my way. The driver gave me a ride to the Hitching Post Trailer Park, where the crowd was still growing. The steaming first stage of the Polaris was in the Banana River, only a couple of hundred feet behind the rows of house trailers.

"We get all the tornadoes, God," someone yelled. "Why us? Why stray missiles too?"

"Anyone hurt?" I yelled back, and voices from among the crowd reported, "No!"

I stopped long enough to catch my breath before I started checking the place out, interviewing eyewitnesses.

There were no apparent injuries or damages, but what had the crowd buzzing, of more interest even than the wayward missile, was the woman who had been taking a shower in her trailer. When the Polaris thundered into the river, she ran out to see what was going on. Yep, she had forgotten one important item—her clothes. The Lady Godiva of Cape Canaveral's Hitching Post Trailer Park received as much print in the local paper the next day as did the runaway Polaris. Go figure.

The Astronauts

N ASA could not have gone looking for astronauts in a more inhospitable place, a barren, snake-infested high desert where sand and sun had whitened the bones of the long-forgotten foolhardy, where winds sliced through the snarled Joshua trees which stood like sentries, and where a flat, dry lake bed offered America's most skilled test pilots the longest runways in any direction: California's Edwards Air Force Base.

It was from this high-tech flight center, as well as from the homes of the country's best naval and marine aviators, that NASA gathered its future astronauts. Each candidate had to have at least fifteen hundred hours' flight time in America's fastest, most unforgiving jets. Fifty-eight air force, forty-seven navy, and five from the marine corps applied.

Early in 1959, these applicants were undergoing extreme physiological, psychological, and leadership tests at Wright Patterson Air Force Base in Dayton, Ohio. NBC thought that, being a pilot, I should crawl in these same horror chambers. But there was a difference. There was no way I was going to ride a temperamental rocket, and I could not think of a single reason why I should put my cowardly body through such torture.

But NBC did not agree, and I headed north to join Jim Kitchell. Kitch

and crew were at Wright Patterson shooting a Chet Huntley Reporting, a thirty-minute news show aired Sunday evenings. For the next four days I held a microphone in my hand, trying to say something that made sense while I was frozen, roasted, shaken, and isolated in chambers so quiet my own heart sounded like the loudest drum in the parade.

I survived, NBC got its twelve "How I Became an Astronaut" reports for our old weekend radio show *Monitor*, and later that week, April 9, 1959, the Mercury Seven astronauts were named—names that would, within a few short years, become legendary.

There was Malcolm Scott Carpenter, a navy lieutenant from the Korean War; Leroy Gordon Cooper, an air force captain who flew the hottest jets; John Herschel Glenn, a marine lieutenant colonel—a fighter pilot from two wars; Virgil "Gus" Grissom, an air force captain with one hundred combat missions over Korea; Walter M. "Wally" Schirra, a navy lieutenant commander, a veteran of ninety fighter-bomber missions in Korea; carrier and test pilot Alan Bartlet Shepard, a navy lieutenant commander; and Donald K. "Deke" Slayton, an air force captain who flew fifty-six combat missions over Europe and seven combat missions over Japan in World War II.

NASA announced their selection at a high-profile news conference in the nation's capital. Since we happened to be in Dayton, Jim Kitchell decided to see if any of the seven were stationed at Wright Patterson. We were in luck. Gus Grissom's home was a short drive and we were off to interview his wife, Betty. Mrs. Grissom was most gracious. She invited us in and as the camera rolled, I asked, "How do you feel about your husband going into space?"

Betty smiled, and nodded toward her and Gus's sons. "The two boys, Scott and Mark, and I have been living with a test pilot," she began. "I don't really feel flying into space is going to be all that different. We feel it will be risky, but if that's what Gus wants to do, then we're all for it."

It was the perfect sound bite, and we were off to our television network affiliate in Dayton to develop the film. It was quick and dirty but we got our report on *Huntley-Brinkley*, and we were grateful. I had been a reporter long enough to predict much of the men's future. The as-

tronauts were instant celebrities, and I knew none of the families was remotely ready for what lay ahead. None had a clue that their privacy would soon be a fond memory.

For the next two years, the Mercury Seven would be hopping and jumping across the country, training to be astronauts while engineers were working to develop and perfect the Mercury space capsule.

Cape Canaveral would soon prove to be their favorite homeport, as the Florida sand spit had been an attractive stretch of land for settlements throughout its history. Here, bear shared the natural habitat with alligator and deer, and Indians buried their dead on sacred mounds. Later, some would try to hack out small patches of black, sandy earth for farming while a few went after the rich harvest of seafood. There were trappers, too, but taming the Cape was tougher than expected. It wasn't only the persistent mosquitoes but rattlesnakes—rattlesnakes as long as gators—that had driven most of the early pioneers away.

Citrus growers followed, but by 1960 beneath the launch gantries, the blockhouses, the hangars, and the offices, there were thousands of electrical arteries, a finely woven network of underground cables through which flashed the impulses of energy, vital messages, and electronic commands that would launch the astronauts. The Mercury Seven loved it. The persistent mosquitoes and sand fleas and other pests were under control. Air conditioning was here to stay, and island libations simply made the hot days and balmy nights a tropical paradise.

It was other chores in the astronauts' paradise that gave them heartache. Among their duties was playing tour guide for an assortment of VIPs. They came from all branches of government and the industrial world, with little or no knowledge of the technological challenges. Putting a man in space definitely would not be easy. It would take time, and America's leaders were shocked when the first Mercury-Atlas was launched. The mighty rocket with an unmanned Mercury spacecraft on top rode a stack of fire into the Florida sky, where it promptly blew itself to hell and beyond.

The leaders looked at the astronauts with genuine pity and offered

them more congressional monies, assuring themselves the taxpayers' dollars would buy success.

The problem was not too little money, nor was it confined to Atlas. The next time the astronauts and congressional and industry leaders gathered, it would be a Mercury-Redstone rocket they would be watching. At the moment of ignition an electrical problem shut off its engine. The Redstone quickly settled back on its pad. Then, just as quickly, the escape-tower rocket fired, jerking itself free from the Mercury spacecraft it was suppose to lift out of danger. It raced into the sky, leaving spacecraft and rocket sitting on the launch pad.

The sight of an out-of-control rocket painting the sky with fiery brush strokes brought loudspeakers blaring the warning, "Everyone on the Cape take cover." It was an unprecedented picture in the new space age: astronauts and congressmen and business leaders and we reporters jumping beneath bleachers and under vehicles to gain cover from flames shooting over our heads. My feet came to a stop under the press-site platform, arms wrapping my body securely around a pylon. Instantly, I felt another set of arms clinging from the opposite side. A grinning Alan Shepard asked, "Are we having fun yet?"

"Your first trip?"

We both laughed as we watched the top of the Mercury capsule pop open and the parachutes unravel and spill down the side of the Redstone.

At the same time, in a sky filled with twisting smoke trails, the escape tower's rocket burned out and the tower tumbled back to Earth. It crashed about four hundred yards from the pad, and for those who care about such things, the tower rocket had scooted to a height of four thousand feet.

"That'll get your attention," Shepard said.

I nodded. "It's your ass."

"You wouldn't ride it?"

"Not on the back of a flatbed truck to Cocoa."

D uring the Cape's early days, humor lightened long workdays. Practical jokes were the in thing, and the astronauts quarterbacked most of them.

About thirty miles south of the Cape's launch-pad row, Jim Rathmann ran the local Chevrolet dealership. A world-class race-car driver who was the 1960 winner of the Indianapolis 500, he was really cut from the same cloth as the astronauts, the only difference being that Rathmann did his speed on the ground instead of in the air. He worked out a deal with General Motors to give the Mercury Seven new Corvettes. Of course, such an arrangement would not be tolerated today by NASA, but in 1960 Jim Rathmann sold General Motors on the fact that the public-relations and advertising benefits would more than offset the cost, and the guys happily hopped into a strong friendship with Rathmann and his hot 'Vettes.

Competition was mother's milk for the astronauts. They had to see who could get the most speed out of anything they flew, drove, sailed, or pedaled, and each astronaut's personal Corvette was at the top of the list. After a full day of training, they would set up drag races on the long, deserted road called ICBM Row.

Cooper, Grissom, and Shepard were an unholy trio on the asphalt. They'd line up and burn rubber down the straight road by the rockets and gantries, sending rabbits, deer, wild hogs, but more important, traffic cops running through the sand dunes.

At first, there was a Barney Fife wannabe who was determined to give the astronauts tickets. The Mercury Seven, and those who had gathered to watch the fun, regarded this deserted and restricted road as none of his business. They took his ticket book and ripped it to pieces. Gordo decided to eat a few pages while the others undressed the "Rent-A-Cop" and threw him and his pistol, badge, and uniform into the surf. Next they drove his patrol car deep into the sand, where it took two wreckers to get it out. It was a great way to get rid of the tension that built up during the long work hours, and the polite astronauts thanked Barney Fife for the good fun.

The traffic-cop matter was soon dropped, because the U.S. Attorney

had the final say on federal property and it seems that he had married the sister of one of those involved. The ticket writer was invited to leave the Cape. He found a ticket-writing vacancy in the Cocoa Beach Police Department.

Only days had passed when the same traffic cop found himself in another donnybrook with the feds.

Air police with Thompson submachine guns were escorting an urgently needed secret missile unit through Cocoa Beach at about 3:00 in the morning. The speed limit was 35, but the urgently needed freight was moving about 50 along deserted A1A. Barney Fife pulled the escorted truck over and began writing the driver a ticket. The air police ordered him to step aside and Barney Fife decided to draw his big, bad .38. The clicking sounds of rounds going into the barrels of the Thompsons persuaded him to rethink his action.

As the story goes, the John Wayne of spacecoast traffic cops decided his talents could best be used in the backwaters of Louisiana. He wasn't missed, and the drag races continued without further interruption.

We reporters weren't permitted on federal property to witness these races, but some of us got the results first hand daily. A few years before Alan Shepard died, he admitted, "Barbree, there's no way all the stories that have been told about us can be true. But most of them are good for a laugh."

Soon Gordo Cooper was leaving Alan Shepard in the dust at the starting gate of the drags. Alan wasn't laughing. Fuming, he turned to Gus. "What the hell's going on?"

Gus grinned. "You're getting your ass kicked," he told Alan, who drove off disgusted and headed for Rathmann's Chevrolet.

Jim was in the garage, and Alan went in growling. "There's something wrong with my car, Jim; you gotta do something."

"Leave it with me, Alan," Jim said, smiling.

Jim was in on Gordo's prank, and when Alan picked up his 'Vette and tried Gordo again, he lost. He had expected his 'Vette to perform better, but now it was even worse. Alan was beginning to smell a rat and he took the car in again, even more adamant with Jim that something be done.

Astronaut Gordon Cooper (seated in race car) is seen here with Jim Rathmann (kneeling) and astronaut Gus Grissom (standing on left) in Rathmann's garage, where most nasty pranks were hatched. (Rathmann Collection).

Fighter pilots had a tradition of painting swastikas or rising-sun flags for each kill on the side of their cockpits during World War II. When Alan returned this time, his car had four Volkswagens and two bicycles painted on its driver's door. Alan was on his knees laughing. He soon learned the mechanic had changed the rear-end ratio on his 'Vette. This gave him more speed but less pickup. Gordo's car could outrun Alan's for about two miles—long enough to win every drag. It was truly a classic "Gotcha."

The fun soon spilled over into their workplace. Walt Williams was the boss. He was a serious man. Williams moved about the Cape's buildings and launch complexes with a driven determination. A frown on his face was a major part of his daily dress, and on one particular day, when the astronauts were working on the Mercury-Redstone launch pad, Williams suddenly remembered he had to make a luncheon speech in Cocoa Beach. "I've gotta be in town in twenty minutes," he complained. "I left my car back at the office."

Alan Shepard stepped forward. "Take my 'Vette, Walt, I'll catch a ride in with Gus."

Walt Williams was rarely offered a favor. He wasn't sure how to respond. He did, however, manage a slight smile. "Thank you, Commander Shepard," he said politely. "But I don't know if I can drive a hot car like yours."

"Sure you can, Walt," Alan assured him. "C'mon, I'll help you get it started."

The two men rushed across the parking lot and Alan helped buckle Walt into his 'Vette. The Project Mercury director sat there, staring at all the knobs, buttons, switches, and instruments. "What the hell," he mumbled, fussing with the unfamiliar controls.

"Here, Walt," Alan said, reaching across and starting the vehicle.

"Thank you," Walt said, closing the door.

Alan heard his 'Vette's gears cry in agony as Walt jammed the stick in first and chugged away, stopping and starting and eventually getting the sports car to move at a somewhat steady pace.

Alan turned and ran into the launch pad's office. As Walt was turning onto the main road, he phoned the cops. "This is astronaut Alan Shepard," he shouted. "Some sonofabitch just stole my Corvette. He's headed for the south gate."

Walt chugged and jerked Alan's 'Vette up to the Cape's exit, and the guards pounced on the stoic man, lifting him from the car and spread-eagling him over the hood.

Alan was already on the phone with NASA security chief Charlie Buckley. "You better get to the south gate right now, Charlie," he laughed. "They have the boss in handcuffs."

Then, it was *the* day.

The seven astronauts doodled at their desks in their office at the Langley Research Center in Virginia. It was January 19, 1961. Tomorrow, John F. Kennedy would be sworn in as President of the United States. But right now Robert Gilruth was more important to the Mercury Seven. As chief of the Space Task Group, Gilruth ran Project Mer-

Astronaut Alan Shepard atop the back of his beloved Corvette. (Barbree Collection).

cury. He owned the candy store. He was Walt Williams's boss, and he would say who would be the *FIRST TO GO!* That had been the engine driving the Mercury Seven's training, and that afternoon Gilruth had called the astronauts. "How about hanging in after quitting time, guys? I have something to tell you."

There it was. He'd made his decision, and each of the seven reviewed where they stood in the program. There'd been an unquestioned break-through in mid-December when a Redstone carried an unmanned Mercury capsule through a perfect flight. That's when Gilruth said oh so casually, "Everybody better start thinking about who goes first."

Okay. Each astronaut voted for himself. Then Gilruth smiled and said, "I would like for you guys to take a peer vote. If you were unable to make the first flight, select the man you think should go." He was aware of their discomfort and smiled. "Drop your choice by my office soon."

The astronauts couldn't determine whether Gilruth had really given them a vote or if he was playing it clever. Either way, the Mercury Seven

knew he could simply select the man he wanted, and the astronauts would never be the wiser.

The door opened. Gilruth came in and got right to the point: "What I have to say to you must stay with you. You can't talk about it, not to anyone, not even to your wives. Now let's keep it that way. Each of you has done an outstanding job. We're grateful for your contributions, but you all know only one man can be first in space.

"What I'm about to tell you," Gilruth continued, "is the most difficult decision I've ever had to make. It is essential this decision be known to only a small group of people. We'll make it known to the public at the appropriate time."

He hesitated only to take a breath.

"Alan Shepard will make the first suborbital Redstone flight, Gus Grissom will follow Alan on the second suborbital flight, and John Glenn will be backup for both missions."

Six hearts sunk as the seventh raced ahead with pride.

Alan Shepard understood the other guys' disappointment, but they all knew from the beginning that one would go, six would watch.

John Glenn stepped forward and shook Shepard's hand as the other five moved in and offered their congratulations before quietly leaving the room. Shepard knew this was a time to keep his feelings inside, but as he went through the door, he permitted himself one little click of his heels.

We reporters were kept in the dark, but within days I learned the selection committee had picked Shepard because he was judged to be the smartest. The committee selected Grissom because of his engineering skills, and Glenn because he always brought his plane back no matter how badly it had been shot up.

None of this did me any good as a reporter, for I had received the information off the record. The other astronauts knew the smart guy would be in the seat for the unknown, the engineer would be there to analyze and fix any hardware during the second flight, and the third guy would push the envelope. If he pushed it too far and they got into trouble, well, somehow Glenn would bring the ship home.

They also knew that if Shepard's flight came off as planned, then

all of them would have their turn. They had no fight with one another. Their struggle was to develop safe hardware and come home alive.

The Mercury Seven returned to Cape Canaveral on a mission to get rid of what the press was calling "AstroChimp."

As a precaution, NASA had decided to send a chimpanzee into space first. The astronauts to a man thought the chimp was unnecessary.

"The only way for us to go," Alan Shepard told the others, "is to stay in the faces of those making the decisions. They must understand the chimp isn't needed and they must know we're ready. We gotta work hard and play hard. What about it?"

There was a chorus of, "Yeah, let's do it." The Mercury Seven grabbed hands, and from that day forward they worked hard, played hard, and "gott'er done." But there still was a problem—a "stinking" problem.

The astronauts' crew quarters in Hangar S were smelly, military, uncomfortable, and too damn close to the chimpanzees' colony. They spent their nights listening to the squat anthropoid apes hoot and holler and howl, and besides all this punishment, the astronauts had to step aside for one of the dung flingers to go into space first.

The Mercury Seven took a vote and decided they might have to follow one of these anthropoids into space, but they didn't have to live with them, and the Homo sapiens abandoned Hangar S. They took up residence in their favorite motel on Cocoa Beach.

The Washington bean counters mumbled something about cost, but the astronauts gave them the silent finger. They felt human again and would spend hours jogging along the hard ocean sands, drinking in the fresh salt air while racing with pelicans and scattering hundreds of sandpipers.

Each astronaut had his own room at the Holiday Inn, run by Henri Landwirth, who as a boy had been one of Hitler's guests in a concentration camp. Somehow the Belgian-born youngster survived the horrors and made it to the United States with two shirts and a pair of trousers. His one pair of shoes held up just long enough for him to apply for

American citizenship, after which he settled in Florida and became an innkeeper.

If the astronauts or anyone gave Henri or his staff trouble, he would throw them out. With his melodious Flemish accent, he reminded them, "Customers I can always get! Where am I going to find good help?"

Henri tried to hide his love for the astronauts, but his hospitality and food and his efforts to get them anything they needed gave him away. He was their protector. He offered them privacy and a place to relax. Gordo Cooper returned his love by having the motel pool filled with fish. With pole and fishhooks in hand, Gordo loudly announced, "I have never caught a fish in Florida, and this time it's going to be different." The rest of the guests weren't too pleased about swimming with salt-water trout and dodging Gordo's hooks. Happily for them, the chlorine soon killed the fish.

The fish-in-the-pool prank held the record until one night the Mercury launch team and the astronauts decided to move their party to Henri's. The only problem was their party was on a boat. The chop on the river grew too rough so they picked up the vessel, carried it by hand across busy A1A, and dropped it in Henri's swimming pool.

The astronauts and engineers clung to the boat, shouting, "More rum, wenches, more rum," until Henri and crew jumped in the pool and heaved them overboard. It took two cranes and a house-mover to get the boat out of the pool the next day, but that wasn't the end of it.

Wally Schirra was a masterful practical joker by himself, and one afternoon Henri and Wally walked out of Wally's room, the innkeeper supporting a wounded astronaut with a bloody towel wrapped around his arm. The pool was crowded with reporters and tourists, and we rushed to Schirra's aid.

Concerned, I asked, "What happened, Wally?"

Wally turned, nodding toward a large field of palmetto and shaggy oaks. "In there, Jay. It was in there. I don't know what," he groaned with pain, "but we got it—we got the damn thing. . . . It tore my arm up good."

"Did you call a doctor?"

"There's one on his way," Henri nodded.

"Good," I answered, staring at the thick, bloodied towel.

"We need to wait for the doctor in the room," Henri said, and some of us followed a moaning Wally Schirra inside.

The bloodied astronaut pointed to a large box on his bed, covered with a blanket, and turned to me. "Be careful, Jay. That thing's dangerous. I think it's a mongoose."

"Big mongoose," Henri agreed.

I shook my head. "There are no mongooses in Florida."

"Maybe it got loose or something. Who the hell cares?" Wally argued, growing more agitated. "Damnit, look for yourself."

Being from a farm, I have never been too afraid of animals. I moved toward the box on the bed.

"Careful!" Wally insisted.

I was wondering why there was no movement in the box when—

WHAM!

A huge, spring-loaded hairy thing with long teeth and claws burst through the blanket into my face, knocking me backward onto the floor. Those who had followed me into the room shot outside, stopping a safe distance away. Wally was on the floor beside me, his arms around the "jack- in-the-box wild thing," doubled over with laughter.

In the coming months, the "mongoose" sent some of the country's most daring astronauts and fighter pilots hurtling through doors and windows to safety.

As of this writing, Wally tells me he still has his treasured mongoose in his garage.

Project Mercury was running out of days in February 1961, and a serious tone settled over the upcoming launch teams. But the decision to mislead the public as to who was going to be first held. The media's general consensus was that John Glenn would be chosen. I didn't agree. Shepard and I had swallowed a little too much of Jack Daniel's sour mash one evening and, off the record, he told me.

I wished he hadn't. Had I learned of his selection to be first another way, I could have used the information.

The secrecy surrounding the selection was to continue right up to launch day, with Bob Gilruth deciding that Shepard's name would be made public only after the Mercury-Redstone lifted off. There was even some incredible deceptive plan about bringing all three of the astronauts to the pad dressed to fly, with hoods over their heads. That way not even the launch team would know who had climbed in the Mercury spacecraft to be first.

I ran into Gilruth in the Holiday Inn. I told him I had heard about this deception, and I asked him a simple question: "Why?"

He stared back, and finally muttered, "It's my business."

I jumped in his face. "No, it is not your business," I said bluntly. "It's the American taxpayer's business. NASA is a civilian, open agency. You want secrecy, join the CIA."

He was not pleased. He walked away without another word.

No one in the know cared for Gilruth's cover-up, but it was a minor irritation compared with the fact the chimpanzee was flying first. All that animal would do was bang levers and push buttons, and get jolted with electricity if he didn't perform as trained. The astronauts protested, but the medical folks insisted. There were too many unknowns about space flight to risk a human life without first sending up a chimp as a possible sacrifice. The fact that a chimpanzee is a highly intelligent anthropoid, an animal closely related to and resembling a human, didn't matter. Killing one's animal cousin appeared to be acceptable.

Of the seven candidates that came to the Cape for final flight training, a chimp named Chang was considered to be prime, and Elvis was the backup. The only problem was that Elvis was a female, so named because of her long sideburns. In order to cause no offense, the names had to be changed. Chang became Ham and Elvis was christened Patti. Ham stood for "Holloman Aero Med," his home in New Mexico, and (known to just a very few) Patti stood for "Patrice Lumumba," the African tyrant, because the chimps came from the French Cameroon.

NASA selected the newly crowned Ham, and on January 31, 1961, the astronauts gathered to watch the launch. The flight turned out to be a bit more interesting. Redstone had a "hot engine." It burned all of its fuel five seconds early. The control system sensed that something was

Space chimp Ham, looking worn
from his near drowning and
harrowing suborbital flight, is
greeted by the captain of his
recovery ship. (NASA).

wrong. Instantly it ignited the escape tower hooked to the Mercury cap-
sule, and it blew the spacecraft away. This sent Ham higher, faster, and
farther. The chimpanaut landed 122 miles beyond his target and came
down hard, hitting the ocean with a teeth-jarring stop.

The rough splashdown was followed with the stomach-churning mo-
tion of six-foot waves, and by the time the recovery choppers showed
up, Ham's capsule was on its side. More than eight hundred pounds of
water had rolled in and they had a sputtering, choking, almost-drowned
chimp on their hands.

Alan Shepard reviewed Ham's flight. He knew he could have sur-
vived it, but he also knew his own flight was in deep trouble. If
only the damn chimp ride had been on the money, then he would have
been off the launch pad in March.

But Ham's flight wasn't on the money, it was a disaster, and Dr. von Braun was worried. He had the responsibility for the astronauts' lives. "We require another unmanned flight," he said soberly.

Working with the engineers, Shepard confirmed that the problem with Ham's Redstone had been nothing more than a minor electrical relay. The fix was quick and Shepard said, "Even von Braun should be satisfied with what we found!"

Shepard was wrong. Dr. von Braun stood fast. "Another test flight."

The March 24 repeat Redstone launch was perfect. Shepard could have killed. He knew he should have been on that flight. America would now have the first astronaut in space.

Over drinks, he told me, "We had them, Barbree. We had the Russians by the gonads and we gave it away."

"Maybe not," I said, trying to resurrect hope. "You could still be first. May's not that far away."

"Not a chance," he said in that distant manner of his. "It's the damn Sputnik thing all over again."

First in Space

He drifted between sleep and wakefulness. That's how it had been most of this night of remembering. They were memories he welcomed, the ones that reminded him of his father, a skilled carpenter who had worked daily to make their wooden home special, and the special memories of his mother. The memories of her smile, of her working in their home, making it warm and comfortable—memories of her kitchen, memories of something good to eat, especially her borscht.

Those were the memories he chose. Not his boyhood memories of the great guns, the ear-splitting thunder of the exploding shells, the earth-shaking rumble of German tanks moving through his hometown; the memories of a boy watching his parents obey the Nazis just so, whenever possible, they could forage for food inside the battlefields.

Only as he was nearing his teens would the other, good memories come—those memories with the welcoming sounds. The airplanes with red stars on their wings followed by terrible fighting, and the tanks pushing into their village, were Russian. The Germans fled and the Russian tanks stayed. And as quickly as the war ended, young Yuri Gagarin studied day and night in school and at home so that one day he would qualify to become a pilot in the Red Air Force.

In 1955 he was accepted in flight school. Two years later he won his wings, the wings of a jet fighter pilot. He had become an expert parachutist, too, and in 1959 he volunteered for an exciting new program.

Cosmonaut!

He moved through the demanding training at the head of his class and on April 8, 1961, only four days before this night of memories, his commander gave him the news: "You will be the first. You will travel first into space."

Until now he really hadn't believed it; it seemed so unreal. But suddenly Gagarin's door opened, and it was real enough. They had come to get him prepared. He met with the doctors and the political commissar. Everything moved smoothly. Breakfast was fun. The flight surgeons said he was ready. Sensors were attached to his body, and his backup and close friend, cosmonaut Gherman Titov, helped him climb into his pressure suit and heavy helmet.

Sunrise swept over the launch pad and Yuri Gagarin stood quietly for several minutes, studying the enormous SS–6 ICBM that would haul him into Earth orbit. No warhead atop this baby. Up there was *Swallow*, his Vostok spacecraft, weighing more than five tons.

Gagarin stopped on the ramp partway up the stairs to the elevator. He turned to speak to the fortunate group who would witness this dividing moment in history. They stood silently, not wanting to miss a word.

"The whole of my life seems to be condensed into this one wonderful moment," Gagarin began with humility. "Everything that I have been, everything that I have done, was for this. Could anyone dream of more?"

He waved farewell, entered the elevator, and when they reached the top, Gagarin climbed aboard *Swallow*. Technicians secured his harness to the specially designed seat. He raised a hand and signaled he was ready. Technicians closed the hatch, and Yuri Gagarin was sealed inside with his destiny.

The countdown moved through its normal stops and starts, checks and rechecks, and then the final minutes. . .

"Gotovnosty dyesyat minut."

Two minutes to go. . .

He braced himself and relaxed his muscles as he felt motors whining. The gantry with the service level was pulling away. He moved with the bumps and thuds as power cables were ejected from their slots in the rocket. He knew what the sounds meant. Now the mighty SS-6 was on its own, drawing power from its internal systems.

He heard a voice shout:

"Zazhiganiye!"

Gagarin needed no one to tell him he had ignition.

His body was suddenly shuddering. The SS-6's rockets were burning with an explosive fury of 900,000 pounds of thrust. There were twenty main rocket motors and a dozen small vernier control engines firing, and the first man to leave Earth headed for an orbital track around his planet.

It was 11:07 A.M. local time.

It was 9:07 A.M. in Moscow.

It was 1:07 A.M. in New York.

America slept.

Only a few in this country's intelligence groups were aware that on the steppes of Kazakhstan, cosmonaut Yuri Gagarin was shouting, "Off we go," bringing smiles and grins to his launch team and flight controllers. With the SS-6 well clear of the launch site, many of those whose duties were completed rushed outside to watch their rocket roar skyward—to see Yuri Gagarin travel faster than any man in history. They watched and jumped and cheered until the rocket was far above the Aral Sea and about to disappear over the eastern horizon.

On board, in spite of his constantly increasing weight under the pull of gravity, Gagarin maintained steady reports. He was young and muscular, and he absorbed the punishment easily. The acceleration generated a force of six times normal gravity.

Gagarin now weighed more than a thousand pounds.

Suddenly, he heard and felt a loud jolt, then a series of bumps and thuds as the protective shroud covering *Vostok* was jettisoned. Through his portholes, he looked out at a brilliant horizon and a universe of blackness.

His sightseeing was short lived.

His rocket shut down on time.

All was silent.

Then more jolts and thuds as his spaceship was released from its rocket's final stage.

The miracle was at hand. Gagarin, in *Swallow,* had entered Earth orbit.

Those on the ground listened in wonder to the cosmonaut's calm reports of what he was feeling, how his equipment was working. Then he went silent as a never-before-known sensation overwhelmed him. He was feeling the magic of weightlessness, feeling as if he were a stranger in his own body. Up or down had no meaning. He was suspended. He was being kept from floating only by the harness strapping him to his seat. About him papers and pencils drifted.

He shook his head to clear his mind. He reported the readings of his instruments. He checked *Swallow's* critical systems. All was okay. Now he could continue his tales of what he saw and felt: "The sky looks very, very dark and the Earth is bluish." He told those on Earth about the startling brightness of the sunlit side of their planet. And by the time he had raced through a rapid orbital sunset and marveled at the wonders of a night in space, he was through an orbital sunrise, nearing the end of his single scheduled trip around Earth.

It was time to come home and Gagarin relaxed his body, exercised his fingers in his gloves, and began monitoring the automatic systems that were turning *Swallow* around, setting the ship up for retrofire.

Suddenly, he was rammed hard into the back of his contoured couch. The retro-rockets had ignited. He smiled. Everything was working perfectly. *Wham!* There it was. He had felt the sharp explosion and *Swallow* and its electronics pack were now separated from the equipment module.

Around the world in eighty-nine minutes, not eighty days.

That was all. He was coming home, flying backward. *Swallow* was plunging downward into thickening atmosphere and he felt weight again. It was building from the hammering deceleration. He was a passenger inside a blazing comet. Outside, he could see flames, thickening

and becoming intense as friction from the atmosphere heated his spaceship to 4,000 degrees. Inside, Gagarin was enjoying temperatures in the comfortable 80s.

Six minutes later, *Swallow* had slowed to subsonic speed, and at 23,000 feet the escape hatch blew away. The first man into space was now seeing blue skies and white clouds again as ejection rockets beneath his seat fired, sending him and his contour couch flying away from *Swallow*.

He and his couch were all that were left, and Gagarin watched as the stabilization chute billowed upward. Everything was working perfectly, and for ten thousand feet he rode downward before separating from the ejection seat and deploying his main parachute. He opened his helmet's faceplate as he drifted through puffy white clouds and took deep breaths of the fresh spring air. What a marvelous ride!

On the ground, two startled peasants and their cow watched the white-helmeted man drift from the heavens. Gagarin hit the ground running. He tumbled and rolled over, jumping to his feet to gather his parachute. The first man in space unhooked his harness and looked up to see a woman and a girl staring at him. The cow decided to keep grazing.

"Have you come from outer space?" asked the astonished woman.

"Yes, yes, would you believe it?" the first cosmonaut answered with a wide grin.

Within months, Yuri Gagarin shared his memories of his historic flight with my colleague Martin Caidin when Caidin was writing cosmonaut Gherman Titov's book. Titov was Gagarin's backup, and he orbited Earth a full day. He named his book *I Am Eagle*.

The ringing phone was not welcome. Especially at 3:42 A.M.

I reached for the noisy necessity. "What?" I barked.

The voice at the other end was soft, polite. "Jay, this is Jerry Jacobs on the desk."

"Uh-huh, sorry, Jerry."

"Have you heard?"

"Heard what?"

"The Russians have put a man in orbit."

"You're kidding." I sat straight up, rubbing my eyes. "How many orbits?"

"One," Jacobs said. "Get on it."

"I'm moving, boss."

I replaced the phone in its cradle, patted a disturbed young bride of seven months on her derriere, and leapt out of bed. I had only one thought: *NASA could have had Alan Shepard up there three weeks ago.*

I hit the *on* button on the radio. Jo groaned and pulled the covers over her head as excited voices spoke of Yuri Gagarin, of Earth orbit. I splashed water on my face, shaved, quickly brushed my teeth, and while putting most of my clothes on I went through door. Following the six-minute drive, I was in the office.

I phoned Colonel John "Shorty" Powers, the spokesman for the Mercury Seven. I wanted to know if the astronauts had a statement, and if NASA had scheduled a news conference.

"Morning, Shorty," I said in my most pleasant voice. "Sorry about the hour."

He definitely wasn't a morning person.

"Morning, my ass," he growled. "Whatta you want?"

"The reaction? NASA's reaction to the Russians orbiting a cosmonaut?"

"Fuck you, Barbree, we're asleep here," he yelled, slamming the phone in my ear.

I laughed and went on the NBC Radio Network with the following:

Overnight the Russians put a man into space, and Colonel John Powers, the spokesman for the Mercury Seven Astronauts, tells me "NASA's asleep." The space agency will wait to hear about man's first flight into Earth orbit over eggs and bacon.

Colonel Powers's "NASA's asleep" remark made the same headline in some of the morning papers.

But more important, it got action, and NASA powers were all over Colonel Powers. "We need a clear-cut statement by the Mercury Seven for the press."

Colonel Powers jumped out of bed and the space agency was talking. The astronauts were allowing they were disappointed, but made certain to offer sincere congratulations to their fellow cosmonauts for a terrific technical feat. And once again John Glenn galloped to NASA's rescue on his white steed. The seeds of a politician were already sprouting in John. He was honest to a fault and he knew precisely what to do: be blunt and truthful.

"They just beat the pants off us, that's all," he told the flock of reporters. "There's no use kidding ourselves about that. But now that the space age has begun, there's going to be plenty of work for everybody."

The question of who was the first human in space would never mean that much. Not really. When Yuri Gagarin went into orbit, the guesswork vanished. But would Shepard fly? Given Gagarin's success and the overwhelming power of the Russian rockets, there were suggestions in Washington that the U.S. man-in-space program be dropped. *The* never-finish-anything-you-start bunch were crying that the United States could never catch the Russians now, so why waste the time and effort and money?

If ever the country's new President needed to take a bold step, now was the time. John Kennedy called in NASA's best minds. "I want you to tell me where we stand. Do we have a chance of beating the Russians by putting up an orbiting laboratory? Or by a trip around the moon, or by a rocket to go to the moon and back with a man?"

"Yes we do, Mr. President. We can beat them to the lunar surface. We can plant the first flag on the moon. The American flag."

Kennedy was just as direct. *"GO!"*

Seven weeks after Yuri Gagarin became the first man in space, America was ready.

Three hours before scheduled launch on May 2, Associated Press photographer Jimmy Kerlin spotted Alan Shepard suiting up, and the name of the first American in space was out.

Shepard was relieved.

But there was no flight that day. Low clouds rolled in, and Walt Wil-

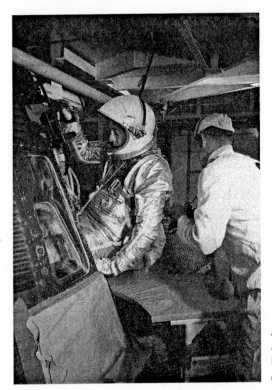

Alan Shepard slips into his Mercury capsule, named Freedom Seven, *for launch. (NASA).*

liams scrubbed the launch. The flight operations director wanted a clear view of Shepard's Redstone all the way through burnout.

Three days later, May 5, 1961, the countdown moved into its final minute, and I could hear my own voice grow with anticipation as I told our NBC audience this should be it. My co-anchor, Merrill Mueller, and I were in and outside our broadcast trailer with a continuous audio report of everything happening. We had been airing all of NASA's reports live and I reported, "Everything looks good. The weather is go, and Mercury Control says Alan Shepard and his *Freedom Seven* are go." Then I switched. "Now for the launch of the first American in space, here's the final countdown from Colonel John 'Shorty' Powers in Mercury Control."

"This is Mercury Control. Alan Shepard and the range are green . . ."

T-minus seven, six, five. . .

Alan Shepard braced his booted feet against *Freedom Seven's* floor.

Four. . .

Shepard had his hand up near the stopwatch on the panel. He had to initiate the timer at the moment of liftoff in case the automatic clock failed.

Three. . .

Left hand on the abort handle. The escape tower was loaded.

Two. . .

Shepard took a deep breath.

One. . .

One last reminder to himself: "Okay Buster, make it work."

Zero. . .

Shepard heard Deke Slayton sing out, *"IGNITION!"*

Rumbling far beneath him. Pumps spinning at full speed. Fuel gushing through lines . . . Alan Shepard tensed his body.

His rocket had been lit.

"LIFTOFF!" Slayton called.

Freedom Seven swayed.

"You're on your way, José!" Slayton shouted, referring to a comedian friend who had a routine called "The Nervous Astronaut."

"Roger, liftoff, and the clock has started," Shepard called out. Now he felt the power. "This is *Freedom Seven*. Fuel is go. Oxygen is go. Cabin holding at 5.5 PSI."

Now he was in his element. This was what Alan Shepard was born to do. He was the quintessential test pilot. He was the most relaxed, most assured person along the entire spacecoast.

Streaking toward the flaming Redstone in F–106 jets were astronauts Scott Carpenter and Wally Schirra. They were geared to chase and observe the Redstone as long as they could before it sped from sight. Tracking and search planes cruised from low-level to stratospheric heights, and the sea was dotted with swift boats and navy ships, all coiled to spring to *Freedom Seven's* rescue if needed.

At the center of Cape Canaveral's fifteen thousand acres was a makeshift press site crowded with trailers, television trucks, prefab offices, bleachers, high viewing stands, camera mounts, a blizzard of antennas, and a snake forest of cabling along the ground. The fourth estate was

linked to sending and receiving facilities in every major city around the planet. NBC itself was hooked up to sixteen networks worldwide including the BBC and the armed forces, and my broadcast partner, Merrill Mueller, and I were reporting every single thought and fact we could muster as others screamed, "Go! Go! Go!" while *Freedom Seven* climbed higher and higher into space. Tough and grizzled news veterans unashamedly cried as they pounded fists on wooden railings, against their equipment, against the defenseless backs of their compatriots in support of Alan Shepard.

Beyond the Cape, along the causeways and beaches and lining the roadways, a great army had assembled to witness an epochal moment in history. Half a million men, women, and children in cars, in RVs, on trucks, on motorcycles, on trailers, on anything that would roll had gathered, nudged, pushed, shoved, and squeezed as close as they could to the security perimeters of the Cape to watch and, most important to them, to shout encouragement.

Two thousand–plus journalists stood fast on the press-site mound watching Alan Shepard rocket into space. (USAF).

They went mad at the sight of the Redstone breaking above the tree line; their combined chorus of hope and prayer was almost as mighty as the roar of the rocket.

Throughout the area now referred to as the spacecoast, people left their homes to stand outside and look toward the Cape. They stood atop cars and trucks and rooftops. They left their morning coffee and bacon and eggs in restaurants to walk outside. They left beauty parlors and barbershops with sheets around their shoulders. And on the ocean itself, surfers ceased their pursuit of waves and stood, transfixed.

Fire was born, the dragon howled, and Redstone levitated with its precious human cargo. That was but the beginning. When the bright flame came into view, even before the deep pure sound washed across the towns and beaches, something wonderful happened.

Men and women sank slowly to their knees, praying. Others were crying.

Time stood still.

Flame lifted Alan Shepard higher, faster. And up there, all alone, America's first astronaut was pleased. *Not bad at all,* he thought. *This is smoother than anything I ever expected. Hang in there, guy,* he told himself. *It's going beautifully.*

Then, he spoke to Mercury Control. "This is *Freedom Seven*. Two-point-five-G. Cabin five-point-five. Oxygen is go. The main bus is twenty-four, and the isolated battery is twenty-nine."

A comfortable, assured "Roger" came back from Deke Slayton.

Shepard was at two-and-a-half times his normal weight. So far the flight had been a piece of cake. Flame beneath the Redstone grew longer as the outside air grew thinner. He was through the smoothest part; he was running into the rutted road, the barrier he had to defeat before he could leave the atmosphere behind.

Redstone was pushing with hammering raw energy into the reefs of Max Q, the zone of maximum dynamic pressure where the forces of flight and ascent challenged its structural soundness.

Buffeting began, an upward gutsy climb for the Redstone over invis-

ible deep and jagged potholes. Shepard's helmet slammed against his contoured couch and inches before him, the instrument panel became a blur.

A thousand pounds of pressure for every square foot of *Freedom Seven* was trying to crack the capsule like an eggshell. He was being pounded from all sides and for a split second Shepard considered calling Slayton, but instantly changed his mind. He reminded himself any sort of transmission at this point could be interpreted as fear, and it could send Mercury Control into a tizzy. It might even trigger an abort by someone overzealously guarding his safety.

The Redstone slipped through the hammering blows into the smoothness beyond. Out of Max Q. Shepard grinned. He still had all his teeth, and he keyed his mike.

"Okay, it's a lot smoother now. A lot smoother."

"Roger," Slayton said calmly.

It was time to smile.

Louise Shepard stared at the television, watching the rocket magically lift her husband into space. She tried desperately to hear, but their girls were out of control, wild, cheering and shrieking at the top of their lungs.

That was their father in that rocket.

This was their moment.

And her moment, too. She smiled, bringing a hand to her lips. "Go, Alan," she said quietly and only to herself. "Go, sweetheart."

Mercury Control called out the time hack. "Plus two minutes . . . "

Alan Shepard was now twenty-five miles up and gaining speed, headed into high flight with the forces of gravity mashing him down into his couch.

Damn it hurt, but it felt terrific. What a ride! He keyed his mike: "All systems are go."

F*reedom Seven*'s flight was prime time for radio and television news coverage, and we were enjoying every moment. The listeners were so many they were not countable, and I was blessed to be on the air with the unflappable Merrill Mueller, a veteran's veteran. He'd done his newscasts through raging battles in World War II, and he'd been the voice that reported the Japanese surrender in Tokyo Bay in 1945 from the deck of the USS *Missouri*. Losing his cool was not an option.

We had a thousand things to say about Alan Shepard, his family, the mission, the Redstone, *Freedom Seven*. But we'd never seen a man disappearing into bright sunlight—a single point of silvery flame leaving Earth.

Merrill was the master, but we had been on the air all morning and we both were running dry on things to say. Our voices fading, Merrill swallowed hard. Then the master found one last masterful thought . . .

"He looks so lonely up there . . ."

The sixteen worldwide NBC Radio networks fell silent.

T*he* rocket's thrust increased Shepard's weight sixfold and he found it difficult to speak. The growing force of gravity squeezed his vocal cords and he drew on experience, on the techniques he had mastered catapulting off carriers in fighter jets. Slayton heard him clearly.

He was struggling, but he was smiling broadly inside his helmet. End of powered flight was near.

Three, two, one, cutoff!

The Redstone stopped burning.

Above Shepard's head a large solid-propellant rocket fired, spewing thrust from three canted nozzles. These broke connecting links to pull the escape rocket and tower away. They were no longer needed.

Next, more rockets fired, and *Freedom Seven* separated from its Redstone. A new light flashed on the instrument panel.

"This is *Seven*. Cap sep is green."

Shepard and *Freedom Seven* were on their own, moving through space at more than four thousand miles per hour.

"Roger," Slayton confirmed.

Mercury Control had its ears on. They wanted to hear what it was like to be up there.

Well, first, only seconds ago Shepard weighed a thousand pounds. Now he weighed less than a thousandth of a pound.

"I'm free!" he shouted.

"Does Louise know?" Deke joked.

Alan laughed and moved within his restraints to feel the freedom of weightlessness. It was . . . well, hell, it was wonderful and marvelous and a miracle. That's what it was. Were he not strapped in, he would have floated about in total relaxation. No up, no down, and as John Glenn had posted on the capsule's instrument panel before Alan entered, "No handball playing in here." A missing washer and bits of dust drifted before him. He smiled.

No rush of wind crossing the skin of *Freedom Seven* despite its speed. No friction. No turbulence. Outside, the silence of ghosts reigned.

But inside his Mercury capsule had its own pressurized atmosphere where ghosts were real. They made their own sounds. Inverters moaned. Gyroscopes whirred. Cooling fans spun. Cameras snapped. Radios hummed. They were the voices of *Freedom Seven.*

Alan Shepard took to space with fierce pleasure as he felt *Freedom Seven* slowly turning around and he realized it was time to go flying. He wrapped his gloved right hand around the three-axis control stick.

"Switching to manual pitch," he radioed Mercury Control.

"Roger."

He moved the stick. Small jets of hydrogen peroxide gas shot into space from exterior nozzles. Instantly he felt the reaction as the capsule's blunt end raised and lowered in response to his commands. He couldn't believe how easy *Freedom Seven* was to fly. It was doing precisely what he asked.

"Pitch is okay," he reported. "Switching to manual yaw."

"Roger. Roll."

Again *Seven* moved on invisible rails. Shepard wasn't just a passenger. He was flying his spacecraft, controlling its attitude. "Finally," he shouted aloud, "we're first with something!"

He checked his flight plan.

Fun time, he smiled, moving to look through the periscope at the Earth below.

Damn, he cursed.

While on the launch pad he had checked the periscope and stared into a bright sky. Immediately he had moved in filters and now, looking through the scope, instead of a brilliant blue Earth, he saw only a gray planet.

He reached for the filter knob and as he did, the pressure gauge on his left wrist bumped against the abort handle. He chastised himself. Sure, the escape tower was gone, and hitting the abort handle might not be a problem, but this was not the time to play guessing games.

Shepard looked again through the periscope. Even through the gray, the sun's reflection from Earth below was enough to give him a picture.

"On the periscope," he radioed. "What a beautiful view!"

"Roger."

"Cloud cover over Florida, three to four-tenths on the eastern coast, obscured up through Hatteras."

Shepard spoke of the rich green of Lake Okeechobee's shores and the spindly curve of the Florida Keys. He shifted his eyes to see the Florida panhandle extending west and saw Pensacola clearly. On the horizon he caught a glimpse of Mobile and said, "There, just beyond, just out of my view is New Orleans." He gazed across Georgia, to the Carolinas, and saw the coastline of Cape Hatteras and beyond.

Then he looked straight down and studied the Bahamian islands through broken cloud cover. "What I'd give," he said, "to have that filter out of there so I could see the beautiful green Bahamian waters and coral formations around those islands."

He was now at his highest point, 116 miles. He reminded himself he had duties. *Freedom Seven*, obeying the intractable laws of celestial mechanics, was swinging into its downward curve, calculated to carry Shepard directly to the navy recovery teams waiting for him in the waters near Grand Bahama Island.

He was on the stick again, moving *Freedom Seven* to the proper angle to test-fire the three retro-rockets. "Five, four, three, two, one, retro angle," Mercury Control confirmed.

"In retro attitude," Shepard reported. "All green."

"Roger."

"Control is smooth."

"Roger, understand. All going smooth."

"Retro one," Shepard shouted. The first rocket fired and shoved him back against his seat. "Very smooth," he added.

"Roger, roger."

"Retro two." Another shove backward.

"Retro three. All three retros have fired."

"All fired on the button," Mercury Control confirmed.

The weightless wonderland vanished. Gravity was back. *Freedom Seven* was plunging into the atmosphere.

"Okay. This is *Freedom Seven* . . . my g-buildup is three . . . six . . ." His voice began to falter. "Nine . . ." he grunted, using the proven system of body-tightening and muscle rigidity to force the words through his throat.

"Roger," Slayton acknowledged.

"Okay . . . Okay . . ." Shepard's voice rose as the intensity of the struggle increased. Eleven times the normal force of gravity, getting close to "weighing" a full Earth ton. But he had pulled eleven-g loads in the centrifuge, and he knew he could keep right on working now.

He did.

"Coming through loud and clear, *Seven*."

"Okay," came the grunt.

"Okay . . ." They noticed the change in his voice. Lower pitch. The g-loads were fading.

"Okay . . . this is *Seven*, okay. Forty-five thousand feet. Uh, now forty thousand feet."

Shepard was through the gauntlet. He had handled the punishing g-forces, the eye-popping deceleration, and 1,230 degrees of blazing re-entry heat. He felt just dandy because during the scorching dive, his cabin temperature hit a peak of only 102 degrees while inside his suit the temperature rose to only 85. Just nice and toasty, he thought.

His altimeter showed 31,000 feet when Slayton's voice reached him again. "*Seven*, your impact will be right on the button."

Great news. Flight computations were perfect. So were the performances of the Redstone and the spacecraft. *Freedom Seven* was heading directly for the bull's-eye on the Atlantic recovery-area target.

"This is *Seven*," Shepard called. "Switching to recovery frequency."

"Roger, *Seven*, read you switching to GBI."

Slayton was eager to cut the hell out of Dodge as fast as he could. Shepard laughed aloud. He knew Gus would be right there with Deke, and the two would be burning sky, blazing their way to Grand Bahama Island so they could be on the ground when he arrived.

"Seven, do you read?" came a new voice on the GBI line.

"I read," Shepard called back.

He was aware the flight wasn't quite over. He still had to reach water in good shape. That meant the parachute system had to work.

Perfectly.

Above him, panel covers snapped away in the wind.

"The drogue is green at twenty-one, and the periscope is out."

Down went *Freedom Seven* and Alan Shepard. The altimeter unwound and aimed for ten thousand feet where the main chute was to open. If it failed, well, he already had a finger on the "pull like hell ring" that would release the reserve.

"Standing by for main."

Freedom Seven continued like the champ it had proven to be. "Through the periscope," Shepard would later say, "I saw the most beautiful sight of the mission. That big orange-and-white monster blossomed above me so beautifully. It told me I was safe, all was well, I had done it, all of us had done it. I was home free."

"Main on green," he reported. "Main chute is reefed and it looks good."

Freedom Seven swayed back and forth as it dropped lower. Compared to moments in his immediate past, Shepard was tiptoeing gently toward the ocean instead of crash landing a jet fighter on a carrier deck.

He opened his helmet's faceplate. Quickly he disconnected all hoses and snaps. He wanted nothing to impede a hasty exit just in case the water landing went haywire.

He braced himself for –

SPLASHDOWN!

"Into the water we went with a good pop!" Shepard said, laughing over a drink with me later. "Abrupt, but not bad. No worse than the kick in the butt when I'm catapulted off a carrier deck."

The spacecraft tipped on its side, bringing water over the right port-hole. He smacked the switch to release the reserve parachute that kept the capsule top-heavy. He was thinking about the chimp's near disappearance beneath the ocean. He began checking the cabin for leaks. He was ready to punch out at the first sight of the wet stuff pouring in.

The water didn't come and he stayed dry. Shifting the center of gravity worked, and the capsule came back upright.

Planes roared overhead. "Cardfile Two Three," he called. "This is *Freedom Seven*, would you please relay all is okay?"

"This is Two Three; roger that."

"This is *Seven*. Dye marker is out. Everything is okay. Ready for recovery."

Green dye spread brilliantly across the ocean surface from *Freedom Seven*.

"*Seven*, this is Two Three. Rescue One will be at your location momentarily."

It went like another practice run. Rescue One was overhead. Shepard opened the hatch, grabbed a harness dropped from the helicopter, and was winched aboard.

Rescue One turned for the prime recovery ship, the aircraft carrier USS *Lake Champlain*, and lowered itself gently onto the deck. "This is the best carrier landing I've ever made," Shepard laughed.

He couldn't wait to tell Deke and Gus and John and Gordo and Scott and Wally all about it.

They, the Mercury Seven, had done it!

John Glenn

A lan Shepard's success solidified questions for John Kennedy about America's efforts in space. The young President knew the difference between American and Russian rockets. He accepted the fact that the Soviets had overwhelming superiority in size and power.

What the President also had come to realize was that in spite of appearances, the Russians were not ahead of America because they were better at science; it was the exact opposite. The Soviets had their monster boosters because they couldn't build a smaller nuclear warhead. They needed the giants to get their five-ton, unsophisticated bombs to American targets. Our warheads, with the same destructive power, were much smaller. They needed only a third of the rocket power to reach their destinations.

For this reason, Kennedy was willing to take the long-range gamble that American science, technology, and industry would persevere and, with clearly defined goals, be able to surpass the Soviets.

At NBC we learned what the President was up to, and I jumped in. "Americans are going to the moon," I reported, and my boss, Russ Tornabene, shouted down the phone line, "Barbree, I want you on this. Kennedy is speaking before Congress and it's your story."

Feeling a historic milestone in the making, I covered Kennedy's

congressional address by closed-circuit television from the Cape Canaveral site where future astronauts would lift off for the moon. In ringing tones, the energetic President told an attentive Congress the nation should take longer strides, America should become the leading player in space, and the country should lead the world into a better future:

> I believe this nation should commit itself to achieving the goal, before the decade is out, of landing a man on the moon and returning him safely to earth. No single space project in this period will be more impressive to mankind, or more important for the long-range exploration of space, and none will be so difficult or expensive to accomplish.

John F. Kennedy spoke and Congress leapt to its feet with thundering applause. If the congressional reaction was any sign of the future, then his "new frontier" had absorbed new life and vitality. Despite the "Bay of Pigs" debacle and a rough start, Kennedy was on his way back. He had absolute confidence that this was a gamble his administration could not lose. Americans would be the first on the moon.

Two months later, Gus Grissom had his *Liberty Bell Seven* Mercury capsule loaded with one more item than Alan Shepard had had: a parachute.

"Damn, Gus," argued NASA engineer Sam Beddingfield. "If you need it, you won't have time to use it."

"Get me the parachute, Sam," Grissom demanded. "If something goes wrong, it'll give me something to do until I hit."

Beddingfield shook his head but stuffed a parachute in *Liberty Bell Seven*, and Grissom lifted off from the Mercury-Redstone launch pad on July 21, 1961. He flew a photocopy of Alan Shepard's suborbital flight— 115 miles up, 300 miles down range. But that's where any similarities to Shepard's mission ended.

Following splashdown, Grissom prepared his Mercury capsule for helicopter recovery. He was lying back, waiting for hookup, when an explosion blasted away his hatch. The hatch, modified to use an explo-

sive primer cord instead of the mechanical locks of Shepard's capsule, had ignited.

Water rolled in and Grissom rolled out. He had to swim for his life as he watched the three-thousand-pound spacecraft slip beneath the waves.

Engineers scratched their heads. Some said the design of the capsule's hatch made an accidental explosion impossible. They covered their asses by suggesting Grissom had panicked and triggered the hatch release. Grissom denied the charge repeatedly, insisting, "The damn thing just blew." His fellow astronauts backed him all the way, and an accident review board cleared him of any wrongdoing.

Nevertheless, it left a bad taste in Grissom's mouth that refused to go away.

The sinking of *Liberty Bell Seven* would not be the only event to throw cold water on Grissom's perfect spaceflight. Sixteen days later, the Russians gave what was left of NASA's pride another swift kick. A second Vostok spaceship, this one named *Eagle*, carried Major Gherman Titov, Yuri Gagarin's backup pilot, into Earth orbit, where he played around in weightlessness a full day.

Project Mercury managers and the astronauts threw up their hands. They agreed that Redstone had done its job. But if there was to be any hope of keeping up with the Russians, it was time to get on with launching an American into orbit. And, most important, to get the job done before the end of 1961. History would record the Russians and Americans did it the same year.

But there was only one rocket in America's stable capable of lifting the Mercury spacecraft into orbit. That was the Atlas ICBM. Atlas worked well with a nuclear warhead on its nose, but its thin stainless-steel skin collapsed under the weight of the Mercury spacecraft. Three times Atlas had left its launch pad with an unmanned Mercury spacecraft on its nose, two of those rockets exploded, dumping chunks of fiery debris into the Atlantic.

The White House told Mercury Operations director Walt Williams to fix it. The President wanted an American in orbit, and Williams was told, in no uncertain terms, "No more excuses." Williams went after the

air force, who held the Atlas contract with NASA, and the job of setting things right went to the toughest test conductor around, a hulking six-foot-one Irish altar boy by the name of Thomas J. O'Malley.

Despite the failures, there seemed to be little concern around the Mercury-Atlas pad. Many thought the problems would resolve themselves. O'Malley called the launch team together. He gave them the new word: "The next son of a bitch who says no sweat, who tells me or anybody else we don't have a problem, will ride the toe of my boot out the door." T. J., as he was known, was simply the tough, hard-nosed manager Atlas-Mercury needed. His hard-boiled attitude whipped the Pad 14 launch team into shape—a team ready to work 24–7 to turn the Atlas into a piece of reliable machinery.

The troublesome Atlas systems were modified, the fragile skin was given its own steel belt, and on September 13, 1961, five months after the last Atlas failure, the rocket was ready for another try. Atlas drilled its unmanned Mercury capsule into a perfect orbit, and after completing

T. J. O'Malley ready to launch John Glenn, the first American into Earth orbit. (O'Malley Collection).

one trip around Earth, a California tracking station fired the capsule's retro-rockets and the spacecraft returned for a safe splashdown.

NASA and the Atlas managers were pleased. O'Malley, the Irish altar boy, had gotten the job done.

John Glenn was ready. He'd been ready from the moment he was selected as an astronaut to be first in space, but Yuri Gagarin and Gherman Titov had shot the hell out of that plan. No more suborbital flights. Mission number three would go for orbit, and Glenn, as backup to both Shepard and Grissom, was in a perfect position. No astronaut had better credentials. Glenn was born in the heart of the great radio days. To the Marine Corps he was a public-relations dream, and to the public, he was Jack Armstrong, all-American.

He was ready, but NASA wasn't. Not quite. John Glenn would have to endure the same humiliation that had tormented Alan Shepard. On November 29, 1961, the marine fighter pilot stepped aside while NASA loaded another chimpanzee, Enos, into a Mercury capsule. The Atlas and Mercury capsule performed flawlessly, but the chimp's equipment failed and the electrical system and light tests went haywire.

Every one of Enos's display's buttons lit up wrong. He banged on every lever he could find, but that didn't help. For his efforts, instead of a banana pellet, he was rewarded with a nasty shock.

Enos came out of orbit biting anything that moved. NASA went through a sort of scheduled greeting, but the chimp wouldn't let handlers diaper him. Enos had a large erection, but this didn't stop the proud officials. NASA news chief Jack King paraded the chimp before the media. This prompted a popular local female broadcaster to ask, "Jack, are you going to breed that chimp?"

Satisfied with the chimp's flight, NASA managers scheduled Glenn's launch for December 20, 1961. Get into orbit before year's end was the cry; it was to be a Christmas present for the boss, JFK. But Santa Claus's elves were not on John Glenn's side. No sooner than the Atlas

and Mercury capsule were erected on the launch pad, there began a series of frustrating delays. It would have broken the spirit of most, but Glenn and the launch team kept pushing ahead. Finally, on the morning of February 20, 1962, after eighty-two days of weather and mechanical delays, Glenn was strapped into the spacecraft he had named *Friendship Seven*. Lady luck smiled. It was try number ten, and the countdown nudged its way toward 9:47 A.M. Eastern time.

But before Glenn could be launched, there was one last thing. The international community needed to certify that John Glenn was actually on board *Friendship Seven*—that he had not slipped down the gantry's elevator before the structure had been moved. So, with the Mercury-Atlas standing alone on its launch pad, lead rocket engine engineer Lee Solid left the blockhouse and escorted the Federation Aeronautique Internationale representative to a clear view of *Friendship Seven*. From the blockhouse, astronaut Scott Carpenter told Glenn to wave. The FAI representative smiled. For the record, John Glenn was on board and test conductor T. J. O'Malley and his long-frustrated launch team moved the countdown clocks ahead.

John Glenn leaves for the launch pad. (NASA).

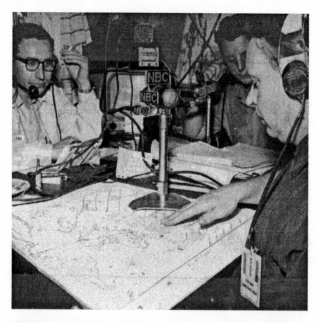

The media gathered at Cape Canaveral's press mound for John Glenn's orbital flight. Inside its broadcast trailer, the NBC team is on the air. Left to right: news manager Russ Tornabene, correspondent Jay Barbree, and correspondent Merrill Mueller. (Barbree Collection).

Again, Merrill Mueller and I were at the NBC microphones, and when possible, we carried the voices from the blockhouse and Mercury Control live on our worldwide networks.

It was perfect radio. Launch-team members' voices were in pure harmony.

"Status check," O'Malley barked into his lip mike, his words carried to the headset of every member of his team. He had to know if all the Atlas-Mercury systems were ready.

"Pressurization?" his sharp clear voice demanded.

"Go."

"Lox tanking?" O'Malley needed to know if the liquid oxygen tank was filled, if there was enough to oxidize the fuel to get Glenn in orbit.

"I have a blinking high-level light."

O'Malley also knew the signal was false. "You are go," O'Malley snapped.

"Range operations?"

"Go for launch." All tracking stations were in the green.

"Mercury capsule?"

"Go."

"All pre-start panels are correct," O'Malley acknowledged. "The ready light is on. Eject Mercury umbilical."

"Mercury umbilical clear."

"All recorders to fast," T. J. ordered. "T-minus eighteen seconds and counting. Engine start!"

"You have a firing signal," astronaut Scott Carpenter told his friend John Glenn from the blockhouse.

O'Malley's boss, B. G. MacNabb, came on the line. He spoke directly to the altar boy: "May the wee ones be with you, Thomas." O'Malley managed a quick smile. He'd take the luck of the wee ones anytime. He'd been praying all day, and the tough test conductor crossed himself. "Good Lord, ride all the way," he said prayerfully.

"GOD SPEED, JOHN GLENN!" The call boomed deep from the heart of Scott Carpenter. A quick nod of acknowledgment between O'Malley and Carpenter, and Scott began racking down the final seconds of the count.

"Ten,

Nine,

Eight,

Seven,

Six,

Five,

Four,

Three,

Two,

One. . .

Zero!"

The voices fell silent. Atlas was ablaze on its pad, flame pouring from its mighty engines, the vibration trembling John Glenn's voice.

"Uh . . . rog-ger . . . the clock is operating . . . We're underway. . . ."

Atlas was now a monolith of flame and gleaming silver with Glenn

and his black Mercury spaceship resting on thick ice from the super-cold fuels beneath it, the red escape tower standing above all, pointing the way into a welcoming blue sky.

Flaming thrust pushed the rocket and spacecraft stack toward orbit. The autopilot ticked away the commands, and Atlas and Mercury obeyed as Glenn reported, "We're programming in roll okay."

People. A million of them were on highways and beaches, atop buildings, and on streets. Atlas rolled thunder from its mighty throat as it pushed steadily upward and the onlookers went mad—a million voices shouting, cheering, and crying.

Tremendous air pressure squeezed Atlas, buffeted the big rocket, hammered against its steel belt strengthening its thin skin, rattled and shook the machine. It was every pilot's old friend Max Q, and the marine along for the ride called Alan Shepard, his CapCom, short for capsule communicator, who was located in Mercury Control.

"It's a little bumpy along here."

Climbing out of Max Q, the engines were increased in thrust and power. Every second they burned fuel they reduced Atlas's weight. Then, a little more than two minutes into the flight, the two booster engines were done—they burned out and fell away with the rocket's rear skirt. This trimmed Atlas to one remaining main engine, called the sustainer.

Friendship Seven was over one hundred miles high and still climbing when the sustainer cut off. The escape tower was gone, the separation rockets spurted, and Glenn and his Mercury capsule pushed away from the now lifeless Atlas.

"Roger, zero-g and I feel fine," Glenn reported. "Capsule is turning around. Oh! That view is tremendous!"

John Glenn and America were in orbit. A grateful country shed its tears and screamed it cheers. Some of its lost prestige had just been restored.

Friendship Seven set its course for the first of three planned trips around Earth, and Glenn reminded himself he had a debt to pay to American taxpayers. They were all anxious, almost desperate, to hear from him. He offered glowing descriptions of the planet sliding beneath

Friendship Seven: the sculpted sands of the deserts, the mantle of snow covering the mountains, and closer to home, the rich deep green of Bahamian waters. He peered down volcanoes, and when it was night, he looked into the blackest of black below and saw great thunderstorms split themselves apart with lightning bolts that left trails of snarling fire.

In that blackness, only the motors and instruments of his spaceship offered any sounds and light. The remainder of the universe had gone mute, and suddenly he was staring at the brightest, most clearly defined stars and planets he had ever seen.

He was surprised by the speed and completion of his first night as he saw the thinnest crease in the darkness behind him, just a sliver of light, and then the sliver grew swiftly, growing into a shout of color and the brightest of suns as the horizon quickly transformed itself from night to day.

Half of his Mercury capsule was now lit; the other half lay in shadow and the dim reflected light from a planet below that was still in darkness. Sunrise on Earth itself was still minutes away.

Suddenly, he saw something strange out of the corner of his eye. Lightning bugs, good old-fashioned Ohio summer lightning bugs were swarming around *Friendship Seven*. Swarms of the tiny creatures. Some came right to his window, and then he realized they were frost, possibly ice dancing and swirling along with him as he moved through orbit.

Glenn had no idea what caused this stunning phenomenon, and he radioed Mercury Control. "I'll try to describe what I'm [seeing] in here." Every person hearing his voice snapped to, eyes wide.

"I'm in a big mass of thousands of very small particles that are brilliantly lit up like they're luminescent," Glenn explained. "They are bright yellowish-green. About the size and intensity of a firefly on a real dark night. I've never seen anything like it."

"Roger, *Friendship Seven*, this is Canton CapCom, can you hear any impact with the capsule? Over."

"Negative, negative. They're very slow. They're not going away from me at more than maybe three or four miles an hour."

As *Friendship Seven* moved into brighter sun, the fireflies disap-

peared, and flight managers shifted their attention to an immediate urgency that could be threatening John Glenn's life. Shining like a pit of deadly snakes on the Mercury Control's wall-wide tracking map was Segment 51—a warning that told flight controllers *Friendship Seven's* heat shield could be loose.

Everyone stopped. If the warning was correct, John Glenn could be cremated during reentry. Temperatures during the atmospheric plunge would reach 4,000 degrees.

Every member of Glenn's team concentrated on the problem. They studied every idea floated, but there seemed to be only one in-flight fix: They could leave the retro-rocket pack strapped to the outside of the heat shield. This package contained six small rockets. Three had been used after Atlas shutdown to push *Friendship Seven* away from the Atlas booster; three larger rockets remained. They would be used to slow the spacecraft for reentry.

The theory was simple. If they left the retro-pack in place after the three de-orbit rockets fired, the straps should be strong enough to hold the heat shield in place until Glenn's dive took him deep into the atmosphere. There, the growing air pressure would keep the heat shield pressed against the Mercury capsule's blunt end.

The other possibility was equally simple. If the retro-pack straps did not hold, the first American to orbit Earth would return as ashes.

The managers in Mercury Control decided not to alarm Glenn by alerting him to the problem. This pissed off Alan Shepard, and Glenn heard it in Shepard's voice. Then, over Canton Island, the tracking station told him to leave the retro-pack in place.

"Why?" he asked.

"You'll get the word over Texas," Canton said.

Now, Glenn was pissed. His heart picked up a beat. For the first time in his mission he was concerned. It was not an unfamiliar role for the ace test pilot and combat veteran. He took a deep breath and relaxed his body. He would deal with it.

The Texas station confirmed he was to leave the retro-pack on

through reentry. Exactly at four hours, forty-three minutes, fifty-three seconds into the flight, he had to manually override the separation switch and retract the periscope and seal its outer doors. He passed out of radio range before he could ask questions.

Four minutes later, *Friendship Seven* was over Mercury Control at the Cape. Capcom Alan Shepard told flight director Chris Kraft and operations director Walt Williams in so many words to go to hell. He knew if he were in Glenn's place, he would want to know. He keyed his mike and gave the whole explanation to John for retaining the retro-pack. The marine was angry he had not been informed earlier. But he understood the decision and told Shepard to pass on his thanks.

"Roger, John," Shepard told him. "Hang tight, Marine. Navy has your back," and right on schedule off the coast of California, the three retro-rockets fired at five-second intervals. Glenn felt three sharp thuds at the base of the craft. "I feel like I'm going back to Hawaii," he reported.

Friendship Seven dropped slowly, skipping over the surface of the atmosphere a bit before sinking into Earth's protective blanket. Instantly, Glenn could sense the heat build up. The capsule swayed. There was a sudden bang behind him: part of the retro-pack breaking away. He called the Texas station. He couldn't get through. He had already plowed into the envelope of ionized air, and the ions kept any radio communications from leaving or entering his Mercury capsule.

John Glenn held tight.

Friendship Seven plunged deeper into the heat.

He could not have been more alone.

Alan Shepard tried to reach him. He was calling Glenn with an urgent message. He was trying to tell him to get rid of the retro-pack the moment he weighed 1g, his Earth weight or greater. This could save Glenn's life. It could keep the retro-pack from ripping his heat shield apart. The message banged against the ionization layer. It could not penetrate the ions and fell uselessly away, lost unheard in *Friendship Seven*'s wake.

John Glenn was cocooned inside a growing fireball, and through *Friendship Seven*'s porthole he saw this fireball devouring itself. A strap

from the retro-pack had broken or burned free and was hammering against the glass. It burst into fire and flashed away with bits of flaming chunks of metal whirling and pounding past his view.

"It was a bad moment," Glenn would tell me later. "I just hoped that everything would not come unglued. If they didn't," he smiled, "I would be okay. If they did, well . . . "

He watched the brilliant orange blaze and burning chunks flying by his window as he had watched the flaming remains of Mig fighters he'd shot down over the Yalu.

Then, he felt the gravity forces building. He could have hugged them. It meant it was all holding together, and he called Alan Shepard in Mercury Control. He was feeling pretty damn good, but there was no way to get through the ions. Not yet.

The heat shield on his back was hanging in there. It was 4,000 degrees outside while he enjoyed a toasty and comfortable atmosphere inside *Friendship Seven*.

In Mercury Control they chewed their nails.

Notre Dame engineer Bob Harrington stood behind Alan Shepard. He was in charge of making Mercury Control tick. "Keep talking, Alan," he begged. Shepard clenched his teeth and called again.

"*Friendship Seven*, this is Mercury Control. How do you read? Over."

As instantly as they had come, the ions were gone, and the words penetrated *Friendship Seven* like the voice of an angel.

Glenn's reply was a simple mike check. "Loud and clear. How me?"

"Roger," a grinning Shepard acknowledged. "Reading you loud and clear. How're you doing?"

"Oh, pretty good," Glenn said, "but that was a real fireball, boy!"

Mercury Control broke out in cheers and handshakes, and Harrington broke out with the Notre Dame fight song.

There was dancing in the aisles, but flight director Kraft yelled through the pandemonium: "Knock it off. We've got a pilot to land."

Instantly, the celebration ended, and John Glenn's team was back on the job.

He and *Friendship Seven* kept losing speed. The Mercury capsule was

In the rain, John Glenn and family rode with Vice President Lyndon Johnson in his Washington parade. Only hours later, Glenn and the vice president had moved on to New York City. They are seen here moving down the canyons of Broadway in an overwhelming ticker-tape parade. (NASA).

now oscillating strongly from side to side, rocking badly enough for Glenn to feed corrections with his thrusters. They weren't much good anymore in the thickening atmosphere.

"What's this?" he muttered to himself, reaching for the switch to override his automatics and deploy the drogue chute early. He was at 55,000 feet and stabilization was important.

From that point on, *Friendship Seven* had a perfect splashdown. The first American to orbit Earth dropped into the water near his recovery ship, *Noa*.

John Glenn arrived in the nation's capital a hero of Charles Lindbergh's stature. He had lassoed the Russian lead, and the White House gave him a parade. A quarter of a million people braved heavy rain to watch the astronaut pass. He was then jetted off to New York

When John Glenn had satisfied all his national appearances, he came home for a parade through Cocoa Beach and a first-hand inspection by President John F. Kennedy of his Mercury spacecraft, Friendship Seven. (Rusty Fischer & Hartwell Conklin Collections).

City, where four million screaming, cheering people greeted him with a tumultuous ovation and a ticker-tape parade.

I joined veteran broadcaster Robert McCormick in NBC's Radio Central at 30 Rockefeller Plaza. We broadcast the parade from start to finish, and for this farm boy's first trip to the big city, about the only thing I felt akin to was Chet Huntley's roll-top desk.

The next morning NBC got me out of bed to cover an award for Glenn at the famed Waldorf-Astoria hotel.

I stopped by the coffee shop for breakfast and was introduced to food in the big city. The menu said two eggs anyway you liked them. That's what I ordered and that's what I got—two eggs. No toast, no coffee, no jam—no anything except two eggs.

In Cocoa Beach in 1962 you received two eggs, sausage or bacon, potatoes or grits, toast, coffee, and orange juice for $1.75. You can image how pleased I was when they brought me a check for $5.75 for my two eggs and a glass of warm water.

I paid the bill and took the elevator to witness John Glenn's award. He was happy to see a face from home.

"Any beach sand in there?" he smiled, shaking my trousers' cuffs.

"Some," I laughed. "How're you doing?"

"Tired," he said, his expression suddenly weary. "I'm ready for a rest."

"For a guy that shortened the distance to the moon, you're entitled."

Standing there, it came to me God didn't turn out too many like John Glenn. When he passes, his epitaph should read:

HERE LIES A CIVILIZED MAN

On Orbit

The public had fallen in love with John Glenn, and NASA could not have been more pleased. The word went out: It's a long way to the moon. Keep the astronauts in orbit, keep the public's attention.

Deke Slayton did just that. He took the reins from Glenn and went to work. Wally Schirra was his backup. But soon we began to hear rumblings that Deke was in trouble. The rumor was that it was his heart.

In Washington, presidential science advisor Jerome Wiesner spoke with NASA administrator James Webb. He told the NASA chief the White House had heard about Slayton's heart irregularity, and added, "Sending Slayton into orbit could be a terrible mistake. Suppose something goes wrong, anything, and the word gets out that the astronaut flying the ship had an erratic heart condition. Who do you think they are going to blame? It wouldn't matter if his heart had nothing to do with the failure. They'd be after the President's ass."

Webb shifted in his seat. "I get your point."

Wiesner looked at him soberly. "It's simple, Jim," he said. "Take him off the flight."

Webb nodded a half-hearted agreement. He realized the presidential science adviser was still smarting over losing his argument that JFK should cancel the whole damn manned space program.

Deke had idiopathic paroxysmal atrial fibrillation, a disturbance of the rhythm in the muscle fibers in the upper chambers of his heart, and the NASA administrator called for a medical panel to review the facts. The panel agreed with Wiesner. The job of telling Deke fell to the Mercury Seven's own flight surgeon, Bill Douglas.

"Goddamn it, Bill, those sons-a-bitches can't do this to me," Deke shouted. "No one was concerned about this during selection. After all the years I've been flying the hottest jets, flying test flights, they said it was no big thing. Now they want me to step down? I can't believe it," he pleaded, shaking his head. "There ain't a damn thing wrong with me."

There was more bad news.

"I know the rules call for the backup pilot to slip into the seat of an astronaut unable to make a mission," Dr. Douglas told Deke, "but Wally won't be going."

"God!" Deke screamed, "What the hell else?"

Douglas explained that Bob Gilruth decided Scott Carpenter, John Glenn's backup, had more time in the Mercury simulator than Schirra, and Carpenter would be going in his place.

NASA gave Deke a few minutes with the press and then got him out of Dodge, got him the hell out of the way of Carpenter's mission. When *Aurora Seven* lifted off on May 24, 1962, Deke Slayton was at a remote tracking station in Australia.

S cott Carpenter made a perfect ride into orbit. He was a gatherer of facts and a builder of knowledge, and in a sense he was the first science-astronaut. He made the most of what he had on board. On his first two orbits he drank more and ate more. He wanted to know how the digestive tract would handle weightlessness, and he wanted to know the limits of Mercury's attitude-control jets. By wringing them out, from one position and then to another, he virtually depleted the fuel available for attitude maneuvering. He took all the pictures he could until his cameras ran hot, and then he ran through his scheduled program checklist, which included releasing a balloon in space.

He was having a ball.

After his first two orbits, Mercury Control began to worry. Scott had consumed so much fuel flight director Chris Kraft was giving serious thought to ending his mission an orbit early. But he made a last-minute decision to let Scott stay up for his third and final planned trip around Earth if he would go into a "drifting mode." That would conserve fuel. Scott liked the idea. He lay back in the comfort of weightlessness.

But as he entered his final sunrise, he couldn't control himself. Scott had an idea. He banged his hand against the inside wall of *Aurora Seven*. He was right. The moment he struck the wall he was flying through a swarm of John Glenn's "fireflies." Again he banged the capsule's bulkhead, and more fireflies slowly moved into view. "Damn," he cursed. "I must know." He fired the jets, swung the capsule around, and proved the mysterious fireflies originated from water vapor vented from the Mercury capsule. Vapor produced primarily by the human on board.

The astronaut's body perspired, urinated, and exhaled, and the moisture was removed from the spacecraft through an external vent on the side of the capsule. The instant this moisture entered the low temperatures of the space night, it froze into ice particles. Some particles swarmed about the capsule or floated away; others clung to the ship's side, to be knocked off when Scott thumped the wall. When the sun angle was just right, at sunrise or sunset, these particles became the famed "celestial fireflies," only to be melted away by the heat of the space day.

The thinking astronaut had solved another mystery. But his eagerness to learn had cost Carpenter precious fuel and time needed to prepare for reentry. He landed 250 miles beyond his intended landing target. Scott was isolated on the surface of the Atlantic, beyond radio range. For nearly an hour he was lost to a frantic Mercury Control and to a worried worldwide radio and television audience.

We stayed on the air during the search, and I talked about every space fact I had ever collected. I was down to telling our listeners what the food was like in the Cape's cafeteria when a recovery aircraft picked up Carpenter's radio beacon.

The aircraft crew found Carpenter floating in the life raft attached to his bobbing Mercury capsule. Scott had had the good sense to make sure his radio beacon had activated, and to bail out of *Aurora Seven* and

climb into his raft. He was just sitting there, eating a Baby Ruth, cataloging what he'd seen and learned.

Behind the scenes, a devastated Deke Slayton was waging a fierce struggle to return to flight status, and his fellow astronauts were worried. To the man, they were concerned about the effect the grounding was having on him.

As you would expect, John Glenn stepped forward. "We're a team," he said. "We've got to pull for our friend."

"We're going to give Deke back his pride," Alan Shepard said.

"Yew man," Gus Grissom agreed. Two words from Gus was a full speech.

So they decided to make Deke their boss.

"Give him the power," Wally Schirra said. "His own title, office, whatever he needs."

"Hell, he'll be chief astronaut," Gordo Cooper said, "but we'll have to work fast."

"Why?"

"Washington's at it again," Cooper told them. "Our friends at Edwards tell me they're bringing in an air force general to take charge of the astronauts."

"Like hell they are," snapped Shepard. "Maybe an admiral, but no general," the future admiral laughed.

"Well," pondered Glenn, "we'll just stand firm."

"Damn right," Cooper agreed. "It's gotta be one of us."

"Damn right," Scott Carpenter said, slamming a fist on the table. "It's gotta be Deke."

They stood solid. Stonewall Jackson would have been proud.

NASA knew the Mercury Seven could not fly all the orbital flights in the upcoming Gemini program. New pilots had to be recruited for the astronaut corps. The agency went back and hired Neil Armstrong, Frank Borman, Charles "Pete" Conrad, James Lovell, James McDi-

vitt, Elliott See, Tom Stafford, Ed White, and John Young. They had just missed the Mercury Seven cut, and with the exception of civilian Armstrong, they were all military. They were immediately dubbed the Gemini Nine.

NASA had also come to realize it needed someone to manage the astronauts' office, to select flight crews, make assignments, plan and schedule training time, and be a link between the pilots and management. In short, be a mother hen to this elite corps.

The Mercury astronauts made three recommendations to NASA management: Deke Slayton, Deke Slayton, and Deke Slayton. NASA administrator Jim Webb smiled and turned a thumbs- up, and Deke became chief astronaut.

Those who were there said it was like turning on a switch. Deke's pride was back. The first rule he made was there would be no copilots in space. No test pilot could stomach being called a copilot, and Deke laughed and proclaimed, "Our Gemini crew members will be made up of a command pilot and a pilot."

Astronaut Wally Schirra is slipped into his Mercury spacecraft Sigma Seven *for his textbook flight. (NASA).*

Some outsiders judged the appointment as a pacifier for a crestfallen astronaut, but that attitude had a short life. Deke took absolute charge. In short order his office was *the* power to be reckoned with. The new levels of respect carried over to the entire astronaut team. Everybody stepped back when it came to astronaut selection for flights. Deke carried the ball, and on October 3, 1962, while the World Series was being played, an Atlas rocket boosted Wally Schirra and his *Sigma Seven* into orbit. Wally proved his skills, as Deke knew he would. He stayed up for six orbits—nine hours. He had been launched with the same fuel quantity as Glenn and Carpenter, but he conserved fuel in a way that amazed Mercury Control. In the process he went through his scientific and engineering checklist with an efficiency that would have turned a robot green with envy.

It was what NASA watchers had been waiting for, a perfect flight. *Sigma Seven* splashed down less than four miles from the main recovery carrier near Midway Island in the Pacific. One broadcaster dubbed it "the flight of the Mongoose."

When the dust had settled in the wake of Schirra's flight, the new Gemini Nine test pilots had been given the title of astronaut. The new group would join the Mercury Seven in flying the Gemini maneuverable spaceships.

Deke Slayton now had fifteen astronauts under his wing. He set the newcomers up for indoctrination and training, and figured the more they saw of the remaining days of Project Mercury, the better prepared they'd be for flying the heavier, larger advanced Gemini—a spaceship that could not only maneuver, but could change its orbit, change its altitude, and rendezvous and dock with other ships, a spaceship that would define and test the procedures needed for Apollo to reach the moon.

Slayton also knew something most reporters didn't. America was going to the moon for national prestige—nothing else. "If the Russians weren't kicking our ass, Barbree," he told me, "there would be no Project Apollo."

The chief astronaut drew up a flight plan that would put Mercury in

Astronaut Gordo Cooper whips himself into shape for his marathon flight by jogging in the shadow of the Saturn 1B *rocket pad. (NASA).*

a category with Russia's ships in time spent in space. No three- or-six-orbit flight for the fourth and final orbiting Mercury. This would be a shot of twenty-two orbits—a day and a half spent circling Earth. And he would need a "hot dog" to handle such a tough assignment. He would need the best stick-and-rudder man in the air force. He would need Leroy Gordon "Gordo" Cooper, a kick-ass barnyard of a pilot who knew only one way: "Git 'er done."

Operations director Walt Williams stopped by Deke's office and said, "Look, I know besides yourself, Gordo Cooper is the only Mercury guy who hasn't flown. But maybe it would be a good idea to consider moving Al Shepard into this last Mercury flight." Then Williams saw the chief astronaut's face. He swallowed hard. "Of course, it's your call, Deke."

Deke began to simmer and could barely nod a goodbye when Williams left. He wasn't fooled for a second. The issue at hand was that Gordon Cooper was too much of a maverick for some in the space-agency

hierarchy. His hotshot jet flying and his tendency to bend the rules did not sit well with them. Deke judged Gordo as nothing less than a terrific pilot. He had come up through the ranks—paying his dues all along the way, flying everything from J–3 cubs to F–106s, and he belonged at the stick of the last Mercury. If anyone knew how it felt to have an earned flight yanked from under his feet, it sure as hell was Deke Slayton. He wasn't about to stand by and see Gordo get the shaft.

And there was something else. There were the elitists who disapproved of Gordo's Oklahoma twang. "He's nothing but a redneck," laughed some members of the press and NASA's public affairs office. To them the fact that Leroy Gordon "Gordo" Cooper, Jr. was one of the best pilots on earth was irrelevant. They just didn't want "trailer park trash" representing NASA.

Gordo Cooper met this problem as he did all of his problems: head on. He invited the NASA public affairs officer leading the attack on his heritage outside and simply assured him he would kick his condescending ass. The man's only defense was to "hide behind the rules and laws drafted by lesser men," and then to run. Scared out of his wits, the NASA mouthpiece went to Deke only to be told by the chief astronaut, "If Gordo needs any help kicking your ass, he can count on me."

That was the end of it. The flight was Gordo's.

Two days before Cooper's scheduled liftoff, the launch team was on an around-the-clock readiness schedule with his Atlas and spacecraft, and our NBC crews were setting up our broadcast trailers for the launch. Everyone was hard at work when suddenly we heard a tremendous *BOOM* rip through the launch-pad complex. Nobody saw flames. Everyone was certain there had been an explosion. But there was no smoke rising, no buildings collapsing . . .

Then we saw it. Cooper's jet howled away from the Cape in a dizzying climb after laying down a supersonic thunderbolt across the launch center. It was his friendly way of saying, "Morning, everybody!"

His thunderous arrival was the art of "buzzing," a tradition that dated back to the Wright brothers, and was hardly new to fighter pilots

of Gordo Cooper's skills. It was a ceremonial rite for the astronauts now, as it had been before they'd ever considered going into space.

Never-smile Walt Williams was standing in his office when Gordo and his F–102 shot by at window level. The sonic boom shook the building, made him drop the papers he was holding, and sent his hands to stop his heart from leaping out of his throat. He spun around cursing and stomped into the outer office, where Alan Shepard sat.

"Does you spacesuit still fit you?" he bellowed.

"What?"

"Simple question, Shepard," he shouted. "Does your spacesuit fit?"

Shepard played dumb. Again. "Why?"

"Because I want to know if you're ready to step in for 'hotdog,' that's why!"

Shepard made a valiant effort to suppress howling laughter. After all, he was hardly innocent of such buzzing greetings himself; he'd shaken more than his share of windows on Cape Canaveral. But he took the diplomatic route. He managed to calm down the irate, foot-stomping operations director and got him to join him and Deke at Henri's bar that evening.

"We'll talk about it then," Shepard assured Williams, before walking outside and grabbing his stomach for his own belly laugh.

That evening, Shepard and Slayton pumped a couple of drinks in Williams and managed a smile from the much-too-serious Mercury boss.

The Mercury Seven stood solid. They told the operations director flatly that Cooper was flying the mission, and Shepard added with a tone not to be challenged, "Gordo has earned that seat, and there's not a pilot among us who'd step in and take it away. Certainly not me."

End of discussion.

On the eve of Project Mercury's final launch, the Gemini Nine judged they should show reverence and respect for the Mercury trailblazers. They planned an elaborate dinner for the Seven, and Henri Landwirth lent his motel's kitchen to the likes of Pete Conrad, Gene

Cernan, Jim Lovell, and Neil Armstrong. Then he helped the gang of nine with their dastardly deed.

They advertised the Mercury Seven's dinner as a magnificent meal of breaded veal, potatoes au gratin, tropical salads, and the finest imported wines.

Well, at least they made good on their promise of the finest of imported wines, and the Mercury astronauts mumbled their surprise and thanks to the new group. They immediately began the required toasting and bestowing of good wishes and fortune on one another. It was comradeship at its finest, a measure of friendship to warm hearts and minds. Then sixteen astronauts sat down to enjoy the gastronomical repast.

The lavish feast was served by waiters using silver trays from Henri Landwirth's own collection. The Gemini group had prepared a sumptuous feast of fried breaded cardboard likened to veal; putrid, au rotten potatoes blackened from their own decomposition; and a bellied-up salad that had been steaming in the hot, tropical sun all day. Silence descended.

Gordo Cooper, who was only hours away from launch, sat quietly, telling himself, "This ain't my first rodeo." He had, indeed, been here before. His own reputation at air bases around the world had been built on such pranks and moments. He simply refused to admit to a truly classic "gotcha!"

He smiled, nodded thanks to his hosts with another toast, and to the utter astonishment of the Gemini Nine astronauts, Cooper chowed down, eating the whole damn putrid and impossible mess.

Morning came with the breaded cardboard and au rotten potatoes digested, and with astronaut Leroy Gordon Cooper suited up and sitting aboard the Mercury capsule he'd named *Faith Seven*. What with the Gemini Nine's dinner the night before, Gordo had spent only four hours in bed. So while waiting out a countdown delay, he managed needed sleep sitting on top of the volatile last manned Atlas.

Many had tried to rattle the cage of this man, and just as many had failed. Prejudice and regional bias had kept Leroy Gordon Cooper, Jr. grounded until the last Mercury launch, and on that morning of May 15, 1963, as the countdown approached liftoff, they had to awaken him

for his long-delayed ride into Earth orbit. He would fly higher, farther, and longer than anyone before—a day-and-a-half mission where he would become the first human to sleep in space. As Slayton and his fellow Mercury astronauts knew he would, Cooper flew a technically perfect mission right on through his nineteenth orbit, thirty hours in space, setting a new American endurance record with every sweep around Earth.

Suddenly, there was a possible problem. Every flight controller in Mercury Control was alert and focused on a green light flashing on the wall-wide tracking map. "Holy crap," Bob Harrington shouted. "He's on the way back!" The light was the ".05g" signal, scheduled to shine when a Mercury capsule began descent into the atmosphere. CapCom made an immediate call to the spacecraft. "Hey, Gordo, this .05g signal light down here says you're on reentry!"

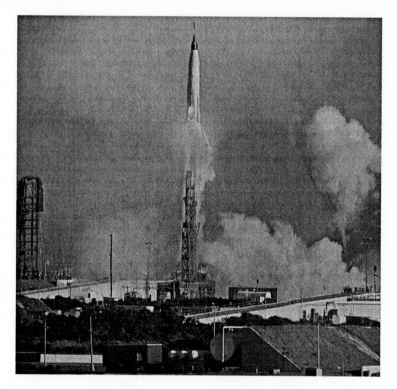

Astronaut Gordo Cooper's Mercury-Atlas heads into space. (NASA).

"Like hell we are," he told the ground.

Cooper settled back. He had been waiting for something like this. The flight until this point had been picture-perfect and after thirty hours in space, this glitch was the first signal that his *Faith Seven* was coming apart. It had been a good ship, but it had been stretched to its limits, and with just a couple of orbits to go, the glitch was certain to grow. It did. Within minutes, electrical surges knocked out the navigational instruments that kept Cooper informed of his location over Earth. Then, on orbit twenty-one, the automatic control system rolled over and died. That meant that Cooper would have to fire his retro-rockets manually.

But to Gordo Cooper, trouble in flight was what they paid him the big bucks for. "Well," he told the ground in his unmistakable twang, "it looks like we've got a few little washouts here. I've lost all electrical power. Carbon dioxide levels are above maximum limits and cabin and suit temperatures are climbing. Looks like we'll have to fly this thing ourselves. Other than that, things are fine."

"Things are fine like hell," Slayton laughed out loud. "If the carbon dioxide levels keep climbing Gordo will be dead, and the only reason why he can still talk to us is his radio is on independent battery. Let's get him down, guys," he yelled across Mercury Control.

Knowing Gordo, Deke had a feeling everything was going to be all right, and he was happy as hell that on this endurance flight man had proven more dependable than machine.

With just an hour to go in the flight, Mercury Control worked out procedures and maneuvers on a precise timetable, and John Glenn, stationed on a tracking ship south of Japan, radioed them up to Cooper.

"It's been a real fine flight, Gordon," Glenn told him. "Beautiful all the way."

After twenty-two trips around Earth in zero-g (weightlessness), Cooper fired his three retro-rockets.

Glenn reported to Mercury Control: "He held it close, very tight. They were right on time on our marks here. They looked good, sounded good, and were good." Even the great John Glenn was impressed.

Gordo Cooper was threading the needle for his return from space. He would tell me later that he flew like he had never flown before. All

of the skills his pilot father had taught him, all that the books and great flyers could teach him in test-pilot training, all the thousands of hours he had spent wearing high-speed jets in the sky, had honed his abilities for this moment.

For Cooper's mission I was on the air with the great John Chancellor. Over and over we said we were witnessing an almost impossible flying job.

Chancellor and I watched as *Faith Seven* came out of the sky, rolling steadily, the Oklahoma farm boy flying with a precision that controllers mumbled was tighter than the autopilot or computers had ever delivered.

Leroy Gordon Cooper plopped his Mercury spaceship into the sea a stone's throw from his recovery ship.

John Chancellor shook his head in disbelief. After we were off the air, he stared at me in question. "He was flying a dead ship, why didn't he die up there? Why didn't he burn to death?" Chancellor shook his head again, disbelieving. "Gordo Cooper today made me proud of my old Kentucky home."

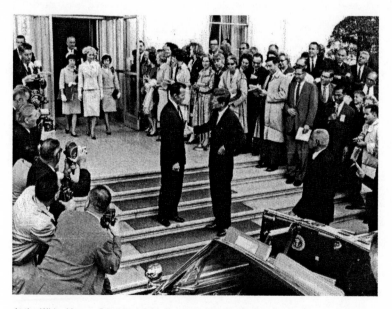

At the White House, President John Kennedy bids farewell to Gordo Cooper and his wife and daughters before he heads to Capitol Hill, where he would speak before a joint session of Congress. (NASA).

I suppose Gordo made all us southerners proud, even Deke Slayton from southern Wisconsin. He told Gordo he'd done the best stick-and-rudder job ever. That he'd justified everything the astronauts had ever claimed, filled every promise that a hands-on pilot was the most needed system to fly in space.

"What a precision ending to Project Mercury, Gordo!" Deke smiled, grabbing his hand.

"We aim to please, Deke," Gordo said with a grin as wide as Oklahoma and half of Texas, and the robot boys, those who say humans are not needed in space, walked away mumbling to themselves.

Gordo Cooper so impressed his country's citizens they gave him a parade in the nation's capital, where afterward he stopped by the White House to pick up a medal from President Kennedy before trotting off to the Capitol to speak before Congress. For the lawmakers, he repeated a spontaneous prayer he had made in space, and the magazine New Republic wrote: "His flight fell on the anniversary of Lindbergh's lonely trip to Paris, who carried with him, you remember, a letter of introduction to the Ambassador. Major Cooper, it occurred to us, carried with him a letter of introduction to God."

The Worst of Times

T he early 1960s were not the best of times for an America on the verge of losing a President. The country's baby boomers were off to college to protest a spreading military conflict in Vietnam, and many of us national reporters were waist deep in Dr. Martin Luther King's equal-rights campaigns.

Meanwhile, NASA was building the hardware to reach the moon. The agency had decided it needed a new Manned Spacecraft Center and a new Mission Control, and movers and shakers across the country were taking dead aim at the prize. Every politician wanted the great economic windfall for his or her constituents. But Vice President Lyndon Johnson had the inside track, and he rode "hell-bent-for-leather" through the political thickets to lock up a site south of Houston. The name of the horse he was riding was "Chairman of President Kennedy's Space Advisory Committee." He used this White House portfolio for a political cavalry charge that would have made Jeb Stuart proud.

But what confounded those in the know was a single question: *Why?*

NASA had everything it needed to monitor astronaut flight at Cape Canaveral. Mercury Control had worked perfectly for six manned missions, and besides, the agency had just purchased 88,000 acres next

door on Merritt Island. The huge real-estate grab was more than enough land for NASA's Apollo launch pads and moonport—a moonport with administrative and training buildings, big rocket hangars, and the mammoth Vehicle Assembly Building, or VAB. In this, the great *Saturn V* moon rockets would be assembled.

This was enough acreage, along with the waters of the Atlantic, to safely buffer the public from any rocket catastrophe, and if NASA needed more facilities, there was enough land left over for a second Pentagon and a medium-size city. And best of all, it was all linked to the nation's Atlantic Missile Range—a multi-billion-dollar, five-thousand-mile string of natural tracking islands that would not have to be duplicated with more waste of taxpayer dollars.

It was said that after President Kennedy announced Project Apollo, all NASA had to do was grab buckets and head for Capitol Hill. There the buckets would be filled to overflowing with greenbacks. So despite more money than every sailor in the navy could spend on a Saturday-night bender, the question was still asked: Why in the world does NASA need to go elsewhere and build something twice?

The answer? The agency didn't.

Everything they were proposing to build in Texas was already under construction at the new Merritt Island Moonport. Even if politicians built ten more Mission Controls, the same facility and flight-monitoring hardware had to be up and running at the launch site for the spacecraft and rockets to fly.

So, again, why was NASA going to Texas?

Because Lyndon Johnson had promised his Lone Star state the lion's share of the Earth to the Moon Project, and when it came to gobbling up pork, Johnson had no equal. He had the glad hand and the political clout to make it happen.

Seven hundred engineers and their families loaded their cars and trucks for the long trip, and NBC thought I should tag along. When we arrived on the flat Texas wastelands, no one could believe this deserted, unproductive place would be the epicenter of the country's effort to send astronauts to the moon.

There not only was a Mission Control and a Manned Spacecraft

Center to be built, but homes, shopping centers, hotels, hospitals, everything had to be constructed—a community had to be raised from piss-poor pasture land where only a few underfed cows grazed. When I said this in my NBC reports, Johnson's friends grinned and said, "Don't y'all worry about that. We'll build all that stuff for you and at a fair price."

While workmen in Texas were trying to make silk out of a pig's ear, NASA was pleased its image had been boosted by stretching the last Mercury flight to its limit. Gordon Cooper had ridden around the planet for more than thirty-four hours. But no amount of praise for Cooper's great performance could persuade the public that America was catching up. The numbers spoke for themselves. While NASA was busy building, the Russians were slinging their hammers in space.

On June 14, 1963, four weeks after Cooper emerged from his dead-stick reentry, *Vostok V,* with cosmonaut Valery F. Bykovsky, headed for Earth orbit, where he would stay only minutes shy of five days, a staggering amount of time.

But even Bykovsky's flight was pushed off the headlines. Two days into his marathon mission, *Vostok VI—Sea Gull—*was launched. Bykovsky watched from orbit as *the first woman cosmonaut* roared away from the Baikonur launch pad. Her name was Valentina V. Tereshkova, and she joined Bykovsky in orbit, where she remained an hour under three days.

With men and women cosmonauts speeding about the heavens, the cry in Washington was heard all the way to President Kennedy's desk: "For God's sake, do something!"

November 16, 1963, JFK flew to Cape Canaveral. He wanted a first-hand look at the launch center and the growing moonport. Dr. Wernher von Braun took the President all over his new *Saturn I* rocket. The big booster was being readied for its first all-up test flight, and the famed rocket scientist told Kennedy, "With 1.3 million pounds of thrust, Mr. President, *Saturn I* will level the playing field with the Russians."

Kennedy left Dr. von Braun and climbed into a helicopter with Gordon Cooper and Gus Grissom. With unabashed excitement and pride,

President John Kennedy is touring Project Apollo's growing facilities at Cape Canaveral six days before an assassin would take his life in Dallas. (NASA).

the two astronauts pointed out the key features of the growing moonport. They showed him where one day a monster called *Saturn V* would stand on its launch pad. Here, the name Apollo was gaining substance with every passing day.

Gus Grissom thanked him for his vision, unaware that he and JFK would not live to see Americans sail across the void between Earth and its moon. Six days after he viewed the launch areas for his Project Apollo, the President of the United States was murdered by an assassin's bullet during a Dallas motorcade.

Shocked and stunned, America slowed to a stop. With the nation wracked by emotional loss, workers at Cape Canaveral joined in mourning for the passing of a man who had meant so much to America's space effort. My family sought the solace of our home and watched the unending drama unfold on television. Our two-year-old, Alicia, walked our floors babbling the name Kennedy. There had never been and most likely never will be another such time. In the coming weeks, a shroud of uncertainty draped itself over Apollo. Its key supporter was dead, and a strange lassitude infected us all.

Lyndon Johnson was now President, and that old saying about a man growing into the job had never before rung so true. In the Congress, and as Vice President, Johnson may have been the top huckster on Capitol Hill, but when he took the presidential oath of office aboard *Air Force One* in Dallas, Lyndon Baines Johnson became a President as serious as a heart attack. He turned out to be the space program's new best friend, but the new chief executive had much more on his plate.

I n the summer of 1964, the battle for equal rights, led by Dr. Martin Luther King Jr., was coming to a head. Surprisingly, one of the major battles would not be in the heart of the old Confederacy. Rather, it would be in the country's oldest city: St. Augustine, a Florida tourist town 110 miles north of Cape Canaveral.

My New York desk called and said, "You're it! Go!"

I left eagerly. Most reporters fought for story variety, and when it came to Dr. King, this was one southerner who wanted to be there. I admired the man, thought what he was doing was long overdue, but still did my best to perform my journalistic duties ethically. I had been in St. Augustine for three weeks when the night of the showdown arrived.

Andrew Young was executive vice president of the Southern Christian Leadership Conference. He was, in reality, Dr. King's "right arm." He was the same Andrew Young who would later become ambassador to the United Nations for President Jimmy Carter. He had been leading marches from a black church to the "Old Slave Market," a downtown tourist attraction. There had been scuffles between whites and blacks, but nothing compared with what was about to take place.

The gathering storm had built to its full force in the evening darkness. Andrew Young led two columns of protestors out of the church. They moved down the street, becoming a surging sea of motion in the bright lights of television news crews.

I walked quickly along the marchers' side, occasionally running to the front, then falling to the rear to make sure I didn't miss a single thing. Our crew kept in step as we listened to the voices, ragged but

swelling, singing through the dirt-street community: *"I ain't gonna' let nobody turn me around, turn me around, turn me around,"* a turntable of repetition, a sound of resolution, of commitment.

They marched down the dstreet in front of a bar whose customers deserted the jukebox and crowded into the doorway to gape at Young and his followers.

"Freedom, freedom . . . ," their voices growing stronger in the night air.

They shuffled their out-of-cadence feet by the pool room, where the familiar snap of cue balls ceased, where the arguments inside stopped abruptly while some stared and some ran outside to join the marchers' ranks.

> *Before I'll be a slave,*
> *I'll be buried in my grave,*
> *And go home to my Lord,*
> *And be free . . .*

They sang and they marched, and Andy Young led them by the red-hot smell of sizzling ribs in the Bar-B-Q and on past teeming shotgun houses where blacks stood in astonished awe.

> *Oh, deep in my heart,*
> *I do believe,*
> *We shall overcome,*
> *Someday . . .*

We watched the marchers turn right at the main street to the downtown park and head for the "Old Slave Market." Cameraman Bill Cavanaugh and soundman Red Davis kept up. We kept filming because we knew tonight would not be the same. Too many new faces were in town; there were too many civil rights activists, and too many segregationists had been alerted in six or seven states. Each television crew began loading fresh film for their entrance into the "whites only" world.

Ain't gonna let nobody,
Turn me around,
Turn me around,
Turn me around . . .

They marched into the park in a small tidal wave, carrying in the audacity of its forward motion the seeds of its own destruction; for whites had gathered in the park, another group at the Old Slave Market, and still another across from the park at the foot of the bridge. Others just sat in their cars and stared.

Andrew Young and his band were hurling the gauntlet, throwing it at the feet of the segregationists. They moved into the Old Slave Market, in a tighter band now, ranks close together, feet shuffling, pounding together beneath linked arms and hands. Still singing as Young held up a hand, marking time, standing fast while his feet tramped. Up and down, a dull thudding boom of hundreds of feet. From the back others shoved and pushed, eager to see what was happening. Young brought his hand down, and with a crash of silence the thudding boom of feet ended. The youthful black leader surveyed the whites before him, his head turning slowly.

Suddenly, Young went to his knees in prayer. On the spot where blacks were sold into slavery more than one hundred years before, he began to pray as white faces moved toward him, cursing. Other whites stood gaping, disbelieving. A man in prayer was being beaten. The scene would be shown again and again on television screens across America.

The response? Outrage! Four little girls had lost their lives to a bomb beneath their church in Birmingham. Marchers had been beaten. Cattle prods and dogs had been used on black children. America's future was located on Cape Canaveral's launch pads just 110 miles away. It was time! It was finally time to get rid of the Jim Crow injustices, and President Johnson and the Congress moved. The Civil Rights Act of 1964 was passed, and President Lyndon Baines Johnson signed it into law. Segregation in LBJ's native South had finally been ended.

And the overwhelming majority of Americans, black and white, felt good.

That November, Lyndon Johnson was elected President in his own right, and qualified and dedicated people raised his Manned Spacecraft Center near Houston. From what was once worthless wasteland grew a cutting-edge high-tech center that would see astronauts to the moon and back safely.

But before the lunar trips there had to be Project Gemini—a two-man spacecraft that would test and perfect all the key techniques needed to reach the moon, rendezvousing and docking with other vehicles and walking in space. When they were ready, two unmanned Gemini spacecraft rode their *Titan II* rockets into orbit and flew successful missions.

Deke Slayton believed Gemini was now ready for his astronauts, and without hesitation, he selected Alan Shepard to lead the way again. Alan would command, and his pilot would be Tom Stafford.

For the first six weeks, preparations to fly the Gemini went without a hitch until one morning Alan awoke feeling nauseated. Well, just not nauseated. He was so dizzy, and the room was spinning so fast, he couldn't focus, and he found himself on the floor. He got up clinging to the wall, and did his best to get his face in the commode before he vomited.

The sickness left as quickly as it came, and he was off to Deke's office to report what had happened. The two chalked it up to some bad hooch, and Alan went about his work without a problem until the fifth day. Just as suddenly as the nausea had appeared before, it came back.

Alan checked in with the flight surgeons. "You've got a serious problem with your left inner ear," they told him. "You have what is called Ménière's syndrome."

"Never heard of it," Alan shot back.

The doctors gathered around. "Certain people who are driven, motivated, will occasionally develop this problem," they explained. "Fluid pressure builds up in your inner ear, and it makes the semicircular canals, the motion detectors, extremely sensitive. This results in

disorientation, dizziness, and nausea. You also have glaucoma. That's just another indication that as an individual you're highly hyper."

America's first astronaut listened patiently to the diagnosis and said, "I have one question."

"Shoot."

"You going to pull my wings?"

"Yep."

A dispirited Alan Shepard sat down with Deke for a heart-to-heart. "Deke, we've got to beat this crap," he said as a promise.

"Yep," Deke nodded. "But until you do, I have a job for you."

Deke was being moved up to a newly created post called chief of flight crew operations. He slid Alan into his old job as chief astronaut.

"Hang in there with me, buddy," he winked. "We'll figure out a way to get our asses back in space."

Alan laughed. "You got it, partner."

They shook hands and moved Shepard and Stafford's backups, astronauts Gus Grissom and John Young, into the first Gemini's seats.

Meanwhile the Russians were busy. A cosmonaut was about to shake the world again. Aleksei A. Leonov pushed himself gently through the hatch, and the first human satellite drifted away from the Russian ship. He was stunned by the sight of Earth below and he turned and tumbled and slowly rolled about, careful not to look directly into the blinding sun. A small camera attached to the top of the Voshkod spaceship's airlock captured the smiling, laughing Leonov as he sprightly leapt and skipped.

The date was March 18, 1965, and for the ten minutes allotted, Leonov walked three thousand miles through orbit, flinging out his arms in rapturous joy as he floated, turned, and somersaulted. Below, Earth rolled by at 17,400 miles per hour.

He would later tell me he had no fear—no worry about falling. He knew he was a human satellite fixed in his own orbit around Earth. "There was only a sense of the infinite expanse and depth of the universe," he said.

When it was time for him to return to the Voshkod, Leonov took a final look at the beautiful, blue planet rolling beneath him and slid into

the airlock, feet first. Suddenly he could not move. He was jammed in the opening. Pavel Belyaev, his commander inside, informed him he was running low on oxygen. That got his attention. Leonov studied the situation. Outside in total vacuum, his spacesuit had expanded and he was caught like a cork in a bottle. Let out some pressure, he ordered himself. Slowly, he depressurized the suit, and using his athletic strength, he pulled himself back into the airlock.

The first EVA (Extra-Vehicular Activity) was history.

The day after the spacewalk, trouble revisited the Voshkod crew. When it came time to fire the retro-rockets for reentry, the automatic stabilization system failed. The cosmonauts went through the proper contingency maneuvers and Belyaev took over manually. This took time, and they delayed firing the retros one orbit. When Belyaev triggered the braking rockets, he did a magnificent flying job through the harrowing reentry, but the extra orbit pushed their new landing site nearly a thousand miles off target.

The Voshkod crashed in the thick forest near Perm in the Ural Mountains, coming down to wedge itself tightly between two large fir trees. Leonov and Belyaev remained inside their crippled ship, unable to open their hatch.

During the freezing night, a recovery helicopter arrived dropping warm clothes, but the clothes fell into the higher branches, out of reach. The next morning, a rescue crew entered the thick stand of firs on skis and wrestled the Voshkod free, releasing the freezing cosmonauts for hot food and warm clothes.

Leonov and Belyaev skied out of the forest to a waiting helicopter. And now that the two cosmonauts were okay and on their way to Moscow, Soviet officials began putting a positive spin on the flight. They emphasized the importance of the world's first spacewalk and trumpeted the new Voshkod as a spaceship capable of carrying three men to the moon.

A *Pravda* headline read, "SORRY, APOLLO!"

Gemini

Five days after the two Russian cosmonauts landed in snow-covered trees, the first countdown for Gemini was underway. Days before, Gus Grissom had created some management discomfort. He had never been able to shake off whispers that the sinking of the *Liberty Bell Seven* was due to his screw-up rather than a technical mistake in the hatch. So Grissom named *Gemini 3 "Molly Brown,"* as in "The Unsinkable Molly Brown."

Well, we guys in the media loved it, and everyone else thought it was fun stuff except Washington. These NASA suits, looking for recognition of their authority, were not pleased. Orders were issued. No more names. We reporters extended our middle fingers and on the airways and in print, *Molly Brown* stayed.

Grissom and John Young closed *Molly Brown*'s hatches and roared off the new *Titan II* pad. The big rocket easily pushed the first Gemini into orbit, where Grissom and Young were told to stay for three trips around Earth. There they would wring out the new ship by testing *Molly Brown*'s systems. They fired its onboard rocket thrusters. The rocket blast moved them into a higher orbit, and then they lowered the Gemini into another, and just for the fun of it, they changed their orbital plane.

Gus Grissom and John Young board Molly Brown, *the first Gemini spacecraft. (NASA).*

These were not only maneuvers essential for going to the moon, they were essential for rendezvous and docking with other spacecraft.

The Russians hadn't done any of this stuff yet.

The new Mission Control in Houston wouldn't be up and running until the next Gemini launch. *Gemini 3* was flying under the direction of Mercury Control at Cape Canaveral, and it came out of orbit with its crew bragging, "Man, does this baby handle right!"

Molly Brown made a perfect splashdown on the Atlantic, where Grissom, taking his title as commander seriously, changed the landing plans. He kept *Gemini 3's* hatches closed until navy frogmen secured the bobbing spaceship with a flotation collar. He was to have opened the hatches for fresh sea air, but there was no way he was going to let water into this baby. The delay took time, and Grissom paid for his decision. The Gemini was a great spaceship, but it wasn't worth a damn as a boat. It pitched and rolled, and Young, the naval aviator, laughed. Gus, the air force flyboy, was green, and John handed him the barf bag.

Finally recovery was over and though Grissom was still sick, his

spacecraft didn't sink, and Young was his usual charming self. He was now the seventh American to fly in space, the first not from the Mercury ranks, and—possibly more important in some quarters—Young gave Wally Schirra a run for his money when it came to high-skilled pranks.

Most any lunchtime you could find John in the Cocoa Beach Jewish delicatessen named Wolfie's. It was his daily rendezvous with a corned beef sandwich.

Jewish delicatessens are what I love most about New York City, and Wolfie's was as close as you could get in Cocoa Beach. The night before *Gemini 3*'s launch I was in Wolfie's, listening to a fun ruckus in the kitchen. Naturally, my nose for news led me through the kitchen door, where some secret tests were underway. Certain members of the astronaut corps were concerned about crumbs gumming up the works in *Gemini 3*'s cockpit. Several corned beef sandwiches were taken to the top of a tall ladder and dropped on sandwich paper on the floor. The sandwich that held together the best without crumbling during "free fall" was sealed tightly into a package and given to the care of astronaut Wally Schirra. Wally smuggled it into John Young's spacesuit pocket before *Molly Brown* headed for orbit.

A couple of hours into the flight, when the mission was under control, John brought out the tasty surprise, sharing it with Gus. Gus laughed, and *Gemini 3*'s crew enjoyed its Wolfie's picnic in space.

Not a crumb was dropped, but when NASA's medical teams heard about the great corned beef caper, they went ballistic. "Eating the sandwich in flight ruined our tests," said one doctor. Engineers agreed. Any crumbs floating about in weightlessness could have fouled up any of the spaceship's equipment and electronic systems.

Seeing a chance to get their faces on television, some members of Congress leaped into the fray, shouting, "NASA has lost control of its astronauts."

Deke Slayton was caught between that old rock and hard place. His astronauts were aerospace engineers as well as pilots and were as concerned about the machines they flew as they were about their own persons. Besides, he had been told about the sandwich gag before liftoff

Jay Barbree and Gus Grissom laugh about the great corned beef sandwich caper. (Barbree Collection).

and as long as it was packaged properly, and knowing the pressure his *Gemini 3* pilots were under, he judged it a great way of relieving the tension.

So now he had to diffuse the brouhaha. He had to come to Gus and John's rescue. He told the brass he had known about the sandwich and approved it, and then he wrote a new order: "The attempt to bootleg any item on board a flight without my approval will result in appropriate disciplinary action." Whatever that is, Deke smiled. The prank was forgotten.

In Houston, the new Manned Spacecraft Center was nearing completion, with workers bolting down the last of the all-new Mission Control Center's equipment. The mouthpiece for the astronauts in those days was a lovable pilot named Bob Button from New Jersey. He tried to live that down, but what the hell—someone had to be from New Jersey, and we reporters and astronauts loved him. Bob was the one kid who played well with all the others in the sandbox, and he loved to spend his off time around the local airport, where he'd created the Gemini Flying Club.

One of Button's flying buddies was a pilot named Neil Armstrong. Armstrong wasn't only an astronaut and one of NASA's ace test pilots, he was an elite glider driver as well.

One day Button and Armstrong and colleague Jack Riley, from NASA's Public Affairs office, decided to take a Piper Tri-Pacer up for some night flying. They just wanted to bore some holes in the black sky. Button took the pilot's seat and Armstrong slid into the copilot's chair, while Riley got in back and went to sleep.

The weather was CAVU (Ceilings And Visibility Unlimited), with none of those low cumulus clouds that always seemed to hover around Houston like fat moths, and as they passed five thousand feet Armstrong was watching the blackness grow darker. They were headed out over the Gulf of Mexico.

"We flew this way in almost total silence for about an hour," Button told me. "We kept the lights of Houston barely in sight on the northern horizon."

Then, Armstrong broke his silence. "Okay, let's head back."

"By now," Button continued, "we were topping ten thousand feet and it was a long way down for the little Tri-Pacer. So, in order not to build up ice in the carburetor while coasting downward, I reached for the carburetor heat, pulled it out. SILENCE! The engine quit. I had pulled the wrong knob, the mixture control, and starved the engine of fuel.

"Riley bounced awake and nearly put his head through the fabric roof of the Tri-Pacer. 'What happened?' he yelled. I'm slapping the instrument panel, pushing any knob that's sticking out, trying to get the mixture back into full rich. The engine comes back to life with a roar; Riley settles down. Neil was his usual cool self. He never uttered a word. Just gave me a half grin. I had done a really dumb thing!

"We shed altitude down to the traffic pattern and I turned on final and made one of my better landings. Having screwed up once, I wanted the landing to be a grease job."

I looked at Button, who was now laughing heartily at himself. "Do you realize you almost killed the man destined to first step on the moon?"

"That's me," Button continued laughing. "But Neil was great about it."

Neil Armstrong and Bob Button sign flight logs following the loss of their aircraft engine power over the Gulf of Mexico. (Button Collection).

"What did he say?"

"He smiled and said, 'Bob, I don't mean to kibitz, but you might want to keep in mind what they teach at test pilot school: When you flip a switch or pull a knob, hang on to it until the airplane does what you told it to do. You might not be able to find it a second time.'"

On June 3, 1965, the *Gemini 4* crew, James McDivitt and Edward White, roared into space for four days. On their fourth trip around Earth, White opened his hatch and stepped into space over the blue Pacific between Hawaii and New Mexico. America's first spacewalk was underway. White took a deep breath to relax. He gripped a hand-held gun armed with pressurized oxygen and fired it in timed spurts. It pushed him in the direction he wished to go. This steering jet right out of the science-fiction comics did its job. He could maneuver his body to the limits of his twenty-five-foot tether.

The beauty of Earth rolling by beneath him was incredible, and White somersaulted, floated lazily on his back, and pirouetted, grinning like a kid enjoying a summer swim. He could "fly," and he witnessed one of the strangest satellites ever launched. A thermal glove he had left on his seat drifted up and away to begin its own orbit.

White and McDivitt were so taken by what was happening that the twelve minutes planned for the spacewalk passed quickly. It was time for White to get back inside while they still had daylight. Gus Grissom was the CapCom, the astronaut assigned to talk to the *Gemini 4* crew from the new Mission Control south of Houston. He knew that the euphoria White was showing was akin to the dangerous "raptures of the deep" that scuba divers experienced.

Ed White was still frolicking in space, and Grissom called in his best command voice, "Gemini Four, get back in."

McDivitt repeated the order: "They want you to get back in now."

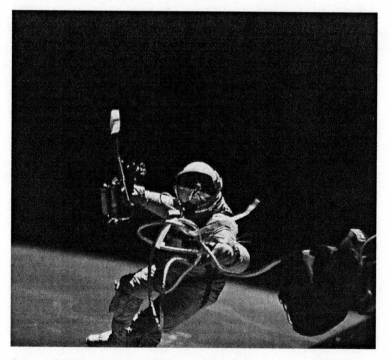

Astronaut Ed White on America's first spacewalk. (NASA).

"What does the flight director say?" asked a happy Ed White.

Flight director Chris Kraft moved to his microphone and barked, "THE FLIGHT DIRECTOR SAYS GET BACK IN!"

White laughed. "This is fun! I don't want to come back in, but I'm coming."

But the spacewalking astronaut discovered that maneuvering his body along the Gemini without the use of the jet gun was easier said than done. After seven minutes of tough going, he finally made it back inside.

He had been out twenty-one minutes instead of the planned twelve, and he told Mission Control, "There was very little sensation of speed. The view was something spectacular. I could see the outlines of cities, roads. I could see the wakes of ships at sea." A smiling Ed White added one more thing. "It was fun."

Gemini 5, with Gordo Cooper and Pete Conrad, stretched long-duration flight to eight days. After spending that much time together inside a spaceship a little larger than a phone booth they splashed down, and newspapers everywhere ran a cartoon of them holding hands on the recovery carrier's deck with the caption: *"We're engaged."*

Frank Borman and Jim Lovell bettered 5's record. They stayed inside *Gemini 7*'s cramped quarters for fourteen days, prompting Lovell to say, "It was like spending two weeks in a men's room."

The monotony of their marathon mission was broken on day eleven by visitors from Earth.

Gemini 6's astronauts, Wally Schirra and Tom Stafford, flew their spacecraft right up to *Gemini 7*, put on the brakes, and began station keeping. It was the first rendezvous in space.

"We've got company," Lovell reported.

"There's a lot of traffic up here," Schirra told Mission Control.

"Call a traffic cop," Borman laughed.

Finally, American astronauts had performed a meaningful spaceflight feat ahead of the cosmonauts. The two Gemini ships orbited Earth together in formation, doing fly-arounds and circling each other in a

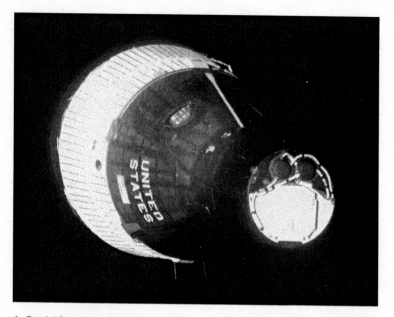

As Gemini 6 *rendezvoused with* Gemini 7 *in orbit, 6's naval commander Wally Schirra's reputation for pranks was obvious. The* Gemini 7 *crew read in 6's pilot window, "Beat Army." (NASA).*

series of figure eights. Schirra reported he closed to a distance of six to eight inches, backed off, and flew in again.

Gemini 6 returned to Earth the next day.

Gemini 7 came home two days later.

Rendezvous of the two ships was another milestone on the way to the moon, but docking two ships in space was still out there. That job would now fall to NASA's only civilian astronaut, Neil Armstrong, who first raced to the edge of space in NASA's X–15 rocket ship. He would command *Gemini 8* with West Point graduate Dave Scott.

The Agena target stage rode an Atlas rocket into orbit on March 16, 1966, and ninety minutes later Armstrong and Scott were off for the hunt. *Gemini 8* caught its quarry, and commander Armstrong circled and inspected the Agena rocket to confirm its stability. Then, with utmost care, Armstrong slowly nudged *Gemini 8's* nose into Agena's docking collar. Electric motors drove the docking clamps together. The two were now one.

"Flight, we are docked," the all-business Armstrong reported to Mission Control. "It was a real smoothie."

"Roger there, *Eight*," came the reply. "Way to go!"

Docking done, they took a breath and Armstrong checked his flight plan. They were scheduled to fire the Agena rocket and let it boost *Gemini 8* to a higher orbit.

But it was not to be. In that very instant, the long Gemini/Agena combination—slowly at first—took off rolling like a log in water. Armstrong and Scott had just enough time to realize what was happening before they were thrown into a struggle to survive.

They were, in fact, in the first real emergency in spaceflight. They were 185 miles above China, out of touch with Mission Control, and they were terrifyingly alone. They were linked to a rocket loaded with deadly fuel that had become a twisting, turning, ticking bomb, looking for an opportunity to explode.

The only good news for NASA was that *Gemini 8* was in the hands of Neil Armstrong. He managed to reduce the roll to a point that he could undock the two craft. With a bang the ships let each other go, and Armstrong was astonished all over again.

"What the hell!" Dave Scott yelled.

Gemini 8 was spinning even faster. The astronauts now knew the problem had not been with Agena, but with their ship. One of *Gemini 8*'s sixteen maneuvering rocket thrusters had stuck open. It was spewing fuel at full throttle. Unless they regained control, the severe whirling of the astronauts meant they would soon pass out.

Suddenly, some good news. The tumbling and spinning *Gemini 8* had completed its crossing over China and was now heading out over the far Pacific. *Coastal Sentry Queen*, a Gemini tracking ship, was listening. "We have a serious problem here . . . We're tumbling end over end up here. We've disengaged from the Agena." The ship was hearing Neil Armstrong's calm voice.

"It's rolling and we can't turn anything off," Armstrong continued his report. Then he threw away the book. He decided to use *Gemini 8*'s nose rocket thrusters—a no-no. The nose thrusters were there for reentry only. But he had to regain control. One by one he shut down

the fifteen other maneuvering thrusters, and slowly, by switching to the reentry nose thrusters, he regained control. He would have to wait now until the thruster that was stuck open, the bastard causing all their pain, spewed all its fuel into space.

The runaway thruster kept spewing—for almost half an hour; then, and only then, did NASA's top rocket man have full control of his ship.

"The X–15 was never anything like this," said Armstrong, reaching for the book. With control, the rules were back, and the rules said that once reentry thrusters had been fired, for any reason, the astronauts were to bring their ship home.

Armstrong and Scott now had to land at the first opportunity, before they depleted the reentry thrusters' fuel supply—before they would be left with no control of *Gemini 8* whatsoever.

There was only one problem: They were nowhere near a main recovery area. Flight controllers huddled. Then they said, "To hell with it," and ordered Armstrong and Scott to set up for an emergency landing in the western Pacific.

High over the African Congo, in darkness, Neil Armstrong fired *Gemini 8*'s retro-rockets. The braking rockets started their half-hour ride through an atmosphere of total darkness—there was not even the suggestion of a light in the African jungle or on the ocean below, and there was not even a voice from a tracking station to give comfort.

Armstrong and Scott performed the reentry with great skill. They splashed down 480 miles east of Okinawa, their shortened mission lasting just under eleven hours. Soon an air force rescue plane roared overhead, dropping rescue teams. Three hours later the astronauts were safe, enjoying hot food and showers aboard a navy destroyer.

Flight director Chris Kraft handed out his own statement: "The spin rate was up as high as 550 degrees per second, about the rate where humans lose consciousness, or the capability to operate. That was truly a fantastic recovery, and really proved why we have test pilots in those ships. Had it not been for the good flying, we probably would have lost the crew."

Deke Slayton took a few days for *Gemini 8*'s emergency to settle some obvious facts in his mind. He told himself Neil Armstrong's abili-

ties to reason, to think, to handle emergencies, to fly the hell out of anything from the Wright brothers to rocket ships, made the civilian test pilot *the* leading candidate to land the first Apollo lunar module on the moon. He expected, and received, no objections from other department heads within NASA.

Deke also conceded that *Gemini 8* proved rendezvous and docking would work, but the shortened flight left the technique without a track record. The final three Gemini missions would give NASA that needed

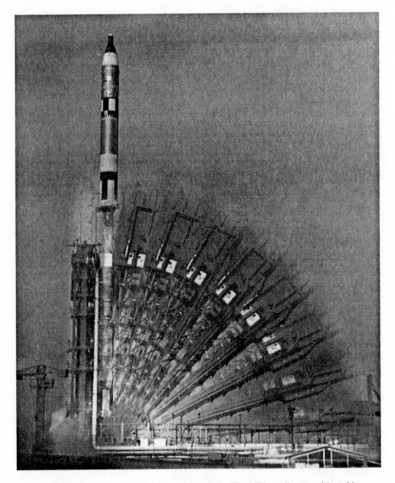

The fan effect of the gantry being lowered and the Titan lifting off was achieved by eleven separate exposures on one sheet of film when Gemini 10 *was launched July 18, 1966. (NASA).*

history—not only in rendezvous and docking, but in using the Agena rockets to relaunch their Gemini ships into higher and different orbits.

But surprisingly to Deke, spacewalking proved to be the most difficult challenge for the Gemini crews. The problem had first raised its head when Ed White had so much trouble getting back in *Gemini 4*. In fact, Deke Slayton had talked to the Gemini commanders after that, telling them bluntly, "If your spacewalker becomes disabled, and he can't make it back inside, cut him loose. Do not risk your life too." It was a tough order, but they agreed.

Gemini 9's Gene Cernan was picked to be the second American to take a stroll in space. Once he and commander Tom Stafford were in orbit, Cernan stepped outside, attached to a twenty-five-foot tether, looking forward to the frolicking good time Ed White had had. He charged off to do the things he'd been told to do—to spend two hours outside having a ball. But he couldn't make any headway. He wasn't trying to move in broad steps; he was just trying to move his body a few feet to the rear of the Gemini, to the equipment storage unit where he would strap on an astronaut's maneuvering pack and attached himself to a 125-foot tether. But he couldn't float, he couldn't pull himself, he couldn't walk, and he told me after the flight he sure as hell wasn't having a ball. Without handholds and footpads, it was a fight for every inch he moved.

A snail could have made better time, but finally he was there. "Whew!" he radioed Stafford with a breath of relief. "It's a strange world out here!"

"Take a rest," Stafford ordered him.

Gene was grateful for the order, and as he rested, he wondered. Could Ed White's steering jet have made the difference?

He caught his breath and tackled getting the astronaut-maneuvering unit on his back. He couldn't. He had failed at everything he'd tried, and Cernan quickly came to the conclusion he was useless. Nothing really worked, and when it was over, the second American to walk, or whatever, in space had been outside two hours and nine minutes. All of it had been a terrible nightmare.

Mike Collins on *Gemini 10*, and Dick Gordon on *Gemini 11*, wrestled with the same problems as did Gene Cernan and Ed White. Collins,

who used a steering jet to move from point to point, reported: "I found that the lack of a handhold is a big impediment. I could hang onto the Agena, but I could not get around to the other side where I wanted to go. That is indeed a problem." Gordon, like Cernan, sweated and his visor fogged. "I'm pooped," he said simply after cutting his walk short.

Deke Slayton wasn't pleased. "What the hell is the matter with these spacewalk planners?" he demanded. "We've racked up rendezvous, docking, changing orbit, stopping and restarting rocket engines—all the things you need to do to get to the moon, but no one can function outside. What the hell is their problem? Can't they figure this spacewalk thing out?"

There was one Gemini mission left and Deke Slayton, the director of flight crew operations, demanded a solution.

Veteran Jim Lovell would command *Gemini 12*. His spacewalking pilot would be Buzz Aldrin, an MIT graduate, and Aldrin had been listening. He was not only smart; Buzz was a tinkerer.

For his mission Aldrin fashioned special devices like a wrist tether, the same type of tether that window washers use to keep from falling, and he made portable handrails and handholds he could mount onto the Gemini or the Agena rocket. These would keep his body under control, but he needed shoes. He crafted himself a pair of "golden slippers," foot restraints resembling wooden Dutch shoes he could bolt to a workstation in the *Gemini 12*'s equipment bay, and he was bringing along tools—a whole bunch of them that he could grip with his thick space gloves. But more important, they were tools that would function in weightlessness, in the extreme temperatures of space.

On November 11, 1966, the last Gemini thundered from its pad and hunted down its Agena target. Docking went perfectly, and then Buzz Aldrin went outside and banished the woes of spacewalking. He proved a master. He took his time, stopping here and there to do some work as he moved down the nose of the Gemini and then to the Agena, making his way without effort along a six-foot rail he had locked into place.

Aldrin hooked different equipment to the ship, removed other equipment, and reattached it. He used a unique "space wrench" to loosen and

tighten bolts. He snipped wires, reconnected cables, and set in place a series of tubes.

Mission Control was stunned. John Young said, "You'd think he graduated from Georgia Tech instead of MIT," and CapCom could only ask, "How's them slippers, Buzz?"

"They're great. Great!" Buzz sang: "I was walking through space one day . . . "

It was a great engineering achievement right out of Buzz Aldrin's book, "Tinkering for Astronauts," to end the Gemini program.

Deke smiled, and when the Gemini 12 crew returned to their quarters on the Cape, they were slack-jaw surprised.

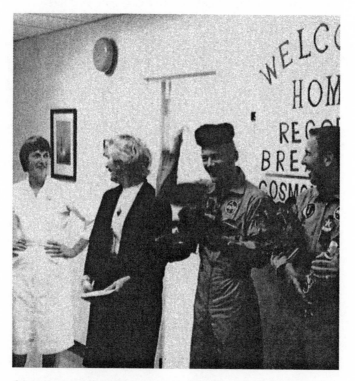

James Lovell and Buzz Aldrin, are met in the astronauts' Cape Canaveral quarters with the sign "WELCOME BACK RECORD BREAKING COSMO-NAUTS." Their den mother, Lola Morrow, gave them the traditional Russian cosmonauts' welcome of vodka, roses, and cosmonaut caps. From left to right: the astronauts' nurse Dee O'Hara, Morrow, Aldrin, and Lovell. (Morrow Collection).

My good buddy Martin Caidin had the undisputed best sources within the Russian space program. His ancestors were Russian, and from the time Yuri Gagarin made the planet's first flight into space, Martin was in and out of the country; as previously mentioned, he co-authored cosmonaut Gherman Titov's book, *I Am Eagle*. Marty never told me how and why he was over there so often, and I never asked. But when he returned a few days before *Gemini 12*'s flight, he brought back much memorabilia from the cosmonauts.

Our friend Lola Morrow was the astronauts' den mother. Because James Lovell and Buzz Aldrin had such a record-breaking success to end Gemini, Lola had an idea. She plastered a huge sign on the wall: "WELCOME HOME RECORD BREAKING COSMONAUTS."

When Lovell and Aldrin walked through the door, they were quickly adorned in cosmonauts' fur caps and given the traditional red roses and vodka. The *Gemini 12* astronauts loved it. Washington wasn't pleased.

"I've got a fire in the cockpit!"

us Grissom stepped out of his door, stopping long enough to study the lemon tree in his backyard. "Ah, there's a nice one," he smiled, reaching for the fat citrus hanging about eye level. He wiped the large lemon across his shirt. "I have a new home for you, baby," he laughed as he turned, walked around the house to his 'Vette. He slid into the seat and backed the sports car out of the driveway. His hand fit comfortably around the shift grip, as he moved smoothly through the gears. His 'Vette was purred down the asphalt. His speed was about ten miles over the limit, just where he liked it. Just enough for an early-morning piss-off of the traffic cops trying to down their fourth doughnut.

Gus reminded himself this was most likely the only fun he would have all day—behind the wheel of his 'Vette, with his thoughts taking him back to the good times he and Alan and Gordo had had in the drags at the Cape.

He smiled. They were the good times for sure, but none were better than that one particular late night. That time he'd headed back to the motel in the wee hours when he was backing up Shepard before the first flight.

He had his 'Vette on a deserted U.S. 1, where his speed of 100-plus was sweet. He was a dodging armadillo when he picked up a Florida highway patrol. There was only one thing to do: put the pedal to the metal. He made a high-speed turn onto the 520 Causeway and raced for Cocoa Beach. A sheriff's deputy felt he should join the highway patrol in the chase. The two were doing their best to wake up the entire space-coast with their screaming sirens when Gus sped through his turn onto A1A. The hot pursuit was joined by a third man—a Cocoa Beach cop. Grissom stomped his accelerator to the floor and his Jim Rathmann-prepared 'Vette left the long arm of the law hopelessly behind.

Gus made a wide seventy-mile-per-hour turn into the Holiday Inn, where he found his luck holding. The parking slot in front of Alan Shepard's room was open, and Gus slid his 'Vette between the lines. He ran quickly into his own room two doors away, shedding his clothes in the dark as flashing lights and howling sirens pulled up outside. He slipped into his pajamas and peeked around the curtains to see the sheriff and the highway patrolman arguing. They were putting their hands on the hood of Gus's 'Vette, feeling the heat coming through the fiberglass. "This is the room," they announced, and began pounding on a sleeping Alan Shepard's door.

When Shepard opened it, all three grabbed him and threw him to the concrete, with handcuffs locking in place around his wrists. A sleepy Alan Shepard found himself trying to explain to "never-listen traffic cops" when the pajama-clad Grissom opened his door and yelled, "Hey guys, can't you keep it down out there? Some of us have to go to work in a couple of hours!"

Gus laughed, remembering that Alan's forgiveness was slow coming with the promise he'd get even. He was still expecting payback from the chief astronaut.

Gus loved his buddy, but Alan's appetite for fun had evaporated since Deke put him in the chief's job. He was no longer the easygoing test pilot since his grounding from his inner-ear problem. Flying a desk here in Houston, he seemed to be "hot wired on pissed off," with the incredible ability to switch moods at will. Alan could be hell on wheels in the morning and his old charming self in the afternoon.

Gus and the others were baffled as how to deal with him until Alan's secretary, Gaye Alford, hit on a unique idea.

Each morning she would determine Alan's mood and select one of two pictures she had mounted back to back in a single frame. She had hung the picture on the wall outside Alan's office door. An astronaut being called before the chief would either see a photo of a scowling Alan Shepard or Gaye would flip it over to the one of him with a beaming smile.

Gus laughed. Those who walked past the scowl did so at their own risk.

It was good to laugh and to remember, even if it was for only a few minutes on the road. Gus was headed to the Apollo flight-simulator building. As he had for Gemini, Deke had given him the commander's seat for the first Apollo, and he wasn't at all pleased with the mission's progress. Nothing seem to be working, and his wrath this day was focused on the flight simulator, and on the operator charged with making sure the machine would fly as if it were *Apollo 1* itself. The man on the hot seat was Riley McCafferty. He braced himself as Gus walked through the door.

"Let's see if this thing will fly, Riley," Gus said as he climbed inside with his crew, astronauts Ed White and Roger Chaffee.

Only a few minutes of the simulation had passed when the *Apollo 1* commander began fuming. The simulator differed in so many significant ways from the actual spacecraft that Gus felt the machine was a waste of time.

"Damn it, Riley," Grissom shouted, "this simulator is worthless! Why isn't it up to speed?"

The defensive simulator operator explained that engineers had made hundreds of changes to the actual spacecraft and it took time. . .

"Bullshit," Grissom interrupted. "It's a piece of crap, Riley. Get it right and we'll be back."

Before leaving, Gus Grissom reached in his briefcase and brought out the fat lemon from his yard. He hung it tightly on the simulator's hatch. "Leave it there," he ordered, walking away from the sounds of polite laughter.

Despite Gus and his crewmates' problems, Apollo was coming. So were the big network stars. Huntley, Brinkley, and Cronkite wanted to be part of man's first landing on the moon, and so did their New York handlers. The lunar landings were being sold to such big advertisers as Gulf Oil, and these corporate giants wanted to see Chet Huntley and David Brinkley sitting on camera in front of their logo.

Many have asked me if it didn't piss me off to spoon-feed information to the New York stars. My answer was simple. Hell, no! That was my job. A person from my background had a slim–to-none chance of getting on national television, and I was damn happy to be the exception to the rule.

I was grateful, and more important, I knew my limitations. How could I not be pleased living and working in paradise? I had long ago recognized a solid fact: I did not have the background to be a Chet Huntley or a Walter Cronkite, and I simply did not want to be. NBC was very fair. I not only had been blessed with a wonderful wife and children, I had a job that was one of the most exciting in the country, and I had cultivated solid sources. They were filling me in on all the bits and pieces of Apollo, including the growing tension between Gus Grissom and the Apollo managers. And I was aware of another fact: No outside reporter could compete with me on my turf.

The Apollo astronauts were in their jets commuting almost daily between their homes in Houston and the Cape, and that evening Gus was at Wolfie's Nightclub in Cocoa Beach. The club featured a popular folk singer named Trish, and Gus loved to hear her sing. When I walked in he invited me to pull up a chair. "We need to talk," he said quietly.

I nodded and sat down. I could see he was troubled.

Over Trish's mellow vocals he slowly began. "Jay, we need your help."

"You got it, Gus."

"Apollo is a piece of crap," he said flatly. "It may never fly. We have problems and they're not getting solved. It's nothing like Mercury and Gemini and working with the Mac folks in St. Louis." He shifted in his

chair. "Hell, these California guys in Downey haven't a clue. They've got their big fat contract and no know-how." He paused again, leaning closer. "You guys in the press, well, shit Jay, you guys have to help us. Apollo is not ready."

I nodded, knowing I was listening to the most engineering-savvy astronaut in NASA. "I'll do what I can, Gus," I smiled promisingly. "What do you think is behind it?"

"The White House," he said soberly. "The White House is pushing."

"Pushing?"

"Damn right," Gus nodded. "It's all about the reelection. LBJ would like to see us on the moon before the polls open in '68."

"He needs the help because of Vietnam?"

"You got it," Gus said, pulling his chair even closer. "Johnson gave Apollo to his buddies instead of the guys with the experience and now he's damn well wanting miracles that ain't there. They're rushing production and we need time, Jay, we need time."

"I'll get on it, Gus," I promised. "I'll get on it."

He nodded a thank-you and moved his chair back, still troubled. Trish finished her set and joined us, and we ended the conversation with a handshake.

Gus enjoyed Trish's company and her singing, but despite what some thought, there was nothing going on between the two except friendship. Trish and I were good friends, as we still are today, and I knew she was involved with an astronaut, but he wasn't Gus Grissom. There were lots of stories in those days about the astronauts and women, but for the most part they were just that: stories.

In one case, a sleazy private investigator had offered NBC an audiotape for a price. It supposedly was a recording of an astronaut in bed with a woman other than his wife. I asked him to leave the tape with me, telling him I needed to play it for my boss in New York. No sooner than he'd left the NBC bureau, I erased it, and called him with a "We'll pass."

Later, I learned he didn't have a copy and my bosses, Russ Tornabene and Jim Holten, joined me for a good laugh.

In the coming days, I questioned Apollo managers often and regularly. I wanted to know why they weren't addressing problems that had been brought to my attention. I wanted to know why they were in such an all-fired hurry to launch in late 1967 or early 1968. John Kennedy had set the launch for before the decade was out. Why didn't they take their time? Was beating the Russians more important than astronauts' lives? But the news media then weren't as aggressive as they are today. This was six years before Watergate, and no matter how many times I raised Gus's complaints with colleagues, most reporters gave his concerns short shrift.

One exception was my friend Howard Benedict of the Associated Press. I briefed Howard and we both stayed on top of Gus's worries, nipping at the heels of Apollo's movers and shakers.

Howard had come to the Cape a year after I did—only a few years out of Tokyo, where he'd worked with my boss Russ Tornabene on the army's newspaper, the *Stars and Stripes*. This sort of made us family, and he and I became tight. We spent three decades leading the pack and watching each other's backs. Damn, I miss him! Howard was the kind of close friend you hated to see leave this world ahead of you.

I kept trying to get NBC to do more stories on the problems with the Apollo. The *Today Show* passed on a story, and *Huntley-Brinkley* turned it over to one of their favorites. He kissed off Gus's concerns while I did what I could on the NBC Radio Network. The press and public ignored the whole damn thing, and the first Apollo labeled "flight worthy" was stacked atop its Saturn 1B rocket. The launch team prepared for the one launch-pad test considered essential. Called a "plugs out" test, it was a complete shakedown of the spacecraft's ability to fly safely—a countdown simulation with 100 percent oxygen and fully suited astronauts sealed inside. The space agency posted Friday, January 27, for this "full dress rehearsal."

Neither Howard Benedict nor myself felt easy. NASA refused us permission to cover the test, and just before Gus slipped feet first into *Apollo 1*, his backup, Wally Schirra, stopped him. Wally hated that damn hatch. He had been arguing all along that it should have been built with a quick-opening explosive mechanism that operated instantly, like those

Veteran astronaut Gus Grissom suits up for the Apollo launch-pad test that would end his life. (NASA).

in Mercury. To Wally, *Apollo 1*'s hatch was fashioned from overtime stupidity. It was double-hulled. It had to be opened manually, and to escape in an emergency it was necessary to open both hulls and then release a third hatch protecting Apollo during liftoff. Engineers had designed it that way to avoid an accidental loss of the hatch en route to the moon or during the punishing reentry, when Apollo would come blazing back to Earth at more than 24,000 miles per hour.

"Listen to me, Gus," Wally told his friend. "It'll take you a minute and a half, possibly two, to get all those hatches open. If you have a problem, even if your fucking nose itches, get the hell out. Make sure they solve the problem before you get back in. Got it?"

"Got it," Gus nodded and smiled. "Thanks, buddy."

"We're ready to get with the count." That from the blockhouse speakers told every person connected with the rehearsal to get with it.

The lights flashed, the clocks ticked, and the countdown moved

through the "plugs out" test—meaning Apollo and the Saturn would stand alone, would operate on their own internal power, with no help from outside.

The launch team was verifying that everything, except fueling and actual launching, would work in a symphony.

The three astronauts, in their full spacesuits and strapped inside *Apollo 1*, were following the script. Gus Grissom was in the left seat, Ed White in the center, and Roger Chafee on the right.

No one saw it; no one knew just when it came to life.

Somewhere beneath the seat of commander Gus Grissom, an open wire chafed. Insulation was worn and torn. The wire, alive with electrical power, lay bare in a thick soup of 100 percent oxygen—one of the most dangerous and corrosive gases known. Exposed to an ignition source, it is extremely flammable. It had been used in the Mercury and Gemini spacecraft without trouble.

But this much pure oxygen inside a ship as large as Apollo was another story.

Gus Grissom shifted his body for comfort.

His seat moved the bare wire.

It sparked.

INSTANT FIRE!

Flames filled *Apollo 1*, feeding on the oxygen-soaked materials surrounding the astronauts.

The launch team froze before its television monitors. Muscles stiffened; voices in the blockhouse ceased in mid-sentence. No one knew what he or she was witnessing. It was something horrifying and unbelievable. Flames rampaging inside *Apollo 1*—a whirlwind of fire raging and burning everything it touched.

The medical readings showed Ed White's pulse rate jump off the charts—showed the three astronauts burst into instant movement.

The first call from *Apollo 1* smashed into the launch team's headsets.

"Fire!"

One word from Ed White.

Then, the unmistakable deep voice of Gus Grissom.

"I've got a fire in the cockpit!"

Instantly afterward, Roger Chaffee's voice:

"Fire!"

Then a garbled transmission, and then the final plea:

"Get us out!"

Then words no one would ever understand, followed by a scream and—

Silence.

In the blockhouse, Deke Slayton jumped from his chair, shouting, "What the hell's happening?"

Eyes stared in horror at the monitors. Flames expanded swiftly, building to a white glare before subsiding, and Deke thought he saw a shadow moving inside. He couldn't be sure, but then he saw bright orange flames flickering about *Apollo 1*'s hatch.

Hellish flames followed by thick smoke boiling outward.

An icy chill moved over his skin. Those calls of fire, that final garbled scream—they had come from inside *Apollo 1*.

Pad crews were rushing to the scene, trying to get to Gus, Ed, and Roger, and astronaut Stuart Roosa on console in the blockhouse was trying frantically to talk with them. Again and again he called, desperate, his face chalk white.

No response.

Then, there was a shout from the pad over the radio loop: "Get a doctor out here, quick!"

Deke heard that! You don't need a doctor for dead men. It was a glimmer, just a small hope. He grabbed two doctors standing nearby and they headed for the blockhouse door.

Deke lived a lifetime in that mad run to the launch pad. He and Gus had been fishing and hunting buddies for years. They had flown everywhere together, and when it came to astronaut training, Gus had saved his ass during a water-rescue drill. Deke had fallen off his raft, and because he'd never really learned to swim, he almost drowned. But there was Gus, who could swim like a frog, and Gus saved him.

"Hang in there, buddy!" Deke shouted inside his head.

They reached the gantry, rode the elevator to level 8, and rushed into the White Room. The hatch was already open.

The doctors leaned in, studied the scene, and then pulled away slowly.

One turned to Deke. "They're gone," he said, shaking his head.

Deke held his position. Just for a moment. Gus was in there. He had to see for himself. He stepped over and leaned inside the hatch. It was all burnt. Everything was black ash. It was a death chamber. Ed White was on the bottom and Gus and Roger were crumpled on top of him. "They were clawing at those goddamn hatches," Deke cursed. "They were trying to get out," he shouted. "Damn it, they were trying to get out!" He caught himself. He was about to lose it. Then he saw it. Their suits! Their suits had protected them from the flames. None of them had burns. "It was all that goddamn crap they were breathing," Deke cursed again. "It killed them, damn it. The fire sucked the oxygen right out of their lungs."

Deke caught himself again. He paused, took a breath. Slowly he was putting things back together, gathering his thoughts.

Suddenly and strangely, he was thankful. He was realizing how quick death had been. He reached down and touched Gus's gloved hand. "You didn't suffer, buddy," he choked back the words. "Thank God you guys didn't suffer." Then, Deke Slayton walked into the darkness and cried.

The tears flowed for five, perhaps ten minutes; Deke wasn't sure. He could only stand there and hurt, and when the tears were slowing he turned once again to the blackened Apollo. "This won't happen again, guys," he promised the fallen astronauts. "It won't happen again."

Within hours after the *Apollo 1* fire, Gus, Ed and Roger were being remembered in America's homes. In the home of Frank Sinatra, the memories were recent and special. Ten days before the astronauts died in the fire, they were flying to the Apollo plant in California hoping to get some training time in an up-to-date simulator. They ran into problems with one of their T–38 jets and had to land at Nellis Air Force

Base outside Las Vegas. While the jet's problems were being fixed, they decided to take in a show.

Frank Sinatra was on stage, and no sooner than they sat down, Frank had them brought up front. They were wearing their astronaut flight jackets, and Old Blue Eyes took a shine to Gus's jacket. He was especially impressed with Grissom's mission patches.

Gus grinned. He stood up, removed his jacket, and gave it to Frank. Sinatra was so moved he cried before his audience. Ten days later, he cried even more.

When *Apollo 1* burned I was on my way to the Bahamas to cover a news conference by New York City congressman Adam Clayton Powell. The NBC news desk immediately rushed me back to the Cape, where I found reporting difficult. I kept wishing I had done more. Just what more, I have never fairly identified.

Gus Grissom was laid to rest at Arlington. Rifle volleys split the air, a bugler sounded mournful taps, and jet fighter pilots roared overhead in a final salute. In uniform, the remaining six Mercury astronauts stood solid, at attention. They had been seven, the Mercury Seven. Tragedy had removed one from their proud number.

Later that day, there was again the salute, the bugler's stirring taps, and the thunder of jet fighters as Roger Chaffee went to rest at Grissom's side.

On the same afternoon, on a bluff overlooking his beloved West Point, Ed White went to his final destination.

It was over.

And as Deke promised Gus, Ed and Roger, it never happened again on his watch.

There *was* a new beginning.

The *Apollo 1* fire sent red flags sailing through the space agency and its contractors with one question: *Why?* NASA boss James Webb gave the job of answering that question to Floyd L. Thompson, director of the Langley Research Center in Virginia. He ordered Thompson to set up a

board of review: "Find out what the hell really happened, Floyd, and get back to me as soon as possible." Thompson nodded, and brought in some of the toughest investigators and specialists on the planet. Among them was Frank Borman, who had commanded the two-week *Gemini 7* flight. Together, they assembled a team of fifteen hundred men and women to trace every inch *Apollo 1* had traveled in its construction, its movements from hangar to hangar, and its tests on its launch pad.

They looked at thousands of dials and switches and transistors and electrical connections, and then they built an exact copy of *Apollo 1* and set it ablaze. The test badly shook many who could not study the results until the next day. Some went home and stared at the walls.

From the outset, heads rolled in the top reaches of executive suites. The search for incompetence didn't have far to go. It was right in front of the investigators' eyes.

By summer's end 1967, NASA's George Page, a veteran of the Mercury and Gemini flights, could swallow no more. He was sick of all the politicos' posturing, stabbing fingers into the air, declaring their innocence while demanding something be done. The problems, Page knew, would be solved at the grunt level, with the techs and engineers pulling wire and turning wrenches, if only the suits in Washington would give them the time.

Page was one of NASA's best managers and he knew who could make the trains run on time. He phoned an old friend. T. J. O'Malley was in Quincy, Massachusetts, working for General Dynamics' electric boat division.

"T. J., this is George."

"Hello there, Mister Page," O'Malley smiled down the line. "How's everything at the Cape?"

"A mess," George said flatly. "No, let's make that a goddamn mess."

"How many asses have you hanged for that fire?"

"Not enough," George said. "If we hanged all those we should, we'd run out of rope."

"That bad, huh?"

"Yep, T. J., it's that bad." He paused. "We need you, old friend. We need you."

"Well, George," T. J. spoke seriously, "I'm expecting a promotion here. I'm expecting it tomorrow morning in fact. And . . . "

Page interrupted. "T. J., we're in a terrible mess. We need you," he pleaded. "Please think it over tonight and we'll have Buzz Hello call you tomorrow morning." Buzz Hello was the vice president for North American Aviation, builders of the Apollo.

T. J. O'Malley turned to his wife, Ann. Few disputed the fact O'Malley had married well above his station in life, and he said, "Mrs. O'Malley, George says they need me at the Cape."

"Tom," she said lovingly, "you've always made this family a good living. We're with you. It's your decision, but," she winked, "Cocoa Beach is nice."

Thomas J. O'Malley returned to Cape Canaveral exactly one year to the day he had left, and was immediately given the job as director of Apollo Operations by North American Aviation.

He went to work that afternoon and within minutes, he knew two things. One, George Page was right on target. And two, he wasn't sure Page was his friend. What in the hell had George gotten him into?

There were no simple checks and balances in the Apollo operation. Each department was going down its own road. Each was buying its own stuff. Each was reporting to no one. And experience? Hell, they had none of that.

The team was overloaded with retired military, with colonels and other high-ranking officers doing little more than flying on North American's travel vouchers to military reunions and such.

The whole thing smelled of military paybacks for aviation and aerospace contracts, and in the coming months while review boards were investigating, while others were pointing fingers and covering their own asses, while engineers in the Downey plant were redesigning and rebuilding Apollo, T. J. O'Malley put on his boots, shined their toes, and began kicking ass and taking names.

On October 11, 1968, a Saturn 1B rocket roared to life on the same launch pad where *Apollo 1*'s Gus Grissom, Ed White, and Roger

Chaffee had died. The heavyweight rose toward Earth orbit on 1.3 million pounds of thrust with *Apollo 1*'s backups, astronauts Wally Schirra, Walt Cunningham, and Don Eisele.

Schirra was the first, and would be the only, astronaut to fly all three capsule-type spacecraft of the era—Mercury, Gemini, and Apollo—and he radioed a Mission Control holding its breath, "Apollo is riding like a dream."

Saturn 1B took Schirra and crew into an orbit 140 by 183 miles high for a mission of eleven days. *Apollo 7*'s new rebuilt systems and its millions of new parts performed superbly. For the first time, live television from the spacecraft itself fascinated audiences around the world, and our radio and television coverage was suddenly easier. We could monitor the television pictures and describe to our radio listeners what we were seeing, and for television viewers, even though they were black-and-white, the pictures and words spoke for themselves.

The astronauts' mission was to fly the new ship farther and longer than it would have to fly to the moon and back. The crew was impressed with the size of *Apollo 7*. Mercury and Gemini had been cramped, but in Apollo, the astronauts could unhook their safety harness and move about the cabin. If they wanted privacy, they could float into a closet-size area beneath the seats, which on later flights to the moon would serve as sleeping quarters.

The eleven-day mission encountered only minor, easily resolved problems. The biggest proved to be with the crew. All three had nasty colds and were orbiting Earth with stuffy noses and headaches. When the mission neared its end, the astronauts were in something less than the best of moods.

The astronauts' irritability reached its boiling point on the ninth day, when Mission Control decided to try some unplanned systems checks. *Apollo 7*'s crew rejected the changes in the flight plan immediately, calling them "Mickey Mouse tasks." Schirra was quick to point out three colleagues had been lost because of lack of attention to plans, called the engineer who thought up one of the tests an "idiot." Wally Schirra refused to accept any more changes.

I knew from conversations I had had with Wally over coffee that

he was flying his last mission. As Gus's backup, he was picking up the reins dropped tragically by his friend, and after he had proved Apollo was safe to fly, as soon as the debriefings were over he was getting the hell out of Dodge. He'd had it with the space program, and he had made promises to his wife, Jo. He believed the Apollo contract had gone to political cronies instead of experienced, capable people, and because of that, his friend and two colleagues had died.

So, as far as Wally Schirra was concerned, his crew was going to fly the well-thought-out mission and no ad libs, thank you. As commander, he wasn't going to put his flight in danger. He owed the *Apollo 1* crew good results, and he owed his country. He knew NASA had some solid intelligence the Russians were getting ready to try a flight around the backside of the moon. Now, if *Apollo 7* could turn in a grade-A performance, the *Apollo 8* crew would feel comfortable about beating the Russians there. In spite of his stuffed-up nose and aching head, Wally smiled. The first lunar Christmas could be just around the corner.

A Christmas Moon

pollo 8's astronauts were filled with wonder as they looked out their windows. A bright sphere eased into their view and they cheered. Their home planet was moving before them. From 200,000 miles in space they were seeing the whole globe, dominant with blue seas and white clouds and brown continents. There was Europe with its bountiful lands and mountains, and below, Africa with its deserts and its jungle greens and at its southern tip, Lake Victoria. Earth was a perfect sphere, a heavenly blue marble.

"Toasting the ship," *Apollo 8* was turning slowly to keep the sun's heat distributed evenly around its outside surface, and the slow roll slid the astronauts' home silently out of their view. They turned from the windows. Tomorrow would be Christmas Eve. That Frank Borman, James Lovell, and Bill Anders were between Earth and the moon seemed impossible. They had gambled their lives by riding the *Saturn V* onto their now lunar flight path. The mighty machine had flown only twice before, without astronauts, the first flight successfully, the second with some problems. But Borman, Lovell, and Anders's ride was perfection.

They also had the largest television audience in history, more than a half billion people taking in sights from space they had never before seen. And when Earth came into their view again, commander Frank

Jay Barbree reports Apollo 8's launch from Cape Canaveral before flying to Houston's Mission Control to cover the Christmas mission to moon orbit. (Barbree Collection).

Borman played tour guide. "What you're seeing is the Western Hemisphere," the former airline pilot said as if he were pointing out the Grand Canyon. "In the center, just lower to the center, is South America, all the way down to Cape Horn. I can see Baja California and the southwestern part of the United States."

Apollo 8 had live television, but it was still television in black-and-white, so astronaut James Lovell joined his commander. "For colors, the waters are all sorts of royal blue. Clouds are bright white. The land areas are generally brownish to light brown in texture."

Mission Control broke in. "You don't see anybody waving, do you?"

They laughed, and the transmission ended. It was time for the astronauts to get back to work as they crossed an invisible line between Earth and the moon. The wall is called the equigravisphere, meaning equal gravity between two celestial bodies. Until this point *Apollo 8* had been "coasting uphill" against Earth's gravitational pull. Now, less than forty thousand miles from the lunar surface, the moon's gravitational pull was greater.

That meant for the first time since leaving Earth, *Apollo 8* was heading downhill, gaining speed, and tomorrow the astronauts would have the choice of sweeping around the moon and heading back home on their present circumlunar flight path or firing the spacecraft's main service engine and slipping into an orbit around the lunar surface.

The world would be watching and celebrating the farthest and most daring spaceflight in history. Yet some were asking, "Why are we going to the moon during Christmas? Why couldn't they have flown the mission after the holidays?"

The astronauts flying *Apollo 8* knew the answer.

Zond.

NASA had its super-booster, the seven-million-pound-thrust *Saturn V*. Russia had its even bigger N–1 rocket.

The difference?

Saturn V had been doing well under Wernher von Braun. My colleague Martin Caidin had learned the N–1 had stalled. Test delays had the N–1 sitting on the ground.

The Russians regrouped, and in the summer of 1968, CIA satellite photographs made NASA aware of the Zond program.

It was a time when the country was in a malaise. America had had it with the Vietnam War. Lyndon Johnson had refused to run for reelection. Richard Nixon was on his way to the White House to end the lingering conflict, and if all went as planned, the Russians could send a single cosmonaut on a circumlunar journey by year's end. The fact that cosmonauts could not land on the moon would not stop the Russians from claiming they had reached the moon first.

But NASA managers saw a chance to fulfill the promise of John F. Kennedy instead of eating the Russians' dust once again. NASA boss Jim Webb told President Johnson it was time to gamble, to consider putting astronauts on the next *Saturn V* and sending them all the way to the moon, possibly even into lunar orbit.

Johnson, seeing a chance for a last hurrah for his administration,

bought it. So, in spite of Christmas, the first manned *Saturn V* headed for the moon.

The great untested rocket burned perfectly through its three mighty stages and sent Frank Borman, Jim Lovell, and Bill Anders rushing away from Earth at 24,200 miles per hour on the morning of December 21, 1968.

Zond was left standing on the launch pad, and bitterness replaced the usual holiday round of vodka and cognac toasts. Lev Kamanin, top aide to Kremlin space officials and the son of the chief of cosmonaut training, sent Martin Caidin a note:

> For us this day is darkened with the realization of lost opportunities and with sadness that today the men flying to the moon are named Borman, Lovell, and Anders, and not Bykovsky, Popovich, and Leonov.

All members of science, however, were brothers in the realization that a marvelous product of human technology and engineering was on its way to the moon. The Apollo command module was moving swiftly toward becoming the first spaceship to orbit another body in our solar system. It was Christmas Eve, and *Apollo 8* was fast approaching the point of decision.

The astronauts and the world would have been happy to know that inside Mission Control the news was good. Every monitoring instrument was "in the green." *Apollo 8* was moving right down the pickle barrel without a red light in sight.

The astronauts seemed to be right on top of the moon, and they held their breaths as they disappeared behind lunar mountains and began their flight around the moon's far side, where radio signals between Earth and *Apollo 8* would be blocked.

It meant astronauts Borman, Lovell, and Anders would be out of contact with Mission Control for more than twenty minutes and Cap-Com Jerry Carr was sending the message everyone wanted to hear: "You are GO for lunar orbit. You are GO all the way."

Jim Lovell's voice was incredibly calm as he responded, "We'll see

you on the other side," and with those words, *Apollo 8*'s astronauts vanished into silence.

Suddenly, the three astronauts were filled with wonder. They were the first humans to see the side of the moon always facing away from Earth. But they were also filled with worry. They were now only thirty seconds away from the moment *Apollo 8*'s main rocket engine had to fire to place them in lunar orbit.

Mission Control could only hope *Apollo 8*'s big rocket ignited as planned, slowing the astronauts into an orbit sixty miles above the lunar surface. But, if it didn't, the astronauts would still be safe. Their higher speed would bring them back to Earth on the "Free Return Trajectory."

The rocket was scheduled to burn four minutes and twelve seconds, and Jim Lovell would later say, "It was the longest four minutes I've ever spent."

The rocket's ignition was a thing of beauty. *Apollo 8* emerged from behind the moon with its crew hearing CapCom Jerry Carr calling and calling, "Apollo 8, Apollo 8, Apollo 8 . . ."

"Go ahead, Houston," came the calm voice of Jim Lovell.

Those three words sent Mission Control into a wild celebration. It was bedlam—cheering, whistling, shouting, and backslapping—as electronic signals flashing in from *Apollo 8* told the mission controllers the astronauts were in a lunar orbit 60 by 168 miles. Later, on orbit three, the SPS rocket fired again, dropping *Apollo 8* into the planned, circular orbit of 60 by 60 miles.

But the hell with all the engineering jargon and numbers! A worldwide television audience wanted to know one thing. *What did the moon look like?*

Tour guide Jim Lovell keyed his microphone and cleared his throat. "Essentially gray in color," he reported. "Its surface is like plaster of Paris or a sort of grayish beach sand." *Apollo 8* relayed pictures of a desolate landscape pitted with both massive and tiny craters. "It looks like a vast, lonely, forbidding place, an expanse of nothing . . . clouds of pumice stone," Borman reported. Lovell saw the distant Earth as "a grand oasis in the big vastness of space." Anders added: "You can see

the moon has been bombarded through the eons with numerous meteorites. Every square inch is pockmarked." Then, Lovell spoke as the poet: "The vast loneliness is awe-inspiring, and it makes you realize just what you have back there on Earth."

It was a Christmas Eve like none before. Millions of families gathered around their home fires, exchanging presents and watching *Apollo 8*'s fabulous adventure.

And for those millions, the astronauts spoke directly.

"For all the people on earth," Bill Anders began, "the crew of *Apollo 8* has a message we would like to send you." A brief pause, and then Anders stunned his audience as he began reading from the Book of Genesis: "In the beginning, God created the heaven and the earth." Anders read the first four verses. Lovell followed by reading the next four. Borman read the ninth verse, and then the commander of *Apollo 8*'s mission sent the world a special Christmas message: "And from the crew of *Apollo 8*, we close with good night, good luck, a Merry Christmas, and God bless all of you—all of you on the good Earth."

Later, as Apollo moved around the desolate lunar landscape, Frank Borman did have one more thing to say as he watched Earth "rising" above the moon's horizon: "This is the most beautiful, heart-catching sight of my life."

No sooner than the Christmas Eve telecast from moon orbit was over, the phones began ringing at the NASA news center near Mission Control. Most calls were praise for what they had just seen, but there was one complaint that NASA, a government agency, was promoting religion. The public-affairs officers smiled and thanked all callers. A Japanese reporter checked in. He had spent most of the day in the news center and now, approaching deadline, he wanted to know when NASA would have a transcript of the astronauts' reading from lunar orbit.

The quick-thinking public-affairs person, knowing the Japanese reporter was most likely Buddhist, asked, "Are you in your hotel room?"

"Yes," the reporter acknowledged.

"Look in the drawer under your phone and you will find a black book."

The Japanese reporter opened the drawer and said, "I have it."

"Good," the NASA spokesman said. "Open it to the first book entitled Genesis, page seven. You'll find the transcript there."

B y the time we had wrapped up the astronauts' Christmas message in the NBC broadcast trailer outside Mission Control, most of us were feeling blue. We were missing our families on Christmas Eve and we were off to phone them from our hotel rooms.

My wife Jo's voice was a needed tonic, and our two-year-old, Karla, and our seven-year-old, Alicia, had to tell Daddy all about the presents they expected Santa Claus to bring.

As families go, I was most fortunate.

After getting a touch of Christmas from home in Cocoa Beach, I realized I hadn't had dinner. I slipped my coat back on and took the elevator downstairs to the coffee shop. I walked through the door paying little notice to a man at the end of the counter.

"Am I too late?" I asked the waitress.

"Merry Christmas," she said, passing me a menu. "What would you like?"

I sat down, ordered, and as the waitress left, returned to my blue, spending-Christmas-alone mood.

The man at the other end of the counter got up and walked over. "Hi, Jay," he said politely, "I'm John Glenn."

I looked up and instantly congratulated myself for being the year's biggest jackass. I had just slighted a national hero whom I admired.

"Of course you are, John," I began laughing, motioning for him to sit down. "Would you believe my mind was at home with Jo and the kids?"

John settled on the stool next to me and nodded, "I believe."

Suddenly, Christmas Eve wasn't all that blue. John Glenn and I downed a few morsels and a gallon of coffee and welcomed Christmas with happy memories.

On board *Apollo 8*, there was more to be done. The crew studied landing sites being considered for Apollo astronauts and took hundreds of pictures.

Early Christmas morning, *Apollo 8* moved through its tenth and final trip around the lunar landscape. Again, the astronauts were on the far side, out of contact with Mission Control, and the most important event of their flight was before them, the critical rocket blast to come home. If it worked, they would return to their families. If it didn't, they would be marooned in lunar orbit.

Command Module pilot Jim Lovell counted down the final seconds— "Ten, nine, eight, seven, six, five, four, three, two, one, ignition,"—and the three astronauts felt the kick of the big rocket's instant life, etching the vacuum with flame sixty miles above the moon.

Lovell watched the timer like a hawk. He needed that rocket to burn for 304 seconds. That was the Delta V needed—engineer's talk for the exact thrust required to get from one point to another—to get from the moon to Earth. The timer clicked and the seconds dragged and those in Mission Control bit their nails, lips, pencils, or most anything within reach. They, along with the worldwide television audience, could only wait.

Finally, *Apollo 8* came around the moon and there was the voice of Jim Lovell: "Please be informed there is a Santa Claus. The burn was good."

Fifty-eight hours after leaving lunar orbit, and with Earth's gravity dragging *Apollo 8* home, the world's first travelers to the moon splashed down on the Pacific in sight of—you guessed it—Christmas Island.

Three citizens of Earth had just completed what the *New York Times* called a "fantastic odyssey."

The road to the moon had been opened.

The Secret Side of Space

Fog.

Fog and mist.

They are living elements of the craggy mountainous cliffs where a Thor/Agena rocket appeared to rise silently, climbing from its launch pad at California's Vandenberg Air Force Base.

At first, no one except those launching the rocket knew it was there. It was ghostlike rising through the mist, but then, the growing roar awakened sea gulls and seals bobbing in the surf and all other living creatures within its voice.

Off shore, a spy ship disguised as a Russian trawler had locked its tracking equipment onto the launch.

Martin Caidin and I were working on a secret space book that would, unfortunately, never be published as the Thor/Agena raced away, leaving the fog clinging to its host mountains. The big rocket burned a fiery path into the brilliantly lit ocean sky and lost itself above a few coastal clouds. Two minutes and forty-five seconds later, the Thor/Agena loaded with its spy cameras was high over the Pacific, heading south, heading toward the South Pole as the Thor stage burned out and dropped away.

Agena would fire twice to boost its photo-reconnaissance satellite into orbit—an all-seeing two-camera system arranged so that it pro-

duced stereo pictures of Russian and Chinese secrets. The 3-D prints could tell CIA analysts what they were looking at, its height and depth, as well as many other details.

The spy's name was Discoverer, and it settled into a one-hundred-mile-high orbit above Earth's north and south poles where our planet below would, every twenty-four hours, rotate its entire surface beneath the seeing lenses of Discoverer's cameras.

America's adversary's borders were closed, but its sky was open and Discoverer was there to steal the secrets it labored to protect. Film-drive motors switched on and the American spy opened its eyes. Below was Russia's Baikonur rocket base with its launch pads and supporting structures. Discoverer blinked and blinked, and twenty-one minutes later the spy satellite had completed its first trip across the Soviet Union.

Next time around, the spy's stereo cameras gathered shots of airfields. Missile installations. Military facilities. Soviet harbors. It was a solid sweep, and ground controllers started the procedures needed to bring Discoverer's secrets back to Earth.

They monitored a countdown display as it fell toward zero.

"Ten seconds," reported the recovery director of the classified flight. "I'll call it out," he told the technician to his right. "I want manual safety override for the retros." Nothing really new. The flight controllers had done this hundreds of times before. The retro-rockets would ripple-fire and slow down the assembly by six hundred feet per second. Soon after, Discoverer's film capsule would begin atmospheric penetration. Descending into thicker air, it would slow to a crawl beneath a ribbon parachute. Then, a C–130 retrieval plane would bore in, snatch the chute with the valued film, and winch it inside its cargo bay.

The recovery was a piece of cake. The fruit of the spy's labor was on its way to the eyes of the Central Intelligence Agency.

Look at this sonofabitch," the CIA analyst shouted. "It's bigger than a *Saturn V*, and the damned thing's gotta have more punch." He turned to a colleague. "You have those data reports on the N–1 ready?"

"Right here."

The CIA analyst quickly scanned the first two pages before slapping the papers against the table. The pictures showed a monster of a rocket, standing almost as tall as the Washington Monument.

The Russians simply called it N–1, and it had one assignment: get cosmonauts to the moon's surface, but more important, get them there and back before American. It was February 1969. The Russian space program was unraveling. Rockets rushed to their launch pads had proven unreliable. They exploded on their launch stands or, if not there, shortly after liftoff. The Zond project had been dropped after *Apollo 8*. No need for a circumlunar flight now. Landing on the moon was the only prize left.

"You know what this means?" the CIA analyst asked his colleague, then quickly answered his own question. "If this monster works, cosmonauts could still beat us to the lunar surface."

Another countdown came to life at Baikonur. It was the first launch of N–1, and years later, after the collapse of the Soviet Union, we would learn missing details.

It was eighteen minutes past midnight Moscow time on February 21, 1969. Russia's cosmonauts watched in awe and hope as thirty rocket engines lit as one. The monster blasted from its launch pad with a roiling sea of flame larger than Times Square. It sent fire whipping across land and steel and concrete as it rose on ten milliom pounds of thrust, nearly twice the power of *Saturn V*, but as it cleared its huge support tower, engines number 12 and 14 "went dark."

Still the monster kept climbing, right on course with twenty-eight remaining engines, and when the largest rocket ever reached Max Q, the maximum external forces on N–1's structure, all engines throttled back to take it easy through the "shock barrier."

That worked. And now, sixty-six second into the flight, it was time to throttle back up to full power. But instead of an expected smooth throttle back up to maximum thrust, the increased power began tearing things apart. N–1 shuddered and rattled so violently it ripped open

its fuel tanks. Instantly, fire began eating the giant. Computers began shutting everything down as fire spread faster and faster, and then, the mother of all rockets tore itself into millions of burning pieces in the most gigantic explosion of any vehicle ever built.

The sky above Kazakhstan burned. The night gave way to a shimmering orange daylight over the steppes before it began raining fiery debris with blazing chunks of burning rocket tumbling earthward.

The Russian managers watching felt no need to speak of the obvious. It would now take a miracle to keep Russia in the race.

N ASA's senior managers were made aware of the N-1's demise, and time was now surely on their side. Deke Slayton got on with the job of picking the astronauts for the first landing attempt. The normal rotation of crews was playing right in his hands. The way it was working out, Neil Armstrong would command *Apollo 11* and Pete Conrad would be at the helm of *Apollo 12*. Deke had long ago made the decision to have either Neil or Pete land the first lunar module on the moon.

Neil was learned, experienced, and had the moxie to get out of a harrowing situation. As NASA's own test pilot, he had survived potential tragedies time and again. *Apollo 11* would get the first shot, but the odds were very high something would go wrong and *11* would have to abort. Deke realized there was no other feasible plan, and he called Neil Armstrong and crew into a private room.

"I'll get right to the point," he said. "Because of *Apollo 8*'s success, we're now on an ambitious schedule. There will be two more test flights and then a landing will be attempted with you guys—with *Apollo 11*."

Buzz Aldrin and Mike Collins grinned like Tennessee mules eating briars. The stoic Armstrong, a devotee of Zeno who was unmoved by joy or grief, stood without expression. Armstrong's lack of reaction to the news was what Deke expected, but he also knew Neil was pleased.

"You're it, guys," Deke told them again. "That is, of course, *if* we pull off successful missions with nine and ten."

If was the operative word.

The first *if* on the runway was to fly that buglike creature called the

lunar module, or LM. Its job was to take two members of the three-astronaut crew down to the lunar surface, serve as the moonwalkers' home base, and then bring them back to the command ship in lunar orbit. It would be *Apollo 9*'s job to take the LM into Earth orbit and see if it could fly.

And *if Apollo 9* did its job, there was *Apollo 10*. It had to pull off a full dress rehearsal. It had to fly the Apollo command ship, the service module, and the LM linked together into moon orbit, then undock the LM from the command ship and fly it to within nine miles of the lunar landscape. From there they would return to dock again with the *Apollo 10* command module for their flight home.

Deke really didn't see any way of avoiding all the potential pitfalls. But, if the job were to get done, it would be like eating an elephant, one bite at a time.

Highway to the Moon

I t appeared to be from another world. Certainly not a vehicle a sane person would ride in. It was covered in gold aluminum foil, and with its bristling antennas and four spidery legs, it looked like something out of a Japanese monster movie.

In fact, it was the first true spacecraft. It was Apollo's lunar module, and it could operate only in space. Returning through Earth's atmosphere, it would burn to a cinder.

Five days after *Apollo 9* slipped into Earth orbit, commander Jim McDivitt and crew members Dave Scott and Rusty Schweickart opened hatches in the docking tunnel that linked the Apollo to the LM. McDivitt and Schweickart drifted through the tunnel and sealed themselves off from Dave Scott in the command module. Scott's job was to keep *Apollo 9*'s systems purring and wait for the LM flyers to return.

McDivitt and Schweickart ran down the lunar module's checklists, made sure every system was ready, and then undocked the ugly vessel, becoming the first to fly a craft designed to fly only in the vacuum of space. The astronauts had to fly the LM back to the Apollo command ship if they wanted a ride home.

Now, with two individual craft in space, NASA had to chuck one of

its useless rules—naming spaceships. Flight controllers needed names for transmission clarity. The *Apollo 9* crew decided to call the LM what it looked like, *Spider*, and the cone-shaped command module *Gumdrop*. The kids liked that one.

First on *Spider*'s flight plan was the testing of its rocket thrusters, and they fired and spat out the amount of thrust asked for, and McDivitt and Schweickart knew they had a winner. They then set *Spider*'s maneuvering rockets for a distance burn. The thrusters burned for the time needed to take them to a point 113 miles away from Scott and the command ship.

There, they were truly alone, ready for the highlight of the lunar module's test—the "break apart" of *Spider*'s two stages. The bottom part of the lunar module was the descent stage. It would be used to lower astronauts onto the moon's surface. Then, when the astronauts were ready to leave, the top part, the ascent stage, would be ignited to return its crew to a rendezvous with the command ship in lunar orbit.

McDivitt and Schweickart triggered the ascent engine, leaving the descent stage with *Spider*'s landing legs behind, and they executed the series of maneuvers needed to make the trip from the lunar surface to the orbiting Apollo command ship. *Spider* proved to be a good little ship. It flew with precision and nudged itself up to astronaut Dave Scott and his command ship. "You're the biggest, friendliest, funniest-looking spider I've ever seen," he told the two astronauts docking for their ride home.

March turned into April, and April turned into May, and *Charlie Brown* and *Snoopy*, the lunar ships of *Apollo 10*, eased into the unfiltered sunlight piercing the moon's black sky. They were circling the lunar surface to perfect navigating to and from future landing sites. The Sea of Tranquility, so named by ancient astronomers who thought it to be a smooth body of water, was the main target.

John Young was the pilot of the big command module *Charlie Brown*. And when commander Tom Stafford and Gene Cernan drifted away in the lunar module *Snoopy* for its vital test, Young was all too aware that

his ship was the only ticket home his two friends had. Make a mistake, and he'd be returning home alone.

Young triggered a burst from *Charlie Brown*'s maneuvering rockets and pulled away. Inside *Snoopy*, Stafford and Cernan saw the command ship leaving, and they held tight for a moment, watching it shrink into the distance.

"Have a good time while we're gone, babe," Cernan radioed a goodbye to Young.

Stafford keyed his mike. "Don't get lonesome out there, John."

Cernan added, "Don't accept any TEI updates."

TEI stood for Trans Earth Insertion, the computer commands Young would need to blast out of lunar orbit and head home.

The command module pilot laughed. "Don't you worry, *Charlie Brown* wouldn't think of leaving without you."

The banter was fighter-pilot stuff.

The two ships kept drifting apart over the craters and lunar mountains, and then, an hour later, on the backside of the moon, it was time to fire the descent engine that would send *Snoopy* on its rocket-control approach to the lunar landscape. The moon was blocking radio contact and Mission Control was going through another bout of nail-biting as the astronauts were moving through critical moves out of touch. But not for long. Suddenly, we heard the excited voice of John Young from *Charlie Brown*. "They are down there," he told flight controllers. "They are among the rocks, rambling through the boulders."

My co-anchor, Russ Ward, and I were on the air, live from the NBC Broadcast Studio atop the Nassau Bay Hotel across the street from Mission Control. We were feeding every word from lunar orbit to our anxious listeners. We had flown to Houston minutes after *Apollo 10* blasted onto its Trans Lunar Insertion flight course to the moon, and when the astronauts spoke we would shut up. *Snoopy* came around the moon and an excited Tom Stafford said, "There are enough boulders around here to fill up Galveston Bay. It's a fascinating sight. Okay, we're coming up over the landing site. There are plenty of holes there. The surface is actually very smooth, like a very wet clay—with the exception of the big craters."

Gene Cernan hopped in with unrestrained excitement. "We're right

there! We're right over it!" he shouted as *Snoopy* raced moonward to within its planned nine miles above the Sea of Tranquility. "I'm telling you, we are low, we are close, babe!"

Stafford's voice followed, equally excited. "All you have to do is put your tail wheel down and we're there!"

This was exciting stuff. Jim Holton, our senior producer, held up a sign he had written: "Stay with this! No sign offs!" And we did—filling in live the details of the astronauts racing through lunar orbit, flying upside down and backward. Then it was time for the critical dismembering of *Snoopy*—separating the lunar module so the legless upper portion would return them to *Charlie Brown*. The procedure would begin with casting off *Snoopy*'s descent stage by firing a set of pyrotechnic bolts. We held our collective breaths, and astronaut Cernan issued a warning. "That mother may give us a kick. You ready?" he asked Stafford as he fired the bolts, only to see everything before him instantly spinning wildly. "Sonofabitch!" he cursed on our worldwide broadcast. "What the hell happened?"

Cernan's curse sent instant alarm through Mission Control, and Stafford punched the button to get rid of the descent stage. Eight long seconds later Stafford regained control, and *Snoopy* was still.

Stafford and Cernan took a few deep breaths, and ten minutes later, in darkness, the two astronauts triggered the ascent engine and began their journey back to John Young. They rose in a closing maneuver to dock with *Charlie Brown*, and Stafford reported, *"Snoopy* and *Charlie Brown* are hugging each other."

Back on Earth, Neil Armstrong, Michael Collins, and Buzz Aldrin were in final training. The success of *Apollo 10* meant all but one of the *ifs* had been blown away. Only landing remained. Millions began gathering on the beaches and roadways around America's newly built moonport. A site with a clear view of the Apollo launch pad was a premium location. There wasn't a room to be had in central Florida. It had come down to private families renting sofas, cots, and spare rooms to the hucksters, well-wishers, and complainers.

The NBC phones kept ringing and callers kept complaining. One was certain the launch would bring about the end of the world, while another was convinced his chickens would stop laying eggs and his cows would stop giving milk and wanted to know who would pay, and a third offered his sixteen-year-old virgin daughter to me if I could get him a seat on the rocket to the moon.

My good wife Jo took a breath and then took care of the situation. She snatched the phones out of the walls and when I went to work, she went along. Her job was to deal with the cranks. She would be nice and syrupy and most of all understanding.

My friend Jack King wasn't faring any better.

A President Kennedy look-alike, from Boston no less, Jack was the Associated Press reporter here at the Cape in the early days. But, within months, he proved to be a traitor. He jumped fence and went to work for the enemy. He was the first public-affairs officer at the Cape for the newly created NASA, and eleven years later, when *Apollo 11* was on the pad, he was NASA's news chief.

And to say he was in demand was the classic understatement. Every reporter wanted a piece of Jack.

And home offered no shelter. Jack's young son Chip had plans for his dad, too. He wanted to make a couple of fast bucks. Chip would charge neighborhood kids a quarter each to hear his dad, the voice of Launch Control, do a countdown. Jack would try to catch a fast nap on the living-room sofa only to be awakened surrounded by nine-year-olds waiting for him to say, "We have a liftoff."

On the morning of July 16, 1969, for Jack King, it was all about going to the moon. As the voice of Launch Control, he was putting out the word:

After a breakfast of orange juice, steaks, scrambled eggs, toast and coffee, the astronauts boarded *Apollo 11* at 6:54 A.M. Eastern time. Commander Neil Armstrong was the first aboard. He was followed by Mike Collins. Buzz Aldrin, the man who is sitting in the middle seat during liftoff, was the third to come aboard . . .

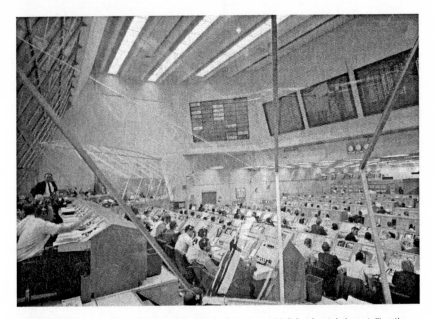

NASA's voice of Launch Control Jack King, seated on the end left forefront, is busy telling the world the latest news on Apollo 11's countdown. King is in Apollo Launch Control with some three hundred members of the launch team July 16, 1969. (NASA).

The countdown was running on time as a million-plus people were pressing the gates and fences of the Kennedy Space Center, trying to see anything and everything.

Three hundred technicians and controllers were running the countdown in Launch Control. Hundreds more worked through the count at Mission Control in Houston. Thousands of other men and women were on duty at tracking stations around the world, aboard tracking ships at sea, and in tracking aircraft in the sky.

In our NBC house-trailer complex at Press Site 39 on the Cape, I had already been voicing reports for two solid days, sleeping on a cot in the studios that had long ago gotten too crowded with Hollywood stars, sports figures, and NBC bigwigs.

I was seated at my microphone with a perfect view through a wall-wide window. *Apollo 11*, atop its *Saturn V*, was only three miles away, being bathed by an early-morning sun. The countdown kept ticking along, and my colleague Russ Ward was moving to his microphone to

give me a break when I felt a finger tap me on the shoulder. A hesitant, stuttering voice asked, "Is it, ahh . . . is it okay if we watch from here?"

I turned. Jimmy Stewart and his wife, Gloria, were standing behind me, smiling pleasantly.

I came to my feet with instant respect. "Mr. Stewart," I said, "you and your dear wife may stand anywhere you wish."

He thanked me, they both smiled, and I had to turn my attention back to the business at hand. I often wondered what it would have been like to visit with the Stewarts for a moment, but the countdown was entering the serious stage and we were on the air nonstop.

"This is Apollo/Saturn Launch Control. We are now less than sixteen minutes away from the planned liftoff for the Apollo 11 space vehicle. All still going well . . ."

The count sailed smoothly down through arming the escape system. Range safety went to "green all the way." Launch Control tested the systems for power transfer to the *Saturn V.* The lunar module named *Eagle* was now alive on its own internal power.

"This is Apollo/Saturn Launch Control. We've passed the eleven-minute mark. All is still GO."

Ten minutes. Armstrong, Collins, and Aldrin's command ship, *Columbia,* was now on its own power systems, and the massive crowd of a million-plus tensed as one.

"This is Apollo/Saturn Launch Control." Jack King's voice was now musical. *"We've passed the six-minute mark in our countdown for Apollo 11. Now five minutes, fifty-two seconds and counting. We're on time at the present for our planned liftoff at thirty-two minutes past the hour."*

The launch team armed the destruct system, and the access walkway leading to the astronauts and their ship *Columbia* swung back out of the way.

"This is Apollo/Saturn Launch Control. T-minus three minutes ten seconds. Apollo 11 is now on its automatic sequencer . . ."

The long-awaited "initiate firing command" had just slipped the rest of the countdown into computers.

"This is Apollo/Saturn Launch Control. We're GO. The target for the Apollo 11 astronauts, the moon, will be 218,096 miles away at liftoff . . ."

T-minus fifty seconds. *Saturn V* went to full internal power. The dragon was stirring. Butterflies swirled deep in Armstrong, Collins, and Aldrin.

"This is Apollo/Saturn Launch Control," Jack King was now singing. *"Neil Armstrong just reported back. It's been a real smooth countdown.*

"Our transfer is completed on an internal power with the launch vehicle. All the second- stage tanks now pressurized.

"Thirty-five seconds and counting. Astronauts reported, feels good.

"T-minus twenty-five seconds.

"Twenty seconds and counting.

"T-minus fifteen seconds, guidance is internal, twelve, eleven, ten, nine, ignition sequence starts."

Far below Armstrong, Collins, and Aldrin, a torrent appeared instantly, exploding beneath the five mighty engines of the first stage. Twenty-eight thousand gallons of water smashing into curving flame buckets to absorb the mighty rocket's fire.

Apollo 11's Saturn V roared to life, but it was anchored to its launch pad by huge hold-down arms, chaining it to Earth until computers judged it was howling with full energy.

"SIX, FIVE, FOUR . . ."

And chunks and sheets and flakes of ice fell steadily from the coatings formed by the super-cold oxidizers and propellants on the huge fuel tanks. *Apollo 11* was ready to leave, *Saturn V*'s mighty engines were screaming, *get the hell outta the way. . .*

" THREE, TWO, ONE, ZERO, all engines running, LIFTOFF. We have a liftoff, thirty-two minutes past the hour. Liftoff of Apollo 11. *Tower cleared."*

The astronauts felt a gentle sense of motion, but it wasn't that way outside.

The earth shook. It shook for all to feel, and in a firestorm of flame and crackling thunder *Apollo 11* began its journey. Birds flew for safety, wildlife fled for shelter, and *Apollo 11's Saturn V* slammed shock waves into the chests of the million-plus pressed against the moonport's fences and gates. Suddenly their teeth were rattling and their skin and clothes were fluttering. They were forced to lean into the powering wave of

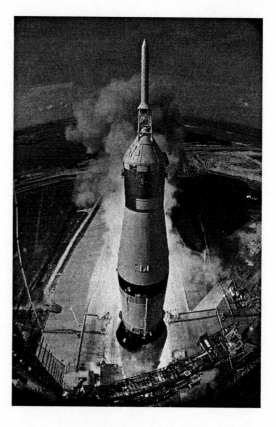

From atop its gantry, Apollo 11 *is seen beginning its journey to the moon. (NASA).*

thundering air now splitting the launch center. *Saturn V* had in fact created its own earthquake. It generated seven-and-a-half million pounds of thundering energy and headed skyward on its hunt for the moon.

Inside our NBC broadcast studio, Russ Ward and I thought the walls and ceiling would crash onto our shoulders, but the shaking building held and we kept shouting into our microphones and Gloria and Jimmy Stewart screamed and hollered along with all the people now crowding our wall-wide window for the best view.

Apollo 11 pushed through Max Q while below, the million-plus crowd was seeing a river of fire eight hundred feet long. The energy trail *Saturn V* left in the thin atmosphere created shock waves that danced in ghostly displays.

Inside *Columbia,* Armstrong and crew were standing by for the

"train wreck." At this point, the forces of gravity had them weighing four times what they did at launch. The five big rocket engines that made up the first stage had compressed the Saturn's three stages and Apollo's two stages like an accordion. But those mighty engines were shutting down. The sudden cutoff threw the three astronauts forward in their seats. The accordion stretched out and then compressed again, and then the astronauts heard metallic bangs and a mixture of clunks and clangs as explosive bolts blew away the now empty stage. They were forty miles high and sixty miles down range, climbing faster than six thousand miles an hour, and they heard more bangs and clangs from the second stage below as ullage rockets fired to settle the propellants in their tanks. Then, the second stage lit off and kicked the astronauts back in their seats with the new increase in acceleration.

The second stage burned and burned and once eleven minutes had passed, *Apollo 11*'s astronauts were 115 miles high, moving faster and faster, when the second stage emptied its tanks and went silent. Again the moon-bound crew snapped forward in their harnesses, only to be pushed back again as the third stage lit.

Two minutes later, the third stage shut down and the mooncraft raced around Earth at 17,300 miles per hour. Mike Collins and Buzz Aldrin exchanged broad grins and Neil Armstrong released his harness.

For the next two-and-a-half hours *Apollo 11*, still attached to its third stage, circled Earth with its crew taking the pulse and status of all its systems, the ones the astronauts would need to reach the lunar surface. Then, the words they wanted most to hear came up from Mission Control: "*Apollo 11*, you're go for trans-lunar injection."

That was it, boy. TLI. Trans-lunar injection, their tickets to the moon. Aldrin and Collins held up gloved thumbs in celebration. They ran through a final checklist and once again lit the fire. The third stage reignited, hurling back a magnificent plume of violet flame.

When they reached the speed needed to break free from Earth's gravity, 24,200 miles per hour, they were on their way.

They were grinning like kids in a down-home swimming-hole. Even Armstrong.

The Landing

N eil Armstrong and Buzz Aldrin stared through their helmet visors in wonder, mesmerized by the lifeless face of the moon rushing toward them. They were in their landing craft *Eagle*, standing with booted feet spread slightly. Each astronaut was sealed within the protective layers of his personal, pressurized spacesuit and helmet.

Flying backward with their bodies tipped toward the silent lunar surface below, they would soon fire the rocket in the descent stage beneath their feet. They would be aiming for a touchdown on a waterless ocean named the Sea of Tranquility.

Back on Earth, near a city called Houston, a fellow astronaut named Charlie Duke listened to the astronauts' chatter and the reports of those manning the consoles around him. As CapCom, he studied each bit of critical information coming into and going out of Mission Control while across the street, I was on my microphone in the NBC studio. We were putting every word between *Eagle* and Mission Control on the air—live. It wasn't as if we didn't know what to do. Hell, we had been getting ready for this for years. We weren't about to muck around with the most historic event of the twentieth century by interrupting it with our own mouthings. We wanted every word, every event, every touch on the moon live on the sixteen NBC worldwide networks.

"*Eagle*, Houston," Charlie Duke's voice shot across space at the speed of light, 186,300 miles per second. "If you read, you're GO for powered descent."

At that precise second, *Apollo 11*'s lunar module was coming around from the backside of the moon, where its receiving antennas had been blocked for twenty-two minutes.

Armstrong and Aldrin were not alone up there. Their crewmate, Michael Collins, was fifty miles out in front of them, orbiting the moon in their command ship, *Columbia*. Collins had heard the vital message clearly.

"*Eagle*, this is *Columbia*." His words flashed instantly into the spacesuit helmets worn by Armstrong and Aldrin. "They just gave you a GO for powered descent."

"Roger," Armstrong acknowledged.

The two men glanced at each other and instinctively tugged at the cinches of their body harness. They were ready to go land on the moon as green-bright digits changed constantly before them, numbers flashing on *Eagle*'s flight panel in a breathless blur.

This was PDI!

Powered descent initiate.

On Earth, billions prayed.

Neil Armstrong and Buzz Aldrin braced themselves for the shock of ignition.

Flame gushed beneath their feet. Inside *Eagle* the two astronauts, who had been weightless for four days, were once again in a gravity field. Their arms sagged. Legs settled within their suits. Feet pressed downward in their boots.

Eagle was in full power, blasting away weight and mass, slowing, slowing.

Headsets crackled. Mission Control was calling. "*Eagle*, Houston. You are GO. Take it all at four minutes. You are GO to continue powered descent."

But all was not well.

Back on Earth, Mission Control was thick with tension.

Those manning the front row of consoles were in what was known as the "trench." This was where final decisions were made.

Eyes were on a twenty-six-year-old computer master named Steve Bales. During a mission he was GUIDO, the acronym for guidance officer.

Today, Bales had come to work early. It could be the most important, demanding, and exciting day of his life. And he knew that twenty-four-year-old Jack Garman was in the back room. Both were experts on the lunar module's onboard computers.

Deep within the bowels of *Eagle*, these essential computers measured all the electronic and mechanical forces needed to reach the lunar surface safely. And every flight controller in Mission Control knew these computers contained sensitive watchdogs—alarm systems to detect anything wrong.

Bales and Garman were familiar with each of those alarms and what they meant, and at the moment, everything they monitored aboard *Eagle* was green and go.

Then, within a flash, *Eagle*'s computers shrilled madly.

Alarm!

"Program alarm!" Buzz Aldrin shouted the warning. "It's a twelve-oh-two."

Twelve-oh-two. A warning that the lunar module's main computer was overloaded. So much was happening and so quickly, so many performance signals were being generated, that the computer could not absorb them all.

In Mission Control everyone sensed an abort.

All eyes were on Steve Bales.

He stared at his console. Coded numbers told him instantly what was going wrong. He needed confirmation that his identification of the problem was correct and safe for Armstrong and Aldrin.

Bales called Garman in the back room. "It's executive overflow," Garman assured him. "If it does not occur again, we're fine."

Bales agreed, and he judged *Eagle*'s main computer was doing its job.

He keyed his mike. "GO!" he shouted.

Charlie Duke showed surprise. "We've got, uh, we're GO on that alarm, *Eagle.*"

The beat speeded up.

Armstrong and Aldrin were four thousand feet above the moon. Flight director Gene Kranz opened his mike. "All right, you guys. It's coming up on GO, or NO GO for landing. What's it going to be?"

Every flight controller in the trenches responded with "GO."

Charlie Duke called the American craft descending on the moon. "*Eagle*, you're GO for landing."

Three thousand feet up, another alarm rang in *Eagle*'s cabin. Steve Bales made an immediate judgment. Another "executive overflow."

"You're GO," Charlie Duke told them.

Two thousand feet high, craters growing larger and larger below, and Neil called it out again: "Twelve-oh-one alarm."

"What about it, GUIDO?" Flight Director Kranz shouted.

Director of crew operations Deke Slayton locked eyes with Steve Bales. The computer master read confidence in that look.

"GO!" Bales snapped. "Just GO!"

Charlie Duke looked at Slayton. Deke grinned and turned his right thumb upward with a quick, firm, stabbing motion.

Duke keyed his mike and swallowed hard. "We're GO, *Eagle*. Hang tight, we're GO . . ."

Inside our NBC broadcast studio, Russ Ward and I were hanging onto every word. No sooner than *Apollo 11* had headed for the moon, we left the Cape on a National Airlines charter for Houston.

Now, *Eagle* was thirteen hundred feet above the lunar surface, beginning its final descent. Flames gushed downward as the craft slowed. Neil Armstrong had flown his mission right along the edge of the razor. He and Buzz were now so close that Neil had to *fly* this ship. He punched PROCEED into his keyboard. The computer would handle the immediate descent tasks. Buzz would back up both man and electronic brain so Neil could switch his eyes and senses to flying in vacuum.

Both men looked through triangular windows to study the surface of

the moon. They'd made simulated runs so many times, they knew their intended landing site as well as familiar airfields back home. Almost immediately they noticed that they weren't where they were supposed to be.

Damn!

Eagle had overshot the landing zone and Neil scowled at the surface rising toward them. Boulders surrounded a yawning crater wider than a football field, and *Eagle* was running out of fuel and headed straight for it. There was no time to waste.

In the lunar void there was no gliding to conserve fuel. *Eagle* was only dead weight in a vacuum. There also was no opportunity to orbit again for another try at landing.

Eagle was sailing down at twenty feet per second. Neil nudged the power, slowing to nine feet per second. He attuned his senses to the rocking motions, the nudges and skidding motions of the sixteen small positioning thrusters that kept *Eagle* aligned through its descent.

Mission Control listened, mesmerized and awed, to the voices closing in on lunar soil. Neil guided his bird without wings. Buzz watched the landing radar and called out numbers that bespoke volumes of split-second judgment and maneuvering.

Eagle was now in a directed hovering mode. There was no place to land. Rocks, huge boulders, and deadly craters were strewn everywhere.

Mission Control was dead silent.

Neil fired *Eagle*'s right bank of maneuvering thrusters, and the lunar module scooted across rubble billions of years old.

There!

There beyond a field of boulders, slightly to the left, the rocks were fewer, revealing a smooth, flat area. That's it, Neil assured himself. That's our new Home Plate.

The numbers ghosted back to Earth.

"Five-and-a-half down . . . five percent . . . seventy-five down . . . six forward . . . ninety seconds," Buzz chanted. "Ninety seconds."

Aldrin had been carefully watching the fuel gage, as had Mission

Control. Ninety seconds of fuel left in their tanks for the descent. *Eagle* needed to land in ninety seconds, or—

No one wanted to think about it. If their engine gulped its last surge of fuel before they touched down, this close to the moon, they would crash, but Neil didn't bother with if's and could-be's. He could *feel* what fuel they had left. His eyes and mind and hands worked beautifully in orchestrated skill. He would bring *Eagle* down and bring her down level.

It would not be easy. *Eagle* was now top heavy, the ascent stage still crammed with fuel, the tanks of the descent stage perilously close to empty.

Charlie Duke sounded the warning. "Sixty seconds."

In sixty short seconds, the rocket power flaming beneath *Eagle* would burn out. The tanks would be empty. An abort would need to be initiated seconds before that happened if *Eagle* was not to crash.

Balancing on slashing flames and banging thrusters, Neil Armstrong calmly aimed for his new landing site.

The flight controllers were almost frantic with their inability to do anything more to aid Neil and Buzz.

"Light's on."

This time the announcement was from Buzz as he watched an amber light blink balefully at him from the master caution-and-warning panel. It was the low-fuel signal. Buzz eyed another button, half afraid he might have to punch it. It read ABORT STAGE.

Neal didn't respond. There was no time. All his senses were brought to needlepoint sharpness.

Buzz intoned the numbers like a priest, steady and clear, voicing the final moments flashing away. He had confidence in Neil's ability. But his hand did not stray far from the ABORT STAGE button.

"Seventy-five feet," he called out.

"Six forward . . .

"Light's on . . . down two-and-a-half . . . forty feet, down two-and-a-half . . ."

Time was the enemy.

"Thirty feet . . .

"Two-and-a-half down . . ."

Then the magic words!

"Kicking up some dust . . .

"Faint shadow . . ."

So close now! So close!

There was no turning back! The door behind Armstrong and Aldrin had closed.

"Four forward . . .

"Drifting to the right a little . . ."

In our NBC studio all was silent. Russ Ward and I did not dare interrupt the voices coming from the moon. The landing was live on NBC's sixteen networks spread around the planet. If it were possible for hearts to stop beating and for humans to still live, we would have done it.

Then these words from Buzz Aldrin . . . "Contact light!"

"Okay, engine stop . . . descent engine command override off . . ."

On Earth, billions of hearts pounded madly.

In Mission Control, Charlie Duke was choking . . . He still needed voice confirmation. He wanted to hear the words.

"We copy you down, *Eagle*," he radioed, and began waiting all over again.

Three seconds for the voices to rush back and forth, Earth to moon and moon back to Earth.

"Houston . . ."

Neil Armstrong had landed so smoothly that Buzz wasn't taking any chances. Were they really down? Stopped? Buzz studied the lights on the landing panel to be certain.

Four lights gleamed brightly. Four marvelous lights were welcoming them to another world where no human being had ever been.

Neil allowed himself the luxury of a long, deep breath as he stared through his helmet visor at the alien world before him. He was surprised at how quickly the dust hurled away by the final thrust of the en-

gine had settled back on the surface. Within seconds, the moon looked as if it had never been disturbed. He keyed his mike. "Houston, Tranquility Base here. The *Eagle* has landed."

Charlie Duke spoke above the bedlam of cheering and applause in Mission Control.

"Roger, Tranquility. We copy you on the ground. You've got a bunch of guys about to turn blue. We're breathing again. Thanks a lot."

It was 4:17:42 P.M. EDT, Sunday, July 20, 1969, eight years after President John F. Kennedy had promised to send astronauts to the moon before the end of the 1960s.

Silently, Buzz and Neil saluted him.

Moon Walk

Neil Armstrong moved slowly and purposefully down the ladder. He was in no hurry. He would be stepping onto a small world that had never been touched by life. A landscape where no leaf had ever drifted, no insect had ever scurried, where no blade of green had ever waved, where even the raging fury of a thermonuclear blast would sound no louder than a falling snowflake.

A quarter-of-a-million miles away billions of eyes were transfixed on black-and-white televisions. They were watching this ghostly figure moving phantom-like, closer and closer, and then, three-and-a-half feet above the moon's surface, jump off the ladder. Neil Armstrong's boots hit the moon at 10:56 P.M. Eastern time, July 20, 1969.

All motion stopped. He spoke: *"That's one small step for a man—one giant leap for mankind."*

Lunar module pilot Buzz Aldrin stayed aboard *Eagle* to keep watch on all of the lander's systems. The LM was Aldrin's responsibility, and as soon as it was safe for Buzz to leave *Eagle,* he came down the ladder and joined Armstrong on the surface.

"Beautiful, beautiful! Magnificent desolation," Aldrin said with feeling as he stared at a sky that was the darkest of blacks. No blue. No green. No birds flying across an airless landscape. There were many

shades of gray and areas of utter black where rocks cast their shadows from an unfiltered sun, but no real color. And there was the lack of gravity. They seemed to weigh a little more than nothing. In spite of their cumbersome spacesuits, both astronauts found moving about in the one-sixth gravity exhilarating and described the experience as floating.

"We're like two bug-eyed boys in a candy store," Neil laughed before starting out to explore. He and Buzz wanted to experiment with the moon's lightweight gravity. They wanted to run and make leaps that would be impossible to do on Earth, where they would weigh 360 pounds with their suits and life-support backpacks. On the moon, in its one-sixth gravity, they weighed only sixty pounds, but they still possessed body mass that restricted their ability to move. If they started to jog, the mass and velocity created kinetic energy and stopping quickly was impossible. They soon discovered "bunny hops" in the suits worked well.

"The surface is fine and powdery," Neil reported to the scientists in Mission Control's back room. "It adheres in fine layers, like powdered charcoal, to the soles and sides of my boots. I only go in a fraction of an inch, maybe an eighth of an inch, but I can see the footprints of my boots and the treads in the fine, sandy particles."

Neil gathered several ounces of lunar surface material in a plastic bag and stuffed it into a suit pocket. The plan was for them to remain outside two hours, planting experiments and collecting lunar soil and rocks, but if something should go wrong, at least they would have a few ounces of the moon that would be invaluable for research back on Earth. So he took a slow look around the moon's surface and continued his report. Those on Earth hung onto every word. "It has a very stark beauty all its own," Neil said slowly. "It's like much of the high desert areas of the United States. It's different, but it's pretty out here."

He then turned and looked for Earth, the true oasis of shifting colors in their solar system. It appeared far larger from the moon than did the moon from Earth. And it was many times brighter. Sunlight made it so by splashing off the bright clouds and blue oceans. It was hope. It was the warmest port in this corner of the universe.

Neil Armstrong lowered his head. There was so much to see and do and so little time. He and Buzz moved their television camera sixty feet from *Eagle*. This would help Earth's viewers see some of the things they were seeing and it let them watch Neil and Buzz going about the business of setting up *Apollo 11*'s experiments.

The two astronauts had problems jamming a pole into the lunar surface to hold the American flag. Though a metal rod held the flag extended, the subsurface soil was so hard they could barely get the pole to remain erect. But once they did, Old Glory stood perfectly.

Armstrong and Aldrin then set up a seismometer to gather information on quakes and meteorites hitting the lunar surface. An instrument to measure the flow of radiation particles inside the solar wind and a multi-mirror target for returning laser beams fired from Earth were deployed—laser reflectors that would not only be used by American scientists, but Russian and other global investigators as well.

In the lunar dust they placed mementos for the five astronauts and cosmonauts who had lost their lives, and Neil Armstrong read the words on a plaque mounted on *Apollo 11*'s descent stage: "Here men from the

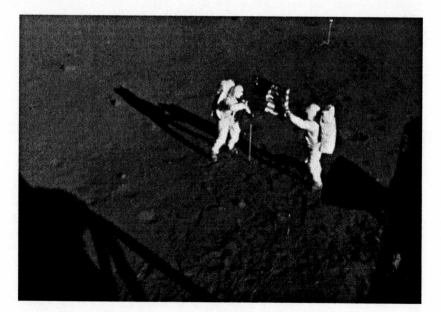

Neil Armstrong and Buzz Aldrin plant the American flag on the moon. (NASA).

planet Earth first set foot upon the moon, July 1969, A.D. We came in peace for all mankind."

The two astronauts gathered fifty pounds of lunar soil samples and rocks, and once everything was loaded for the flight back to Earth, they shut down the first moonwalk.

Twenty-one hours after Neil Armstrong and Buzz Aldrin landed on the lunar surface, they fired *Eagle's* ascent engine and left the moon.

They saw the first American flag deployed on the lunar landscape toppled by the rocket's blast. That was all the time the astronauts had for sightseeing. They had to man *Eagle's* controls and computers and radar systems for the three-and-a-half-hour trip needed to reach Michael Collins and *Columbia* orbiting sixty miles overhead.

Armstrong and Aldrin flew *Eagle* precisely down the route pioneered by *Apollo 10's Snoopy* two months earlier and, as steady as a rock, linked up with *Columbia*. After they moved their lunar booty into the command ship, they discarded their faithful *Eagle*, leaving it to orbit the moon for several weeks before lunar gravity pulled it into a crash landing.

It would take two-and-a-half days to make the return trip home, but Neil, Buzz, and Michael knew the way. All they had to do was follow the trail locked in the computers by Frank, Jim, Bill, Tom, Gene, and John—the astronauts of *Apollos 8* and *10*.

Back on Earth, the uncontrolled celebrations began.

Apollo 11's splashdown parties set a record.

In fact, the parties quickly grew into one that covered all the communities in and around Mission Control, and when they were finally over, Houston had to lend the small towns a fleet of garbage trucks to haul away the mess.

NBC's Chet Huntley, America's number-one and most-loved television news anchor of the day, was one of the warmest and most considerate people you could meet until he decided to take a drink. Then Chet

would change from this fatherly, lovable introvert to an "everything goes" extrovert.

During his very successful career (so I'm told), Huntley could be found pushing his stalled automobile through the streets of Miami's infamous Liberty City at 3:00 A.M., directing late-night traffic in the middle of the George Washington Bridge, or driving a hansom cab through Central Park with a governor and not his bride in the back.

On the night of *Apollo 11*'s great splashdown party, Chet and us folks from NBC partied hard. We partied down the streets, on the streets, across lawns, up stairs, on balconies, down stairs, through pasture lands, and in and out of all bars, and when we could no longer motor, Chet came up with a unique way of topping it all off. There had been much complaining about the talents of a piano player located poolside at our hotel, and when the last sour note was hit, Chet pushed piano and player in the pool.

Shad Northshield, NBC News's general manager, stood staring at the piano on the pool bottom as he watched the drenched musician climb out of the water.

"Whose expense account am I going to put this one on?" he asked no one, before wobbling away for the privacy of his room.

Tales of *Apollo 11*'s splashdown parties were the talk of most social events through the summer and into the fall until *Apollo 12*'s Pete Conrad, Alan Bean, and Dick Gordon set sail for the moon's Ocean of Storms on a wet November 14, 1969. NASA quickly learned that a thirty-six-story-tall *Saturn V* rocket climbing in rain clouds becomes a lightning generator.

I was standing under the launch on the NBC studio balcony, voicing a "radio on the scene" report. I was telling our listeners how I had just lost sight of *Apollo 12* in the clouds when the only lightning bolt of the day cracked across our location. It filled the small city of buildings, tents, trailers, trucks, and grandstands with rolling thunder, and it cut a jagged streak from the *Saturn V* to its launch pad. I stopped my broadcast on a dime for our listeners to hear commander Pete Conrad's report to Mission Control: "I think we got hit by lightning. We just lost the guidance platform gang. I don't know what happened here."

Tokyo, Japan: Heavy crowds and confetti greet the Apollo 11 *astronauts as they motorcade down the Ginza. The "Giant-Step-Apollo 11" Presidential Goodwill Tour took astronauts Neil Armstrong, Buzz Aldrin, and Michael Collins and their wives to twenty-four countries and twenty-seven cities in forty-five days. (NASA).*

Lightning had cracked against *Apollo 12*, tripping the spaceship's main circuit breakers. Inside the command module all electrical power went out, returning with a flight panel filled with flashing warning lights.

"We just had everything in the world drop out," Pete Conrad told the ground, and as the astronauts slid into Earth orbit, they worked with Mission Control to bring all of *Apollo 12*'s systems back on line. For the moment they were safe enough, but they had little more than two hours to get their ship back in the condition it needed to reach the moon. Few of us believed the second lunar-landing mission would ever leave Earth orbit. Every guidance, navigation, and computer system had to be reset with updated programs, and then validated by Mission Control.

The odds were definitely not in the *Apollo 12*'s favor, but we boarded a jet charter from the Cape to Houston and immediately began laying bets on the mission's demise. I sat across the aisle from Frank Borman,

the commander of *Apollo 8*, and he was convinced Pete Conrad, Alan Bean, and Dick Gordon would not see the moon on this trip.

About an hour into our flight to Houston, one of the pilots came back and spoke to astronaut Borman.

He leaned over and whispered loud enough for me to hear. "Colonel Borman, I have a message for you," he began. "Mission Control and *Apollo 12*'s crew have pulled off the impossible. They have all systems up and tested, and the third stage just fired. *Apollo 12* is outbound—it's headed for the moon."

Frank Borman threw his hands into the air, shouting, "They're on their way. *Twelve*'s up and running."

Everyone on board the charter shouted and yelled, and a tired bunch of reporters and astronauts and NASA officials had just one request: flight attendants, keep the booze coming.

The three navy commanders inside the command ship they had named *Yankee Clipper* sailed into orbit around the moon. Crew commander Pete Conrad planned to land within six hundred feet of an unmanned Surveyor robot that had touched down to scout the Ocean of Storms landing site thirty-one months before.

Conrad and Alan Bean had named their lunar module *Intrepid*, and the two naval aviators flew to the moon's surface with incredible accuracy. Conrad sat *Intrepid* down only a short walk from the Surveyor and Mission Control shouted, "Outstanding!"

Pete Conrad told those on the ground, "I can't wait to get outside! Those rocks have been waiting four-and-a-half billion years for us to come out and grab them. Holy cow, it's beautiful out there."

Astronauts Conrad and Bean took two four-hour walks from *Intrepid*, deploying scientific instruments and collecting seventy-five pounds of rocks and lunar-surface soil. They jogged down the slope to Surveyor, where they collected fifteen pounds of parts and pieces from the robot to return to Earth for study.

They were enjoying every moment of their stay, but Conrad had one complaint. The dust was getting into everything and during their rest

and sleep periods inside *Intrepid,* they remained in their suits to keep everything working.

Back for their second moonwalk, Conrad and Bean found the unexpected—a group of conical mounds, looking like . . . small volcanoes. They found green rocks and tan dust, and scientists back home were beyond pleased.

The two moonwalkers left the Ocean of Storms and made a perfect flight to hook up with Dick Gordon and *Yankee Clipper* for the return trip home. JFK's goal of landing astronauts on the moon and returning them safely to Earth before the decade of the 1960s was out had been achieved—twice.

The Successful Failure

Houston, we've got a problem!"

Inside Mission Control, flight controllers jumped to their feet.

"What the hell happened?" a voice called out. "The data's gone haywire!"

Shift manager Sy Liebergot was on it instantly. "Listen up," he ordered as he stared at the numbers on his monitor. "We've lost fuel cells 1 and 2 pressure, and we've lost oxygen tank 2 pressure and temperature."

Apollo 13 was built for deep space and only moments before, astronaut Jack Swigert had flipped a switch to "stir the soup," to activate tiny mixing paddles inside the liquid oxygen and hydrogen tanks. These super-cold liquids in *Apollo 13's* fuel cells kept its three astronauts supplied with breathing air, drinking water, and electricity for their weeklong mission.

Unknown to the astronauts and Mission Control, during the "stirring," two electrical wires had touched. A spark flashed. Fire raced toward the tank's oxygen supply. Internal pressure grew. The tank's dome blew as if it were a shotgun, blasting and shredding everything in its path.

Until that moment, fifty-five hours and fifty-five minutes since *Apollo 13* had launched from Cape Canaveral, the third mission to land two men on the moon had been uneventful—even boring. But when the left side of the service module exploded, the astronauts felt a sudden *bang!* Two hundred thousand miles out, all hell had broken loose. Linked together like a train, the three-unit *Apollo 13* assembly was rocked. The service module, the command module, and the lunar lander twisted and rolled through the debris field from the explosion while inside the command ship, Swigert contacted Mission Control. His words, "Houston, we've got a problem," put everyone on alert. Flight controllers took the temperature of *Apollo 13*'s life-support systems. Liquid oxygen had to remain at a critical 297 degrees below zero, and the liquid hydrogen tanks even colder, an unbelievable 423 degrees below, if the fuel cells were to continue supplying power and oxygen and water to the astronauts.

Apollo 13 continued its wild flight toward the moon. It looked as if the assembly of space vehicles could be breaking apart. The alarms wailed, the lights flashed while the crew and Mission Control clung to the belief that electrical glitches were causing the problems. No one wanted to believe *Apollo 13*'s astronauts were in mortal peril as the three quickly moved through their emergency list. They were resetting their cockpit's switches, adjusting proper instrument settings that had been sent spinning by the explosion, and they were expecting that once they had everything back in its proper place, back on line, all would be well.

They were wrong. When they completed their emergency list resets the alarms still wailed, the lights still flashed, and in the language of pilots everywhere, they told Mission Control, "No joy."

Apollo 13's assembly continued to pitch, roll, and moan like a sailing vessel being tossed by high waves. Commander Jim Lovell and his crewmates, Fred Haise and Jack Swigert, were not only concerned, they were puzzled. Thirteen minutes had passed since the jolting bang when Lovell looked outside, through a porthole. My God, he thought quietly as he stared at what could be a catastrophe.

"Houston," Lovell said quietly. "We're venting something out into the . . . into space."

Jim Lovell felt a knot tightening in his stomach—a familiar knot from years of hairy situations in test flight. He was 200,000 miles from home and the only tank that still held life-sustaining oxygen was draining itself into the black void. He was instantly aware that they had lost any hope of landing on the moon, and the immediate emergency was simply staying alive. His ship was in a circumlunar orbit—a figure-eight flight path around both Earth and the moon—and in this orbit, without a miracle, they would be marooned.

I f the crew of *Apollo 13* were to survive, experts on the ground had only hours to calculate and engineer a rescue.

Gene Kranz, the no-nonsense flight director who had landed Neil Armstrong and Buzz Aldrin on the moon, was in charge. He began by calming his shocked flight-control team. "Okay, now let's everybody keep cool," he said. "We've got the LM still attached. The LM is still good, so if we need it to get back home then let's solve the problem. Let's not make it worse by guessing."

Kranz had barely pulled his team together when the second oxygen tank on *Apollo 13* began to fail. It had been damaged in the explosion. The flight director told Lovell and his crew to start powering down the ship and reduce to an absolute minimum what they needed to survive. Then, he took a deep breath and paused for effect. "Two hours from now, unless we come up with something that's never been done before, those guys are going to be in a derelict ship," he told his team. "All they'll have left are three short-life batteries and their reserve oxygen supply. And we can't use them. They must save them for reentry."

Deke Slayton stared at Kranz. "If they get that damn far. Let's get this situation under control," Slayton shouted. "We're not losing this crew."

CapCom Jack Lousma turned for his mike, only to be stopped by the words coming in from Jack Swigert on board *Apollo 13*. "This is *Odyssey*, Houston. What's our oxygen status?"

"Oxygen is slowly going down to zero. We're starting to think about the LM as a lifeboat."

"That's something we're thinking about, too," Swigert fired back.

The lunar module named *Aquarius* was the only chance Lovell, Haise, and Swigert had. They had to shut down the command ship and put it into hibernation, so later on it could be brought back to life for reentry.

"*Odyssey*, this is Houston. It looks like we've got about eighteen minutes left. The last fuel cell is going fast."

Lovell and Haise pulled themselves through the docking tunnel connecting the two ships. The lunar module was built to land two astronauts on the moon safely and then, after a two-day stay, launch them for a rendezvous with the command ship. Under normal conditions the LM would be used for about forty hours. Somehow those forty-hour systems must be stretched to support not two, but three astronauts for four days, time needed to fly them around the moon and bring them back to Earth.

Swigert stayed behind in the dying *Apollo* while Lovell and Haise powered up the lunar module. One by one he shut down the *Apollo*'s systems. When the lights were off, he continued working by flashlight before he joined the others in the LM. Swigert transferred the precise alignment of the *Apollo*'s guidance platform to a similar guidance system within the lunar module. The guidance platform was a collection of gyroscopes and instruments needed to keep the spaceship aligned precisely with Earth and the moon—to keep *Apollo 13*'s location known to Mission Control every moment of the flight.

Even though *Apollo 13*'s crew would now be sustained by the lunar module, the astronauts would need to return to the cold, damp, hibernating command ship for food and bathroom facilities. It promised to be an uncomfortable ride.

Flight director Gene Kranz and his team decided to use the lunar-module descent engine for needed propulsion. They worked out a couple of rocket burns that should bring the *Apollo 13*'s crew safely home: "We'll go for a brief burn a few hours from now before they reach the moon. That will give them the free-return trajectory. Then

we'll do a second burn later to drop them into the slot for reentry. That should bring them home in four days."

Five hours and thirty-five minutes after *Apollo 13*'s service module blew away its left side, the astronauts fired off the lunar module's descent rocket for thirty-one seconds. The burn was perfect. "Okay, Houston. Burn's complete," Jim Lovell reported. "Now we have to talk about powering down."

The astronauts had more than enough oxygen to get home, but the carbon dioxide canisters needed to scrub the poison from the air they breathed was another question. They had to find a way to make the canisters in *Apollo* work in the lunar module for three or four days, or the two big guys would have to throw the little guy overboard.

They had more than enough carbon dioxide scrubbing canisters from *Apollo*, but they were square. They would not fit the round openings used on the LM.

Deke Slayton laughed. "What do you expect from a government contract?" he shouted. "Now damn it, let's do a little engineering here; let's rig it to where they'll all work together!"

Farm-boy Slayton led a group of engineers that came up with what they called "the Wisconsin dairy farm fix." Using only materials the astronauts had on board, they jerry-rigged a contraption that would use *Apollo 13*'s square canisters.

It worked. *Apollo 13* swept around the small world, disappearing behind its cratered surface. The crippled spaceship crossed the backside of the moon and when it emerged with its antennas pointing toward Mission Control, the astronauts were told by Houston to prepare for the lunar module's descent-rocket burn. This would be the long rocket firing, the one needed to get them home.

On any other flight, proper flight-course alignment would have been confirmed by using a space sextant to sight a suitable navigation star and feed data into the computer, which would verify that all was set to ignite the course-correction burn. But *Apollo 13* was on its way home in the midst of a cloud of trash left by the explosion. The trash was really a part of the *Apollo*/lunar module assembly that traveled along at the same speed.

"If a star wasn't visible, what about the sun?" Mission Control worked out the details. Before racing around the other side of the moon, the crew and ground controllers conducted a sun check and locked into the lunar module's guidance platform.

At two minutes and forty seconds before the burn, Houston Cap-Com Vance Brand radioed a voice check.

"Roger, we got you," Jim Lovell responded through a storm of air-to-ground static.

There was long silence, then Brand called, "One minute."

"Roger," Lovell acknowledged and returned to silence.

One minute passed, and Lovell reported, "We're burning forty percent."

"Houston copies."

"One hundred percent," Lovell announced, excitedly.

"Roger." Static roared full-blown into their headsets. "*Aquarius*, Houston. You're looking good."

The lunar module's descent rocket was at full thrust, and every person involved was holding his breath.

"*Aquarius*, you're still looking good at two minutes."

"Roger," Lovell answered.

"*Aquarius*, you're go at three minutes."

"Roger."

The life-saving rocket burn was just beautiful.

"*Aquarius*, ten seconds to go," reported Brand.

"Five, four, three, two, one."

"Shutdown!" Lovell smiled.

"Roger. Shutdown. Good burn, Jim," and the *Apollo 13* train chugged on.

The most major milestone of their uncertain flight was behind them. But cold and wet, their teeth chattering in the powered-down spacecraft they called the refrigerator, the astronauts of *Apollo 13* were lonely. Ahead were sixty-three uncomfortable hours of crossing the quarter-of-a-million-mile void. Even though each hour was getting them

closer and closer to home, Deke Slayton was becoming more and more concerned for the astronauts' emotional state. They were sleeping only in short catnaps. They were not only worn out, their food was frozen, and for drinking water they had to suck on ice cubes. "Damn it," cursed Slayton, "they need rest." They were now two days away from reentry and were needed at their best.

Lovell smiled and told Mission Control, "We're three men cold as frogs in a frozen pond."

Slayton laughed and moved into the CapCom's chair. "Hey, guys, this is Deke."

"Hey, Boss," Lovell answered. "How's it going?"

"It's going great, Jim," he answered as if he were enjoying his favorite rocking chair. "Just wanted you guys to know we're in great shape. Las Vegas says it's a hundred to one we're gonna get you back." Slayton didn't mind lying when it was necessary. "We think the odds are better than that. You guys are in good shape all the way around. Now, I just had to break a few heads down here to make sure they leave you alone so you can get some sleep. I want you guys rested and at the top of your game come reentry. You've already proven you are three of the best pilots we have in the Astronaut Office. Let's put that thing on the deck of the recovery ship. Okay?"

"Okay, Boss," Lovell acknowledged.

"And Jim," Slayton grinned. "According to your mother if we gave you a washing machine to fly, her Jimmy could land it. Is that true?"

"You betcha, Boss," Lovell laughed. "With or without wings."

"Get some sleep," Slayton said, laughing too. "We'll call if we need you."

This was Boss Deke Slayton talking. The man they trusted implicitly. Deke's personal touch did the trick. Soon those cold frogs were snoozing in their icy pond.

More than a billion of Earth's people listened to every broadcast, camped out in front of their radios and televisions, staying within earshot of every report. Such an extraordinary effort had never before

been launched to save three humans. People of every faith prayed. *Apollo 13* was headed for a splashdown near American Samoa. There the aircraft carrier USS *Iwo Jima* waited to fish the rescued from the sea.

Since the beginning of the four-day emergency, I had been on the air with few breaks. The phone in our NBC broadcast trailer outside Mission Control rang.

"Jay, this is Russ Tornabene."

"Hi, Boss," I smiled. "What's up?"

"Following the splashdown," Russ began, "President Nixon will be flying to Mission Control to congratulate the flight controllers, and then on to Honolulu to meet the *Apollo 13* astronauts. We want you to join the White House Press Corps in Houston and make the trip with the President."

"You realize this is going to cut into my splashdown party big time, Boss?"

"Party on the plane," Russ said, laughing.

*A**pollo 13* was wrapped snugly in the arms of Earth's gravity, racing toward reentry as Jack Swigert floated forward from *Aquarius* to start the "reincarnation" of the command ship *Odyssey*. He drifted into what had been a familiar spaceship cabin to find a cold and clammy flight deck. Every piece of equipment and instrument was soaked. His fear was that the icy water had seeped into electrical connections and circuit points waiting to arc into instant flame once power began to flow.

Swigert moved one switch at a time to return life to his Apollo, and because Gus Grissom, Ed White, and Roger Chafee had given their lives in the *Apollo 1* launch-pad fire, every circuit in *Odyssey* held solid. No arcing, no short circuits. Swigert peered down the connecting tunnel and called to Lovell and Haise, giving them a thumbs-up.

Lovell said a quiet prayer, giving personal thanks too to *Apollo 1*'s crew, and Swigert switched on the three batteries needed to power the command module during reentry. Two batteries were fully charged but

the third was low, so Swigert went back to *Aquarius* for a power cable. He returned and recharged the weak battery from the lunar module's power supply.

Astronaut Haise called Mission Control. "What are you guys reading for cabin temperature in the command module?"

"We're reading 45 to 46 degrees," Houston replied.

"Now you see why we call it a refrigerator."

"Uh-huh. Sounds like a cold winter day up there. Is it snowing in the command module yet?"

"No," Haise grinned. "Not yet."

"You'll have some time on the beach in Samoa to thaw out."

"Sounds great."

More fighter-pilot banter, good for the nerves as *Apollo 13*'s astronauts slipped into the final hours. They were getting set to fly a reentry from the moon on Friday morning, April 17, 1970, just over five hours before splashdown. One last time, Lovell fired the lunar module's small steering thrusters to improve his landing-target accuracy.

An hour later, Swigert separated his command module from the *Apollo 13*'s battered service module. Lovell snapped several photographs as the section of the ship that had caused all the trouble drifted away. "There's one whole side of the spacecraft missing," Lovell reported. "The whole panel is blown out almost from the base of the engine . . . It's really a mess."

Three hours later, just one hour away from punching through the atmosphere, Lovell and Haise moved into the restored command module. They closed the double hatches of the connecting tunnel, triple-checked the seals, and pressurized the connecting passageway. They fired the explosive bolts designed to separate Apollo from the lunar module, and, just as expected, the LM popped away like a champagne cork.

"Farewell, *Aquarius*, and we thank you," Mission Control called with a salute to the astronauts' lifeboat.

"She was a good ship," Lovell said with emotion.

Odyssey, along with its crew of three, plowed into Earth's atmosphere at 24,500 miles per hour—a speed at which it would take the astronauts only six minutes to cross the United States. Instantly, they were feel-

ing the pressures of deceleration, and instantly they were surprised. It wasn't snowing, but it was raining inside *Apollo 13*'s command ship. As the temperature rose and the forces of gravity grew, the icy mush that had saturated the command module's interworks broke free in a sudden shower, pooling along the bottom around their booted feet.

Then, *Apollo 13* was deep into the fires of reentry. For three minutes the ship was encased in heat hotter than a volcano's bowels. A plasma sheath formed around the spacecraft, cutting off all communications.

Clocks crawled.

Mission Control was a church of silence.

Squawk boxes crackled. A tracking aircraft over the Pacific radioed. It had picked up a signal from *Apollo 13*. No one cheered. Not yet. What about the heat shield? Had it held? Or was it damaged in the explosion? And what about the parachutes? Had they opened?

Apollo 13 broke through a cloud deck two thousand feet above the ocean riding beneath three huge orange-and-white parachutes. Mission Control went mad with relief, applause, and cheering.

Unbelievably, *Apollo 13* splashed down only three miles from the *Iwo Jima*.

Jim Lovell and crew were lifted by helicopter to the deck of their prime recovery ship, and splashdown parties worldwide burst into wild and thankful celebrations.

In Houston it was 12:07 P.M. April 17, 1970, three days and fifteen hours to the minute since *Apollo 13*'s oxygen tank 2 exploded.

In the Lovell home, Pete Conrad, the commander of *Apollo 12*, opened the first bottle of champagne. Buzz Aldrin grabbed the second, and he and Neil Armstrong popped the cork. Others followed. In the midst of hugs and screams of joy, Jim Lovell's wife, Marilyn, heard the phone ring. She ran into the master bedroom and picked it up.

"Mrs. Lovell?"

"Yes."

"Hold for the President."

She couldn't take her eyes off the television. She watched her husband's spacecraft bob in the Pacific as she danced in place, about to burst with joy.

"Marilyn, this is the President. I wanted to know if you'd care to accompany me to Hawaii to pick up your husband."

"Mr. President," she said, laughing, "I'd love to. How soon can you get here?"

Mr. Nixon was there bright and early the next morning, shaking the hands of the flight controllers who had snatched *Apollo 13* from the jaws of failure, and soon *Air Force One* was winging its way to Hawaii.

As ordered, I had joined the White House Press Corps for the trip. Amidst Hawaii's swaying palms and a cheering assemblage of thousands, the President welcomed *Apollo 13*'s astronauts home. We reporters filed our reports and took to the Honolulu sun. We were walking on clouds instead of sand, but my thoughts were with my friend Alan Shepard. Thanks to pioneering surgery that had corrected Shepard's inner ear problem, he was back on flight status and had been given command of *Apollo 14*.

We all knew the near-fatal flight of *Apollo 13* would delay *Apollo 14*. There could be no other way. Every nut, bolt, and inch of the Apollo's service module would need to undergo inspection, review, and design improvement. And thanks to President Nixon, we also knew *Apollo 14* would fly. Mr. Nixon had promised NASA that America would return to the moon, and I knew the burden of saving the country's space program would again fall on the shoulders of America's first in space.

As darkness fell over the island, I found myself walking alone in the balmy spring night, trying to ease my thoughts. The success of the *Apollo 13* rescue gave all Americans great pride in the men and women of NASA. But I had been there from the beginning. The first Russian cosmonaut flights had mocked America's stumbling efforts to ascend to Earth orbit. Alan Shepard was to have led the way as the first man in space, but the stumbling block then had been lack of confidence, not the reliability of the rocket, and Shepard had had to settle for being the first American in space.

He had been called upon then to save America's space future from the myopic, from those who were so eager to quit in the face of what they judged to be Russian superiority. They were convinced the Russians could never be matched, let alone exceeded. The decade since has

shown them to be wrong, and we of confidence, this night, were aware that even though *Apollo 13*'s crew had been safely returned to Earth, the never-finish-anything crowd were certain the mission had been a failure.

It was equally clear to us that Alan Shepard had more than a space flight to command. He again carried the full weight of Apollo on his

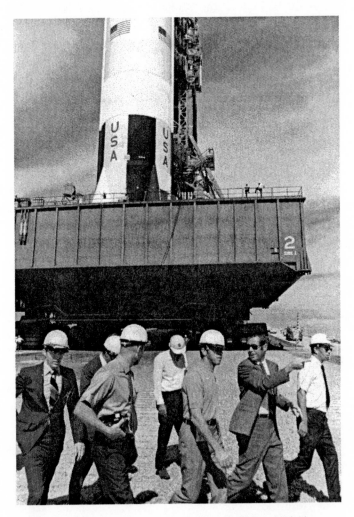

Jack King (second from right) escorts astronaut Alan Shepard (third from right) and his crew as their mammoth Apollo 14 moon rocket is moved to its launch pad. (NASA).

shoulders. If *Apollo 14* succeeded, he would share the accolades. If it failed, he alone would bear the burden. I found comfort in the thought that I was damn sure Shepard was up to it.

The next morning, *Apollo 13*'s astronauts were headed home to take their place in NASA's future. Instead of *Apollo 13* being NASA's darkest defeat, it was clearly the agency's finest hour, thanks to the men and women who would not accept failure as an option.

Inside the wings of *Air Force One* and the White House Press Corps' jet on April 19, 1970, sat the mellow and satisfied. Who said a superb glass of wine wasn't good for the soul?

Below, for that single day at least, all was right on a planet called Earth.

On the Moon

Astronauts Alan Shepard and Ed Mitchell had named their lunar module *Antares*, and after their quarter-of-a-million-mile journey of fits and starts, they were on the moon, ready to plant their boots in lunar soil. Shepard was first. He stepped off *Antares's* small porch and moved slowly down the ladder. He paused on the last rung. The last three-and-a-half feet were only a lazy drop for the carrier pilot.

Like the mythical bird of yore, NASA's *Apollo 14 Phoenix* had risen from *Apollo 13's* ashes, equipped with more reliable hardware and safeguards. But, more important to members of the space family, America's first astronaut was in command. Alan Shepard would be the only one of the Mercury group to reach the moon. He had gone for all seven, for all of us who'd been there with him from the beginning. The lunar dust he'd kicked up with his drop to the surface settled quickly as he paused. "It's been a long way," the son of New Hampshire spoke quietly, "but . . . we're here!"

Alan was talking about all the years he and his friend Deke Slayton had been grounded with ailments, all the years they'd watched others go, and Deke in Mission Control answered with affection, "Not bad for an old man."

Shepard had reached the moon at age forty-seven. The country's

original astronaut turned slowly, pushing his boots into the grayish-brown dust, reminding himself no living creature had ever done this before in this desolate, silent world. "Gazing around at the bleak landscape, it certainly is a stark place here at Fra Mauro," he said as if he were speaking only to Deke and those in Mission Control. "It's made all the more stark by the fact that the sky is completely dark." He surveyed the wide lunar landscape, turning his back to the dazzling sun. "This is a very tough place, guys."

Ed Mitchell worked his way down the ladder. The MIT Ph.D. of everything technical dropped to the surface and quickly began moving about, testing his body's reactions to the weak gravity in a world one-sixth the mass of his own. Mitchell was the first of a new breed of astronaut. He was a member of academia instead of flying warriors, and he found the moon a playground for learning.

"Mobility is very great under this 'crushing' one-sixth g-load," Mitchell quipped.

He and Shepard gathered samples of rocks and soil into containers to please the scientists back home. They placed their remote television camera sixty feet away so those on Earth could watch them setting up their experiments. They unloaded a new device for hauling materials across the lunar landscape. The engineers named it a modularized equipment transport, or MET, but Mitchell and Shepard simply called it their lunar rickshaw.

The rickshaw carried an extensive supply of tools, cameras, instruments, safety line, core tubes for digging into the lunar crust, and maps and charts for the two moonwalkers to navigate their way through and around craters, gullies, and boulder fields.

Overhead, their command ship, *Kitty Hawk*, raced across the moon's black sky. Crewmate Stuart Roosa had remained at *Kitty Hawk*'s controls, and he continued his circling of Earth's natural satellite. Every two hours he was making one complete pass around the moon, and suddenly his voice became very excited. "I can see *Antares* on the surface!" he told Mission Control. Sunlight gleamed from the spidery moon ship surrounded by a bright and new wide area of dust that had been splayed outward by *Antares*'s landing.

When Roosa reached the moon's other side, he made further thrilling discoveries. He swept *Kitty Hawk*'s cameras across craters never seen from Earth, including an extremely bright crater directly beneath his orbital path. Unseen, unknown by astronomers, it was a meteoric impact that was only weeks, possibly months, old—a virgin crater on a world that had been bombarded with such impacts for 4.6 billion years.

Back on the lunar surface, Alan Shepard was looking upward into the blackest of skies, thrilled at the blue-and-brown miracle that was his home planet. One-third of Earth hung magically suspended, floating. "That was breathtaking! The ice caps over the poles, the white clouds, the blue water . . . gorgeous, Barbree, just gorgeous!" he would tell me later with an excitement and a knowing he had seen something reserved for the gods.

"Earth," he explained, "is limitless to everyone with its vast oceans and towering mountains. There's always a distant horizon and changing dawns and sunsets. But looking at Earth from the moon, earth is in fact very finite, very fragile . . . so incredibly fragile. That thin, thin atmosphere, the thinnest shell of air hugging the planet, it can be blown away so easily! A meteor, a cataclysmic volcano, man's own uncaring."

Suddenly this master of wings and rocket fire, hero to millions, confessed to me that he had unashamedly wept with his boots planted firmly in lunar soil. Tears streaked down his cheeks as he stood praying for our only safe port in this corner of the universe. Minutes passed before he could stop his tears and prayers, before he could force himself out of his introspection.

Not only was Alan Shepard a sensitive person, the future admiral was a tough, no-nonsense "get 'er done" leader, and he knew their assignments on the moon demanded attention and labor, so he and Mitchell continued their appointed tasks. They strode and bunny-hopped in their spacesuits hundreds of feet from the protection of their lander *Antares*. Those on Earth watching the moonwalkers' television images learned quickly that the lunar landscape is a visual illusion. What seems flat and featureless is much like an ocean surface on Earth. The "flatness" is in reality a long-waved undulation of the moonscape, and several times during their moonwalk, the astronauts' exertion while toting

heavy loads, bending and stooping to lift rocks, gave Mission Control reason for alarm. They could hear the astronauts grunting, sometimes loudly sucking in oxygen. The flight controllers realized they were pushing too hard, overloading bodies already drained by the demands of launch and flight to the moon.

Shepard and Mitchell were ordered to slow their pace, and soon they were moving through their chores with ease. Four hours and fifty minutes into their first moonwalk, they returned to *Antares* and loaded on their samples.

Their first excursion was complete, and like little boys crawling into their tree house, Shepard and Mitchell eased their way back into *Antares*'s cabin, sealed the hatch behind them, pressurized their ship, and ate and drank their fill. They replenished their spacesuits' containers with oxygen and water, checked the battery packs and systems, and enjoyed the pleasure of being free of their cumbersome exoskeletons.

Exhausted, they slept.

A*ntares*'s astronauts were up and ready to go two hours early. They had slept well, and were telling the 150 people in Mission Control and its back rooms to get the lead out.

"Hey, we're up and running this morning," the forty-seven-year-old Shepard boasted. "The shape of the crew is excellent."

The flight surgeon nodded, the flight director was delighted, and CapCom told the moonwalkers, "We're turning you loose."

Shepard and Mitchell bounced down *Antares*'s ladder eager to top every item on their moonwalk work list. This was the first full "geology field day." They loaded their lunar rickshaw for the trip to Cone Crater, sure it would carry their heavy load, giving them a break from lugging rocks as big as bowling balls. But the rickshaw failed to fulfill its promise. Fra Mauro was covered with thicker and deeper dust than that found at the *Apollo 11* and *12* landings sites, and pulling the rickshaw was like plowing through deep sand.

"This is ridiculous," Mitchell called to Shepard. "Let's pick up the damn thing and carry it."

There was no argument from the commander, and the two carried the rickshaw loaded with supplies only to be fooled by the undulating nature of the terrain. It was like looking at mountains across a desert on Earth. In clear air, a mountain peak or range might appear to be only a few miles away when it is actually forty or fifty miles distant.

The navigation charts seemed to have been prepared for some other planet, and distance measurement proved to be misleading. The sun angle and the crystal-clear sharpness of a world without atmosphere threw off their depth perception.

Their journey had become a fierce slog. Frustrated, their strength sapped, they lost sight of where they were, and more important, where they were going. Every time the astronauts stopped they referred to their checklist, collected samples, and noted lost time. They were gulping oxygen, drenched in perspiration, but they weren't giving up. "There's the rim of Cone," they assured each other. "We're getting close now."

Houston was concerned and told them to take it easy. Keep moving, but take it easy.

Then, finally, before them a steep climb loomed. It was a slope longer than a football field to the rim of Cone Crater. To get there, they would have to slug it out through a massive boulder field. There was rubble and smashed rocks everywhere, and they knew they were almost out of time. They pushed themselves as hard as they could—fighting up the slope in ankle-deep moon dust.

"You take two steps up," Shepard told Mission Control, "and you slip back one. It's like a day at the beach, plodding through deep sand."

Suddenly, Shepard slipped to one knee and Mitchell had to come to his rescue and help him up. It was becoming obvious they were nearing the end. Houston would soon be ordering them to start back to *Antares*. They gulped in air and kept on pushing and pulling, digging their boots into the loose, dusty surface. But it was painfully clear Cone Crater had won.

Time, oxygen, and physical strength were all running out, and Mission Control knew Shepard and Mitchell were at the very edge of their endurance. They were still about seventy-five feet from the top.

"Alan, Ed, you guys have already eaten into your thirty-minute reserve," said CapCom. "We think you'd better proceed with the rock sampling where you are."

The high rim of Cone Crater would remain unchallenged.

"I think we're looking at what we want right here," Shepard told Mitchell, trying to put the best face on their failure.

They gathered samples from the boulder field and started back. Coming down the slope was much, much easier. They could almost fly. Striding downhill, the moon's weak gravity permitted them to leap over rocks as they went, and soon they had reached the lunar module. They loaded their booty aboard and were ready once again to climb into *Antares*'s cabin.

Well, almost ready.

"Houston," Shepard called Mission Control, removing a small metal flange from his suit pocket. He carefully attached it to the long aluminum handle of the collector he'd used to pick up rock samples.

I was co-anchoring the NBC Radio Network's coverage in our broadcast trailer outside Mission Control, and I laughed loudly. I knew what was about to happen. Shepard had let me in on his secret. I turned to my stunned co-anchor. "Russ, have you ever wondered how far an average golfer could hit a ball in lunar gravity? Well, Mr. Ward, you're about to find out."

"Houston," Shepard paused for effect, "you might recognize what I have in my hand . . . the handle for the contingency sample. It just so happens to have a genuine six-iron on the bottom."

Those in Mission Control were now laughing.

Shepard reached into a pouch of his suit and held up a golf ball.

"In my left hand I have a little white pellet that's familiar to millions of Americans."

The flight controllers grinned.

Alan Shepard, an avid golfer, dropped the ball into the moon dust. He made his best effort to assume a normal two-handed stance to address the ball, but his bulky spacesuit would permit only a one-handed swipe.

"I'm trying a sand-trap shot." He laughed as he swung awkwardly,

the six-iron spraying moon dust and dropping the ball into a crater only a few feet away.

"I got more dirt than ball."

"Looked more like a slice to me," Mitchell quipped.

Shepard wasn't to be stopped. He dropped a second ball and the home-rigged golf club found its target, sending the white ball racing away into the black sky.

"There it goes! Miles and miles and miles!" Shepard said with pride.

Some argued the golf ball sailed only a few hundred yards while others, taking the weak gravity into account, suggested it could have gone into its own lunar orbit.

With his Tom Sawyer grin Alan later told me, "I really don't know where the damn thing went."

Shepard and Mitchell ran through their pre-lunar-launch checklist, made sure everything that was suppose to be on board was on board, and Shepard turned to the remote television camera.

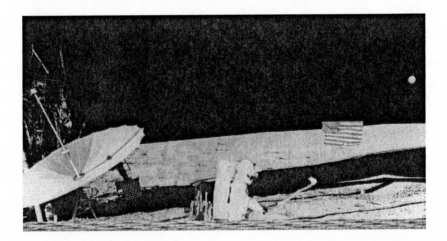

Alan Shepard's golf shot on the moon. (Shepard Collection).

Apollo 14 *moon rocks. Alan Shepard (right) leans over to view a basketball-size rock being examined by Ed Mitchell (table, left). (NASA).*

"Okay, Houston, the crew of *Antares* is leaving Fra Mauro Base."

"Roger, *Antares*."

With mixed emotions, Shepard and Mitchell closed their lander's hatch and monitored the countdown timers as they flashed away the minutes and seconds. *Antares*'s ascent rocket shot flaming thrust into its descent-stage launch pad. The lunar module leapt from the moon and sped into the black sky, into its rendezvous orbit with *Apollo 14*'s command ship *Kitty Hawk*.

The docking of the two spacecraft was perfection. *Kitty Hawk* fired up and carried its smiling crew home.

The legacy of *Apollo 14* went far beyond returning the lunar landing program to safe flight. The three remaining *Apollo* lunar landings, which had been on the edge of cancellation, would not be cut.

On July 26, 1971, *Apollo 15* astronauts Dave Scott, Jim Irwin, and

Al Worden flamed onto the lunar highway. Scott and Irwin rode their lander, *Falcon*, to the foothills of the Apennine Mountains while Worden, overhead in *Endeavour*, began a photo survey for future landing sites.

Dave Scott and Jim Irwin became the seventh and eighth astronauts to step onto the moon. They had been given a great landing site. They stared in wonder at the Apennines, mountains towering fifteen thousand feet, as they drove the first lightweight electric car, a cross between a golf cart and a dune buggy, over the lunar surface. They drove it up and down slopes heavily laden with tools, moon rocks, and other lunar samples as well as cameras. With the ability to travel a distance of six miles, the two astronauts did little moonwalking. They increased the area to be traversed, studied, and sampled. The six miles was a safety limit. If the "moon buggy" broke down, the astronauts would still have enough power and oxygen in their suits for a steady walk back to their lunar landing craft. *Apollo 15*'s Scott and Irwin spent three days at the feet of one of the moon's largest mountain ranges.

In April of 1972, *Apollo 16* astronauts John Young, Charles Duke, and Ken Mattingly flew to the moon. Young and Duke left Mattingly in lunar orbit babysitting their command ship, *Casper*, while they rode their lunar module, *Orion*, to a wide plateau on the edge of the Descartes Mountains. The second moon buggy took the two astronauts through massive boulder fields, around and through craters, and through some chemical rocks with aluminum basalts. They came home with 213 pounds of samples for happy geologists.

Late that year, on December 7, 1972, shortly after midnight on a Cape Canaveral coast mantled in darkness, people within fifty miles thought the sun had come up. What appeared to be daylight flared along the beach, spreading outward as the *Saturn V* rocket with *Apollo 17* went to full thrust. It rose atop its own blazing fireball, leaving a light that was seen five hundred miles away atop Stone Mountain in Georgia.

Astronauts Gene Cernan, Jack Schmitt, and Ron Evans were on their way to what would be the last landing on the lunar landscape for half a century. Gene Cernan had traveled the same path to the moon before on *Apollo 10*. He and Jack Schmitt, the only geologist to sink his pike into the lunar crust, landed in the Littrow Valley of the Taurus mountain region and capped the most incredible series of expeditions in the history of the human race. They spent three days on the lunar surface, including more than twenty-two hours in a trio of stunning geological journeys, riding their moon buggy to fields of enormous boulders, to the slopes of steeply rising mountains, and along the edges of precipitous gorges from where they stood in awe of the chasms torn in the moon's surface. They managed to load 243 pounds of rocks and soil aboard their lander, conduct dozens of scientific experiments, and strip away many of the moon's secrets that had confounded people on Earth for centuries. The *Apollo 17* finds have kept scientists of many countries intensely busy well into the twenty-first century.

What emerged from *Apollo* is a picture of a moon that was born in searing heat, lived a brief life of boiling lava and shattering collisions, then died geologically in an early, primitive stage. It came into being some 4.6 billion years ago, when great masses of gaseous matter called the solar nebula began condensing to form the sun, Earth, and other planets and moons of the solar system. The nebula first condensed into chunks of space debris—from small pebbles to miles-wide boulders— that crashed together and fused to form celestial bodies. This compacting of debris generated intense heat that turned the lunar surface into a sea of molten lava, to a depth of several miles. The cooled lava became the moon's primitive crust. Debris left over from the creation of the solar system continued to bombard the moon, carving out giant craters and valleys and forming mountains by piling up large piles of rocks.

The young Earth apparently underwent the same period of meteorite bombardment and volcanism that the moon did for about a half billion years. Then the histories of the two bodies diverged. The weak lunar gravity could not prevent volcanic gases from escaping into space, and the moon became a dead body where life could not exist. But the larger Earth, with strong magnetic and gravity fields, held onto its vol-

canic gases, and they formed an atmosphere and oceans, creating conditions for the development of life.

America's lunar landings learned more about the moon and our solar system than humans had learned in their species's history. Technology advanced fifty years ahead of where it would have been had we not gone. *Apollo 17's* flight ended the four-year stretch when twenty-four Americans, some twice, rocketed through the vacuum from Earth to the moon. Twelve of the twenty-four descended from lunar orbit to walk and drive across the small world.

NBC Radio and Television was there for every flight, from launch to splashdown. We enjoyed an out-front position and first-place ratings. Jim Kitchell, our executive producer, was simply the best. He had cut his teeth in television news by directing the first newscast put on the air by journalists, not broadcasters, who simply read what they were given. The show was the legendary *Huntley-Brinkley Report,* where Kitchell was the first to cover a breaking news event live. When it came to covering space flights, he led, we followed; and when Neil Armstrong and Buzz Aldrin reached the moon, Kitchell's space unit was given the Emmy for "Coverage of Special Events."

But sadly, as quickly as Project *Apollo* had arrived, it was gone—gone for thirty-one years until January 14, 2004, when President George W. Bush dusted off its historic pages. As of this writing, astronauts not yet born when *Apollo 17* returned from the moon December 17, 1972, will head back to the lunar surface as early as 2018.

And if you should be asked, the first Martians are already here. They are your sons and daughters, and as soon as they move through the halls of learning, they'll be saddling up to fly to our planetary neighbor on rockets and interplanetary ships named *Ares* and *Orion.*

As history had its voyages to the New World, its wagons west, its Kitty Hawks, and its Lindbergh flights to Paris, Mars will be the next generation's Apollo.

It just could be the greatest adventure of all.

After the Moon

A merica was proud of its moonwalkers, but we who followed spaceflight daily knew earthlings' first visits to the moon could have been different. Had Russian cosmonauts sustained their early lead, the number going there might have been two or three times twenty-four.

In the beginning, the competition was fierce. The Soviets had gone all out in their desperate attempts to be first. But costly failures slowed them to a halt, and then, only two weeks before *Apollo 17* returned from the moon, the Russians were down to a last-gasp hope that their giant N–1 rocket would fly. They could no longer be first, but they still struggled to get their cosmonauts to the moon in the same period in history as American astronauts had. Such a landing would restore some Soviet pride.

It was not to be.

Martin Caidin was in Russia. It was N–1's fourth launch attempt. The mammoth rocket was to boost a heavy, unmanned lunar-landing spacecraft directly to the moon in a rehearsal for a manned landing. It rose into the Kazakhstan sky only to be ripped apart again by a series of violent explosions, its wreckage tumbling earthward while sounding the death knell of the Russians' last, slim hope.

From the ashes of N-1, the Russians returned to their proven rockets and spacecraft and became successful in their efforts to place a space station in Earth orbit. The Salyut station led the way, while the American road to space in the aftermath of the highly successful Apollo moon landings developed potholes and detours.

A simple "breaking and entering" burglary at the Democratic Party's headquarters in the Watergate scandal propelled this country into a self-devouring frenzy that would last until a peanut farmer from Georgia was elected President in 1976. No longer was there the driving force in the country's space effort that had carried America to the moon. NASA's visions were lost on the floors of a disenchanted Congress and a public that rapidly became apathetic.

Slowdown was NASA's new marching orders. The agency's planners and builders were replaced by a new wave of bureaucrats who swayed with the political winds, sadly short on dreams, drive, and any determination to keep forging outward beyond Earth.

NASA's new task was to build something that could be flown again and again. It didn't have to go anywhere but into Earth orbit and it didn't necessarily need a mission, so bureaucrats inked their drawing boards with the STS—Space Transportation System—known as the Space Shuttle.

NASA failures were not with its equipment, but in promising that the Space Shuttle would be all things for all missions, that it would serve both civilian and military needs—and save truckloads of money in the process. The Space Shuttle program escalated swiftly in cost and decelerated just as rapidly in productivity. Weeks became months, and projects meant to take months stretched into years without a definite future.

Something had to fill the gap.

Engineers still on the job from Project Apollo dusted off the Saturn rockets and Apollo spacecraft left over from the three lunar landing missions that had fallen victim to the congressional ax. The few visionaries left in NASA proposed modifying this hardware into a modest space station where astronauts could study the sun and other stars, conduct experiments seeking pure materials and medicines, and learn to live

in space for long periods just in case someone came up with a sensible thought of going somewhere else in the solar system. The cost would not be great, and the White House and Congress agreed what was left of the great NASA Apollo launch teams should be preserved. Thus *Skylab*, the country's first space station, was born.

The third stage of a *Saturn V* was stripped and converted into the house-size "home away from home" with racks of scientific equipment, a state-of-the-art astronomical laboratory, and more than thirteen thousand cubic feet of comfort and freedom for three astronauts. Gone were the cramped spacecraft of the past. Cooking facilities, private quarters, showers, even the astronauts' own gym for keeping in good physical shape while spending months in weightlessness rounded out *Skylab's* interior.

America's first space station thundered into orbit May 14, 1973. Three successive missions of three astronauts each rode smaller Saturn 1B rockets and Apollo spaceships to NASA's first orbiting outpost. The final crew's stay in 1974 was extended to eighty-four days and proved that astronauts would suffer no ill effects during long weightless voyages.

In the normal course of events, the man who rode herd on the astronauts would have been Deke Slayton. But during *Skylab,* Deke was busy getting himself back on flight status. He was being treated and tested by Dr. Harold Mankin, a world-renowned cardiologist from the Mayo Clinic in Minnesota. Dr. Mankin found Slayton's heart was, and had been, disease free and he was placed back on flight status. No one was happier for Deke than his close friend Alan Shepard, who had taken charge of the astronaut office.

Meanwhile, the Russians and NASA were plotting a mission where the two countries would meet and dock in space. Their efforts were inspired by Martin Caidin's novel *MAROONED,* which legendary Hollywood producer Frank Capra had made into an Academy Award–winning motion picture. In the novel, a Russian cosmonaut saved American astronauts, and it was agreed a common docking device between both countries' spacecraft would be wise. Project Apollo-Soyuz was born.

The selection team would have been shot if they had not picked

Legendary Hollywood producer Frank Capra (center) at Cape Canaveral with the author of MAROONED, *Martin Caidin (right). (Caidin Collection).*

Deke Slayton as a member of the *Apollo-Soyuz* crew. A classic party was thrown for Deke, and the happy and drunken astronaut was carried onto an aircraft with his crewmates Tom Stafford and Vance Brand. It was wheels up for training in Moscow.

Two cosmonauts and three astronauts would make up the team that would meet in Earth orbit. The problems of making the Russian and American pilots function as a tightly knit unit were as formidable as the many technical issues that had to be resolved. The cosmonauts didn't speak English and the astronauts didn't speak Russian. Neither side could read the markings and lettering of the equipment on the other's spacecraft.

But world peace and possibly Earth's survival itself were riding on the *Apollo-Soyuz* mission scheduled for the summer of 1975. The goal was critical for every American and Russian. Until now, any crew marooned in space with limited oxygen and power would have been lost.

With the universal docking equipment being built for *Apollo-Soyuz*, chances of a future rescue would be almost certain.

For three years the Americans and Russians, supported by backup teams of engineers and space veterans, modified their spaceships, built new needed equipment, learned their respective languages, and practiced orbital flight maneuvers in new simulators.

The barriers came down. Russian and American suspicions waned. When cosmonauts Aleksei Leonov and Valeri Kubasov found themselves at Mission Control in Texas, and at Cape Canaveral's launch pads in Florida, they eagerly waited to fly the astronauts to their Baikonur launch site to watch their big rockets thunder into the sky. In between forging the equipment needed and training to fly what they had created, there were three years of friendship-building with hot dogs and beer, borscht and vodka, swimming in the Florida surf, and wild snowball fights in the cosmonauts' playground in Star City.

Slowly the pieces of the international puzzle came together. The *Apollo-Soyuz* teams were each firm in trusting their own equipment. Now they had gained trust in a never-flown international spaceship. Once *Apollo* and *Soyuz* were joined high above Earth, the tunnel formed by the common docking module would pressurize, hatches would open, and men who had been near enemies but now were close friends would form a union in space.

For Deke Slayton it would not be the moon, but it would be space, and what happened in the hard vacuum of Earth orbit would begin the melt of the cold war far below.

A Handshake in Space

On the fifteenth day of July 1975, according to the best intelligence available, some 200,000 rockets built for war were in the arsenals of the United States and the Soviet Union. Many were small, shoulder-fired weapons. Others were clustered aboard armored vehicles. Still more were slung beneath the wings or within the bomb bays of fighters and bombers. Hundreds of war rockets were ready to pop from beneath the sea from the missile tubes of nuclear submarines. They could race up to four thousand miles to their target while thousands of silo-buried heavy missiles, some as tall as a ten-story building, were ready to launch with up to ten thermonuclear warheads, each destined for individual targets within a given spray on any distant continent. Never in history had our planet been so threatened by its dominant species.

On that day, only two of those rockets carried humans instead of means of destruction. The first off its launch pad was to be Russia's *Soyuz 19*. It was to be followed six hours later by America's *Saturn 1B* with the *Apollo*. The two ships were to rendezvous in space for a handshake—a meeting of friendship and understanding; but more important, if it was a good day, it would be the beginning of the end for the massive nuclear threat.

Détente, the diplomats were calling it. Richard Nixon had created it. The world was listening and watching. Its inhabitants were staring at the first live television ever broadcast from Russia's launch pads on the steppes of Kazakhstan.

"Launch is ready," the loudspeakers blared.

Soyuz 19 and its rocket's internal systems were alive.

"*Tri* . . .

"*Dva* . . .

"*Odin* . . .

"*Zashiganiye!*"

Editor's note: Use photo #60 here: Caption: *Soyuz 19* leaves its launch pad to meet *Apollo* in Earth orbit. (NASA).

In Florida, happy NASA officials awoke Tom Stafford, Deke Slayton, and Vance Brand: "Your friends are upstairs. Right on schedule."

Soyuz 19 was coming around the planet on its fourth trip when the American crew climbed aboard their rocket and spaceship. This was the last Saturn 1B booster, and the last Apollo in the stable.

"Aleksei and Valeri, from *Apollo*," Commander Tom Stafford called *Soyuz*. "We'll be up there shortly."

Saturn 1B came to life. Flame spewed in sheets over the launch platform, and it took only seconds for Deke to know their booster was no smooth and mighty *Saturn V*. *1B*'s first stage was really eight of Dr. Werner Von Braun's Jupiter rockets clustered as one, and it clawed its way into the sky with each of the eight rocket engines fighting for dominance. Deke felt as if he were riding an old pickup truck, slam-banging down a rutted road on his Wisconsin farm, as the rockets thundered along with a cacophony of noises—propellants pounding through lines from turbo-pumps spinning at tremendous speed, pressures surging with booming thuds throughout the stage, all to the accompaniment of a teeth-rattling, eye-blurring ride.

They punched through Max Q and then shot upward like a frightened jackrabbit until the rockets' roar and the high-pitched howl of air ripping past them vanished. The teeth-jarring ride was suddenly over. But only for a second. Explosive charges blew apart the two stages, and then the second stage fired and took dead aim at that small doughnut in

space—that small rendezvous target they had to pass through to settle them on that orbital track they would need to meet *Soyuz 19*.

They made it, and Deke Slayton shouted, "I love it! Damn, I love it. It sure as hell was worth waiting sixteen years."

"You liked that, huh, Deke?" Tom Stafford grinned.

"I would like to make that ride about once a day," the fifty-one-year-old rookie laughed as he suddenly felt the marvelous and strange feeling of weightlessness. "Yowee! I've never felt so free," he yelled again.

Stafford and Brand shared the enjoyment. But they had work to do, and they quickly shed their cumbersome spacesuits, climbed into their flight coveralls, and readied *Apollo* to execute the maneuvers needed to meet the Russian ship.

Vance Brand tuned in *Soyuz*'s frequency. Speaking in Russian, he said, *"Miy nakhoditswya na orbite!"*

They heard Valeri Kubasov answer in English: "Very well. Hello, everybody."

"Hello, Valeri," Deke spoke in Russian. "How are you?"

"How are you? Good day!" Kubasov replied.

"Excellent!" Deke boomed. "I'm very happy."

Aleksei Leonov's voice came on. *"Apollo, Soyuz,* how do you read me?"

"I read you excellently," Deke answered. He wasn't the most loquacious astronaut up there, but who in hell cared? That wasn't the point; he was in orbit, and it was time for the hunt to begin.

Tom Stafford took the controls of *Apollo* and fired the first of several rocket-thruster maneuvers needed to track down *Soyuz* during the next two days. They were playing a celestial game of tag and they were having a ball. Circling in a lower orbit and making precise course-correction burns, *Apollo* gradually caught up with *Soyuz* high over the French city of Metz, where they performed an orbital ballet for a worldwide television audience. *Apollo* relayed pictures of *Soyuz* glowing green in a brilliant sun against the blackness of space and the azure of Earth's oceans below.

With a slight shudder, while traveling at 17,400 miles per hour, Tom Stafford docked *Apollo* with *Soyuz*. "We have capture," Stafford reported.

"Well done, Tom," the *Soyuz* commander told *Apollo's* commander. The two were destined to be generals in their respective air forces, but more important, they would become good friends. "*Soyuz* and *Apollo* are shaking hands," Leonov added.

Throughout the world, television audiences watched as the astronauts and cosmonauts cleared the hatches between their respective ships and floated in the weightlessness from one spacecraft to the other.

"Friend," Stafford called out as he shook hands with Leonov.

"Very, very happy to see you. How are things?" Leonov asked, reaching out to give Stafford and Slayton the traditional Russian bear hug.

The two crews exchanged gifts before gathering around a green table in *Soyuz* for a meal and a toast to their success. They feasted on reconstituted strawberries, cheese, apple and plum sticks, and tubes of borscht the cosmonauts had mischievously labeled vodka. Later, aboard *Apollo*, it was potato soup, bread, more strawberries, and grilled steak.

During the forty-seven hours the two ships were docked, the Americans and Russians executed their own brand of diplomacy. Aleksei Leonov said the flight had been made possible by the "climate of détente" that had been begun by President Richard Nixon and termed it "a first step on the endless road of space exploration."

President Gerald Ford could hardly wait for his chance to talk to the astronauts, especially to Deke Slayton.

"As the world's oldest space rookie, do you have any advice for young people who hope to fly on future space missions?" the President asked.

"Never give up," Deke chuckled. "Decide what you want to do and then never give up until you've done it."

Until now, the Russian and American spaceflight had been an *Apollo* show. It was time to prove cosmonaut skills as well. The two spaceships separated. Aleksei Leonov flew *Soyuz 19* through several maneuvers and then, as slick as a greased pig, the master cosmonaut who was the first human to walk in space slid the two ships together for a perfect hard dock.

There remained no question that in a space emergency, either nation could fly to the rescue of the other.

Only a few years before, a joint American-Russian space mission would have been judged unthinkable. Now five persons from both countries gathered 140 miles above the planet and held news conferences with the worldwide media. That was the lasting foundation and the heart of the *Apollo-Soyuz* mission. Earth's two most powerful military nations, bristling with antagonism and weaponry, met peacefully, in full cooperation.

When it came time for the final separation between *Apollo-Soyuz*, Deke Slayton got his chance to fly in space. He took the controls of *Apollo* and with a deft and sure hand, developed first in the European and Pacific campaigns of World War II, he backed *Apollo* away from *Soyuz* and began flying dazzling maneuvers around the Soviet ship. They flew together for a short time.

After six days in space, Leonov and Kubasov fired *Soyuz*'s retro-rockets and began their trip home. Soviet television for the first time showed live coverage of a Russian spaceship parachuting to its touchdown, and the *Apollo* crew applauded.

Soyuz was home, but *Apollo*'s trip was not yet done. After all, it was the last *Apollo* out, and the astronauts wanted to stay in orbit as long as possible.

Predawn the following day, salmon fishermen in the Gulf of Alaska looked through scattered clouds. One star in the night moved. It first appeared above the northwestern horizon, a sharp pinpoint of light that quickly grew in size as it traveled across the top of the world and sped away silently in a long, sinking fall across the curve of the planet over Canada. The bright messenger in the heavens was in fact America's last Apollo, sweeping toward daybreak.

Deke Slayton braced himself at *Apollo*'s large viewing port and looked downward, awed by the deep orange glow of dawn directly ahead over Lake Superior, and, with his practiced eye, his skill of searching for landmarks from a lifetime of flight, he checked the southern

shore of the lake against the sparkling lights of Duluth. Now he followed the Mississippi River winding southward, dawn reflecting off the muddy water. He looked for the confluence of the Mississippi with the Wisconsin River, and when he found it, there was La Crosse, unmistakable with its night lights still glowing in the dawn, and from 140 miles high, the town of Sparta—his hometown—was securely in his sight. Five miles below Sparta, the countryside flowed along hills and valleys that were the most familiar place on Earth to Deke, his family's farm. One hundred-sixty acres still held the footprints of his boyhood years.

Deke Slayton felt at home in two places at the same time. Down below, a forever place in his memory, and here, home in his immediate physical surrounding—within the interior of the last Apollo he had waited so patiently to fly.

One home was lasting. His home in space was another question. It would be at least four, more realistically six, years before the new Space Shuttle would launch. But despite the uncertainty of the astronauts' future, there was a much larger question—the fate of Earth rolling beneath his orbit.

America's oldest space rookie looked down and there it was, the beginning of life, its present, and its end; and coming from a farm, Deke had no doubt that the bounty of the precious planet was finite. Its supply of energy, foodstuffs, clean atmosphere, pristine waters—all were finite. And whatever age to come was being shortened by the myopic uncaring of mankind.

If Deke, and the other astronauts before him and those who would follow, were successful, then Homo sapiens had taken their first faltering steps not merely to other worlds close by, but to far distant stars and worlds revolving about those alien suns. Deke continued looking down with a mixture of hope and sadness, knowing one day this good Earth below would pass into history.

The hope was, Deke knew, that if humans one day were successful in journeying to distant stars, and populating those faraway planets, then the human race would be safe. A star might go nova, obliterate an entire solar system, but if the human species populated many solar systems . . . life would go on.

That was the gift to the future of Deke Slayton's generation of astronauts, but it was also a time for members of the space family to worry. The long string of missions named Mercury, Gemini, and Apollo was ending. Thousands of people would be losing their jobs. There was a high probability I would be one of them. I could not imagine NBC keeping me on the payroll for four to six years waiting for the Space Shuttle to fly. As the last Apollo returned safely, I packed up my microphone and flew home from Houston's Mission Control to my family.

At the end of our street, Jo and my eldest child, Alicia, stood waiting as they had hundreds of times before. Alicia leapt in my lap, slid under the steering wheel, and finished the drive home. Despite the dark clouds on the horizon, my family was a smiley bunch. The possible loss of my job wasn't all that frightening. "Don't worry, Daddy," Karla, the youngest one said, "I'll just sell more cookies."

Down Home with Jimmy Carter

D uring the second half of the 1970s, NASA busied itself with getting the first Space Shuttle ready to fly and I busied myself setting my family's house in order.

Despite the space-flight hiatus, NBC had asked me to stay on the job with a cut in pay, promising they would use me on stories elsewhere. My wife expressed her dislike for starvation and went back to her old job at our bank. Friend Dixon Gannett, the son of the founder of Gannett Newspapers, the publishers of *USA Today*, *Florida Today*, and a few dozen more fish wrappers, threw a few coins my way. He offered me the job of editor of one of his magazines. He said he couldn't stand to see me on the public dole. I thanked him, and asked if instead I could have a paper route because it paid more. Old Dix smiled and said, "Hell no! Every person had to starve in the editorial pits before they could get a shot at the big money."

I took Dixon's editorial job, and was then suddenly all smiles when NBC News added a career-saving assignment.

Up the road in 1976, Jimmy Carter was getting ready to run for President and NBC decided one Georgia peanut farmer should cover an-

The author is seen here with Dixon Gannett, frequent lender of money needed to secure the federal debt. (Gannett Collection).

other. I packed up, took my magazine-editing job on the road with me, and began tagging along with the Carter campaign.

We went all over the country covering one Jimmy Carter political rally after another, traipsing through farm fields from state to state. But as one Georgia plowboy to another, it was obvious the presidential candidate preferred them "old cotton fields back home" as a place to kick back and trade a few boyhood yarns.

I certainly didn't consider myself Mr. Carter's equal, but as farm boys in southwest Georgia we'd traveled down many of the same roads. The war years were a time of rationing stamps and going without, but also a time when folks in Georgia believed, devoutly, in Jesus Christ, Santa Claus, Franklin Roosevelt, the Democratic Party, and most important, their own mule.

The presidential candidate laughed when I explained his family was better than ours. They owned two mules and my family had to rent one. And Mr. Carter added, "We had two cars on blocks in the front yard."

There certainly was no disagreement that if you didn't have a mule in the 1940s, you most likely went without. Anyone who lived on south-

ern farms in those days knew there was a bond between the farmer and his mule. The one was necessary for the survival of the other. It was important to have a mule that would obey and had a good gait. There was something pleasing about man and mule moving down a cotton row in unison in tune with the commands of "Gee" and "Haw" and "Whoa." It was simple: If you didn't have a mule pulling the plow, then you were doing the pulling.

That's why those of us without a mule were left with one choice: If you wanted cash in your pocket, you got on your knees and picked the cotton from sunup until sundown. And if you were a sissy, forget about it. Especially in a hot August sun with 100-degrees-plus temperatures, crawling on your knees and pulling a heavy sack, moving your bloodied fingers as fast as you could, trying to pick one hundred pounds of cotton every day. Why? Because we were paid one cent per pound picked, and if you wanted to make a dollar, then you had to pick one hundred pounds. The future President said that must have been where the old saying "Another day, another dollar" came from.

Well, as a boy of twelve, I failed again and again, and it was beginning to look like I would never make a dollar, no matter how fast I worked. I was at the point of giving up when two of my black friends, J. W. and George, took pity. They pulled me aside and told me to pack my early-morning dew-drenched cotton very tightly in the bottom of my picking sack, and secondly, when I went to the bushes during the day, to make sure I urinated inside my picking sack to keep the cotton wet and heavy. Water spilled from the drinking jug into the sack helped, too.

I smiled. I had been introduced to the world of science. This explained cotton's unique smell and color. And what about the cheating? In the broiling sun and with the nightly aches, it was easy to convince yourself it was justified. Daily, I walked from the cotton fields a little less honest, but with a dollar tightly in my fist.

Jimmy Carter was elected President, and we went off to the Georgia coast where the President-elect holed up a few days on Sea Island to

unwind. Here he told the media that once while fishing in a cypress hole in a small, one-man bateau, his fishing was interrupted by a swamp rabbit swimming across his bow. Most reporters had never seen a one-man bateau let alone a cypress hole plentiful with good eating bream, and they sure as hell didn't have anything else to write about. The television and radio folks got out their chuckles and microphones and the newspapers writers grabbed their supply of ridicule. They had a field day.

"President-Elect fends off an attack rabbit with his paddle," the stories appeared in bold print, and while the ill informed heehawed, we country boys had our own good laugh. Earth's surface is 71 percent water or thereabout, and in swamps and marshes and other areas with little solid land, swimming and slithering animals and reptiles were nothing new. When meat on your table was hard to come by, we country boys chased swimming wild hogs, rabbits, and even an occasional gator. It was obvious most of my colleagues in the media were strangers to hard times.

The reporters born during or on the latter side of the Great Depression were falling by the wayside, and I was most grateful looks weren't a requirement for my generation. NBC executives agreed I had the perfect face for radio, and retiring was the farthest thing from my mind.

Jimmy Carter was arguably the most gentlemanly and good-natured President ever, and no one enjoyed a good laugh more. Many times, he bent over grabbing his stomach in hysterics, laughing at my lack of ability to umpire his softball games.

The President was a pretty fair country ball player and he would field a team with his Secret Service detail. His brother Billy and the inept media would be called out to play them and because I was hands-down the worst player on the field, I had to be the umpire. Billy, who spent the day downing his short-lived Billy Beer, thought his team would benefit from favoritism by this Georgia boy.

Well, he did get favoritism, because there was a major problem. The President and the Secret Service were good players. Billy was drunk before the third inning, and the reporters on his team were plain rotten. If we were ever to complete a game, I had to call any pitch or play in favor

of the media team or we would have been at it all night. Ever hear of a game called because of sunup?

To this day I hope the President understood, because Mr. Carter would stand there rolling his eyes at my called strikes. Some of them I called strikes even if Billy just managed to roll the ball across the plate. It was a hell of a fix to be in, and I still can't believe I stood there and argued a strike call with the President. Just where did I get the nerve to overrule the Chief Executive of the United States?

Despite his taste for beer, the President's brother was a great guy, as were all members of President Carter's family, and I was most grateful for the assignment and for the Carters' hospitality. The NBC News Desk made sure I received most of President Carter's vacation and down-home assignments and before you knew it, it was election time again, and in 1980 Ronald Reagan won the White House and I came home to Cape Canaveral, where the launch team was working full speed ahead to get *Columbia*, the first Space Shuttle, into orbit.

As a journalist, I have always taken pride in being apolitical, but hanging out with the Carters was fun. There's something to be said about the fresh wind of naiveté, and Jimmy Carter had it. There's also something about the stink on a professional politician that's hard to abide. President Carter never paid his dues in that club and I must admit, returning to my first love—the space story—felt like walking in my favorite pair of shoes. Jo ran off some guy she'd taken up with while I was gone, and—I'm lying! It was good to be home.

The Space Shuttle Era

N othing like it had ever flown before.

It was a winged spaceship the size of a jetliner.

It stood on end on a rocket's launch pad strapped to two towering solid rocket boosters and a huge tank filled with more than 500,000 gallons of super-cold fuels. Those engineers who should know about such things said it would blast off like a rocket, perform all kinds of useful maneuvers in space, and return to land on an airport runway.

While I was in and out of town on other assignments, NASA engineers spent five years solving the problems that beset the revolutionary spaceship. The high-tech machine was called the Space Shuttle, and it was pushing the technological envelope with main engines and booster rockets and fragile thermal tiles and reinforced carbon-carbon panels needed to protect it and its crew through the volcanic heat of reentry.

Slowly the problems were overcome and NASA set about its job of building four of these revolutionary fliers. The agency named them after historic sailing ships: *Columbia, Challenger, Discovery,* and *Atlantis.*

Columbia was the first rolled out and the media horde returned, settling on the press site only three miles from the Shuttle's launch pad. Most major news organization, as did NBC, had their own building on

the six-acre mound along with trailers, television trucks, bleachers, high viewing stands, camera mounts, and a blizzard of antennas.

My friend Dixon Gannett had the latest in RV comfort and we managed to outfox security. We parked his recreational vehicle on the press site near the NBC building. When the security guards weren't looking, we enjoyed "not permitted on federal property" libations. Our on-air performance was noticeably improved.

Speaking about not permitted, all accredited members of the media had the freedom of driving through the security gate directly to the press site, where we were to remain with a couple of exceptions. We had the freedom of moving about the press mound and permission to drive to the nearby cafeteria, but nowhere else. Anyone caught elsewhere on the federal complex would be jailed. Some out-of-town coworkers had to test it. They felt the urge to leave the mound for a close-up look at an Apollo *Saturn V* rocket display. They were having a good time crawling all over the huge moon rocket when they were arrested. They were thrown behind bars and, crying for help, they called our executive producer, Joe Angotti.

Now Joe is definitely a great newsperson and a great boss. He's also definitely a gentleman. But he's just a little bit stupid. "I'll come over and get you out," he said, and proceeded to drive to the rescue of his crew. Joe had forgotten one minor detail: He wasn't permitted to leave the press mound either. He introduced himself to the gendarmes and they in turn introduced him to their jail.

Sitting behind bars, a light glowed. Should I call someone who would know what to do? Yep Joe, I would say that would be a good idea. We sent official NASA escorts to haul the red-faced culprits back to the permitted area about the time John Chancellor arrived.

Chancellor, anchor of *NBC Nightly News*, would host our launch coverage. Naturally we were all concerned about John's well-being and comfort. Not that he demanded it; such a gentleman never would. But Chancellor deserved it. So we moved him into Dixon Gannett's RV. It was a happy union. The largest stockholder in the Gannett newspaper chain was fully stocked with whatever he wanted, and when it came to beer, Dixon wanted Coors. Coors in those days could not be bought east

Dixon Gannett and John Chancellor. Who has the Coors? (Gannett Collection).

of the Mississippi River because of its brewer's discipline of constantly refrigerating his Rocky Mountain brew. Coors just happened to be John Chancellor's favorite, and he found instant happiness in Gannett's home on wheels. Only work forced him to leave.

Veteran moonwalker and NASA's most experienced astronaut, John Young, had been assigned the command of *Columbia*'s maiden flight—the same John Young who'd carried a corned beef sandwich on board the first Gemini with Gus Grissom. The same John Young who would later fly twice to the moon, nearly wrecking his moon buggy in a lunar rock field. And, keeping with "the good old boy" spirit, NASA managers told the son of an east Texas roughneck to join Young for the Space Shuttle's first launch. The rookie's name was Robert "Crip" Crippen, and true to his east Texas roots, he drove a pickup truck with about a square foot of metal that hadn't been dented.

NASA officials patted themselves on their decision-making backs. They knew in Crippen they had picked an outstanding test pilot, and they also knew they had selected an outstanding "Space Shuttle shake-

down crew." But on April 12, 1981, no one really thought the first Space Shuttle would lift off on only its second countdown. The machine was too complicated. Too testy, too damn many parts . . . over a million of them that had to work before the computers would cut the space plane loose.

The first countdown had been scrubbed two days earlier by a computer glitch. No harm; it had been expected. Launch-team members and astronauts alike were sure it was only the first of many. They even bought tickets for a cash-up-front pool on how many countdowns it would take to get the sophisticated, complicated tangle of high-tech mess into orbit.

Nevertheless, John Young and Robert Crippen sat fat and happy atop their 500,000 gallons of high explosives. They waited for the rich combustible liquid to ignite in the chambers of *Columbia*'s three main rocket engines. That should be a kick in the pants within itself, but the firing of the twin solid booster rockets should be something else. Talk about a kick! The power of the *Saturn V* moon rocket would be booting them into orbit and I told our NBC audience, "Astronauts Young and Crippen are strapped in their ejection seats and if there should be an emergency the two pilots could eject themselves safely away from any disaster."

My radio colleague Steve Porter and I were broadcasting from the NBC building's porch three miles away. We couldn't believe the countdown was actually moving closer and closer to a liftoff.

Suddenly on board *Columbia* there was belief too, and Crip turned to John and said, "I think we might just do it!"

Young, the most experienced astronaut in NASA, was widely known for his sense of humor. "Did you lock your pickup?"

Then something never before seen happened. Ignition began in a swift rippling fashion, a savage fire birth as three liquid-fuel engines ignited one after the other, creating a blizzard, a swirling ice storm shaken from the flanks of the Shuttle's fifteen-story-tall super-cold external tank, and I could not believe what I was seeing. I shouted into my microphone, "They're going to do it. They're going to launch."

And when eight seconds had passed, the three main engines were up and screaming, waiting for the computers to sense all were running

and ready to fly, and new flame raged. The giant solid boosters had ignited with six million pounds of thrust instantly growing into two large pillows of fire and steam. The boosters were alive, pushing against concrete, steel, and a Niagara of water flowing through the launch pad's flame trench. *Columbia* was suddenly climbing from its insanity of fire—fire that was growing fiercer, then brighter, two legs of rocket thrust pounding into the Shuttle's launch pad . . . determined to lift the mighty spaceship from Earth . . . both pillars of fire stretching longer than two football fields . . . shattering the quiet of Florida's spacecoast with earsplitting thunder, thunder never before heard even from the mighty Saturn moon rockets . . . thunder rolling across water and earth and marsh to pound our chests, to physically move our skin and our clothes, to shake our teeth and bodies.

I looked at Steve Porter; he couldn't seem to say anything. The all-new Space Shuttle glistened in the morning sun, muscling itself from the grip of gravity, slowly pounding its way skyward. Porter was clearly mesmerized by all the fire and thunder rising before us, so I did my best to tell our NBC audience what we were seeing, what we were hearing, as *Columbia* blazed its way deeper and deeper into a bright Florida sky.

Some fifty thousand had wormed their way onto the space center itself while three-quarters of a million crowded the fences, the causeways, the thickets, the beaches, anywhere they could to watch this unbelievable new space machine climb toward orbit. It was thunder that never stopped thundering, fire that never stop burning, and when two minutes had passed, *Columbia* kicked its towering burnt-out solid boosters to each side and sped out of our view, flying like a homesick angel into Earth orbit.

The new space plane shut its main engines down and Young and Crippen, the gutsy fools, grinned at each other. Crippen savored the joys of weightlessness and told Mission Control, "You're missing one fantastic sight."

Then, the astronauts opened the clamshell-like doors covering the Shuttle's sixty-foot-long cargo bay. The operation was critical. The inside surfaces of the doors were the Space Shuttle's radiators, and with-

out them the ship could stay in space only hours. Equally important, the doors had to be closed tightly during reentry. Otherwise, the Shuttle would go out of control and tear itself apart.

But mission planners weren't having any of that. No troubles, thank you. They were keeping this first flight short—only fifty-four hours. They wanted safety margins as wide as possible. Young and Crippen spent the next two days shaking down *Columbia*'s systems and then headed to the wide-open dry lake bed at Edwards Air Force Base in California. The astronauts wanted all the room they could possibly use for the first Space Shuttle landing.

While flying backward, Young had fired the Shuttle's twin maneuvering rockets over the Indian Ocean. The braking thrust slowed *Columbia*'s orbital speed. The new spaceship's reinforced carbon-carbon wing panels and fragile thermal protection tiles handled the three-thousand-degree fires of reentry. The two fliers glided their new space plane to a perfect touchdown on California's high Mojave Desert. There, more than 200,000 space fans riding all-terrain vehicles, dirt bikes, sport-utility vehicles, and RVs chased *Columbia* across the hard desert.

"Welcome home, *Columbia*," Mission Control radioed. "Just beautiful, beautiful."

Seven months to the day after the first Space Shuttle launched from Cape Canaveral, *Columbia* became the first spaceship to return to orbit. At the controls was a pair of space rookies: Joe Engle, who had been bumped from his ride to the moon on *Apollo 17* to make room for scientist Jack Schmitt, and Richard Truly, a learned gentleman who would later become the boss of NASA. They were followed by shuttle crews sending spinning satellites out of *Columbia*'s cargo bay and by premiere spacewalker Dr. Story Musgrave. Musgrave opened the space repair business by testing new spacesuits and tools, every tool you could imagine that would be needed in weightless orbit.

Columbia put America into the space transportation business and the next Space Shuttle, *Challenger*, stepped to the plate and made its debut

two years later. It carried the $135 million tracking and data relay satellite (TDRS) into orbit, and then NASA officials turned their attention to a thorn in the agency's side since its birth: female astronauts.

A female cosmonaut was one of Russia's first space fliers.

In 1978 and 1979, NASA selected eight qualified women and began their training. After sending eighty-two men into space in twenty-two years, the United States finally was ready to launch a woman. Her name was Sally Ride, and on June 18, 1983, as the Space Shuttle *Challenger* thundered from its pad, my colleague Steve Porter was shouting into his mike, "Ride Sally Ride."

Ride did her job exceptionally well, reporting, "It's the most fun I ever had in my life," and proved women were just as adaptable to space-flight as were men, and in some cases better. Two months after Sally opened the space door to women, another door was opened. America's first black astronaut, electrophoresis engineer Guion Bluford, Jr., flew aboard *Challenger.*

Astronaut Sally Ride, the first American woman in space, talks with Mission Control. (NASA).

Shuttle flights were happening so fast and successfully that a smiling NASA was realizing its dream of routine access to Earth orbit. There were problems, however. Computers did terrible, unpredictable things by halting countdowns, shutting down main engines after they had ignited, and, as computers can, just being shits. Of course, there were also the nit-picking mechanical problems, and the weather—always the stinking Florida weather halting one launch attempt after another and diverting landings to Mojave's high and dry desert lake bed.

But America's Space Shuttles flew and flew, and their crews delivered satellites and brought some back for repair. Astronomy astronauts gazed at the heavens while other astronauts tested space-station assembly techniques, conducted extensive medical research, and when no one was looking, dropped off secret spy stuff for the military.

Missions were coming and going so fast the media and a large percentage of the public were becoming bored. After all, Space Shuttles were only circling Earth. Many Americans had been rocked to sleep with NASA's "can do" attitude and safety record. Forget about the fact space flight could be a killer.

The public at large believed the winged spaceships were as reliable as a passenger jet. The fact U.S. Senator Jake Garn was permitted to go into orbit didn't help discredit that fantasy. As chairman of the Senate subcommittee that oversaw NASA's budget, the senator joked in a meaningful tone that he would not vote for the space agency's budget if he didn't get a shuttle ride. When NASA finally said okay, critics accused Garn of using his political clout to make the ultimate congressional junket. But the former navy pilot brushed off the carping and, after four months of training, he rode the shuttle *Discovery* into orbit on April 12, 1985—four years to the day after *Columbia*'s maiden launch.

To make himself useful on the journey, Garn volunteered to be a medical guinea pig. NASA needed to better understand space motion sickness. More than half of Shuttle fliers were experiencing the malady. Well, by crackey, Jake Garn turned out to be a perfect subject. It seems, because he'd used his senatorial clout to get his ride, the good senator's proper meds to reduce space nausea were somehow misplaced. His crewmates returned to Earth hysterical with laughter. They told me

Garn was sick the whole flight and, when he appeared just once before the television camera to speak to the voters back home, he was held upright and steady and stuck to *Discovery*'s cabin wall by Velcro. Since that day, Shuttles fly with the "Memorial Jake Garn Wall" for all those who need a barf bag, and sick astronaut upchucks are measured in one, two, or three Garns.

One might think flying nonessential astronauts in space would have ended there.

Well, it didn't. NASA now had a congressional problem of its own making. The agency felt it simply could not fly the chairman of the Senate subcommittee that oversaw its budget without inviting his counterpart in the House of Representatives. Congressman Bill Nelson didn't ask to go. The gentleman of our capital city would never impose on anyone, but when NASA insisted, he climbed aboard the shuttle *Columbia* and was given the proper meds. Nelson made it through his flight without once turning green.

And as the old saying goes, when it comes to climbing on the bandwagon, going all out to get what you want, we are all prostitutes. For years we reporters had been told the first citizen in space would be a journalist, and I found it easy to imagine myself an astronaut only temporarily earthbound. I had visions of broadcasting every second of the thundering and rattling ride into orbit no matter how scared out of my wits I was, but President Ronald Reagan was on the prowl for votes he didn't need. His 1984 reelection campaign went after the large National Teachers' Union with the promise "a teacher will be the first citizen in space."

The people voted, and Reagan swept the country and kept his promise. No one could disagree. The teachers' choice, Sharon Christa McAuliffe, was simply perfect. She was a thirty-seven-year-old social sciences teacher from Concord, New Hampshire, who planned her assignments with all the enthusiasm of a senior going to her prom with permission to stay out all night. Smart and sharp, she won her ride into orbit over eleven thousand other applicants, and we reporters heaped on the deserving praise while the program to select one of us among 1,769 applications moved ahead.

The application to participate in the Journalist in Space Project was itself a trap. It was managed by the Association of Schools of Journalism and Mass Communication, and it was very specific and discouragingly long. It was filled with demanding essays and structured questions, and the impatient simply tossed it into the nearest waste can.

The selection committee wanted to weed out the "never finish anything you start" bunch from the opening bell. More traps came not only with the requirement of precise answers and essays, but with requests for references qualified to judge your work. The selection committee was not impressed with whom you knew, but with those references who had the expertise to judge your talents. While others put down governors, senators, astronauts, and movie stars, I gave the committee Dixon Gannett, John Chancellor, and Martin Caidin as references—each established and respected in my field. When the 1,769 were whittled down to national semifinalists, I was most pleased to learn I was among them.

As it's been said, good news comes in bunches. The next morning the mailman brought me a higher-paying contract with NBC News, and wife Jo called the carpenter and had double doors put on the front of the house. She explained we needed the extra width to get my head through. Then she announced loudly, "Come summer, I will be leaving my job." She reasoned that if her worthless spouse was finally earning enough to feed his family, there was little reason for her to stand on her feet most of the day punching dollars into complaining customers' bank accounts.

Congressman Bill Nelson's flight was the twenty-fourth for the Space Shuttle.

Christa McAuliffe's launch was to be the twenty-fifth.

Challenger was rolled to its launch pad.

A bitter cold wave was rolling, too!

Southward.

Challenger: A Disaster

In late January 1986, a frigid weather front rolled southward out of Canada and headed straight for Florida. The rare, bone-chilling freeze gripped unsuspecting palms and palmettos, stiffened and cracked rolling groves of citrus, and froze Florida's sprawling Kennedy Space Center to a slow crawl. The spaceport—making use of the latest electronic miracles and a step ahead of the cutting-edge of technology—had never felt such cold.

During the predawn hours of January 28, temperatures fell below freezing. Frost appeared on car windshields and ice fog formed above canals, swamps, lakes, and saltwater lagoons. Alarmed forecasters predicted a hard freeze in the 20s by sunrise.

Not a single tropical insect moved in the frigid stiffness. Birds accustomed to warm ocean breezes huddled in stunned groups. Fire and smoke rose from smudge pots set across Florida's citrus belt in last-ditch attempts to save the budding produce.

Along the beaches beneath the towering rocket gantries, only the sparkling white form of the Space Shuttle *Challenger* appeared in dazzling floodlights, its metal and glass and exotic alloys unfeeling of the arctic air—the great ship of space rising like a monstrous ice sculpture above its steel foundation. Finally, night slipped away and sun-

rise brought the first hope of warmth. *Challenger's* seven astronauts appeared on the launch pad. Their number included the courageous social-science teacher Sharon Christa McAuliffe, who had a smile big enough to adorn any magazine cover. She was a brilliant selection by the National Teachers' Union for the coveted role of the planet's "first citizen in space."

She had emerged from the enthusiastic wave of applicants giving all to become the one individual selected for NASA's acclaimed Teacher in Space Project. Those who wished her well went far beyond her contemporaries and the everyday citizens who prayed for her success. Millions of schoolchildren eagerly awaited her departure from Earth.

McAuliffe wasn't going into space as a tested scientific or engineering member of the crew. She was leaving Earth to command the attention of the world, including awestruck American schoolchildren. Having squirmed beneath congressional brickbats and attempts to slash

Citizen-in-space Christa McAuliffe is seen here (third from right) with her crew days before the seven would be lost in the Challenger accident. (Michael R. Brown/Florida Today).

NASA's budget, even to do away with the superbly engineered Space Shuttle program, the space agency stoked the Teacher in Space Project as the perfect response to dull the political ax held at its head.

You could scrub an astronaut, cancel a mission, condemn a fleet— but you did not mess with Apple Pie, Mom, and Our Sainted Teacher.

"This is a beautiful day to fly," *Challenger's* commander, Dick Scobee, said as he stopped on the walkway to the entry hatch. To the veteran astronaut, the cold, cloudless sky was perfect—conditions that experienced pilots called severe clear. It was true: On such a clear day you could see forever, and from nineteen stories above ground the crew beheld a sparkling, shining string of ocean breakers in the curving surf along the Cape's coastline to the south.

One by one, the space-farers donned their helmets and, with the assistance of the specialist, climbed through the hatch into the deep and wide recesses of the crew compartment. As McAuliffe prepared to enter *Challenger*, a member of the closeout crew presented the teacher with a red apple. It was a nice public-relations touch for our television audience, including the families of the astronauts who sat in warmth three miles distant in their VIP suite.

But in spite of the public-relations portrait being painted, *Challenger* was in every respect a contained iceberg. That the presence of so much ice was a clear danger to the launch team was demonstrated when the countdown reached its standard ten-minute hold at T-minus nine minutes in the count. This time the call was heard loud and clear.

"Hold!"

Launch Control explained the delay. The standard hold of ten minutes would be extended. The count would be held at the T-minus nine– minute mark for hours, if necessary, until the temperature rose to 40 degrees. Everyone looked at the sun, beseeched its warming rays.

But the warmth of the sun on the outside could not solve the problem of the critical O-ring seals inside the solid rocket boosters. Without the direct rays of the sun, they would stay cold, hard, and brittle until the needed hours of warm outside temperatures slowly thawed the inner workings of the booster. Any first-year engineering student should

have known that—known as well the fact that the more frozen the O-rings were, the longer you had to wait for them to thaw.

The synthetic rubber O-rings' design purpose was simple enough: to seal the joints so tight they would prevent violently hot gases from escaping as spears of flame. It was a hard task for any piece of equipment, and the booster engineers felt helpless. For months, they had been studying the O-ring seal problem. They knew a disaster was coming, but no one stepped forward and said, "Stop this train until it's fixed."

At about 11:00 A.M. Eastern time, Launch Control notified the *Challenger* crew that conditions were definitely warming up. The launch team anticipated resuming the count shortly.

"All right!" came the enthusiastic response from *Challenger*'s commander Dick Scobee.

At Mission Control in Houston, flight director Jay Greene polled his team for their final status report. At the Cape, launch director Gene Thomas ran through his checklist items with his team in launch control. It was a familiar and critical litany of last-moment review and checks.

Every response was "Go!" Not a single call to stop.

Inside *Challenger*'s crew cabin, the pilots, Dick Scobee and Mike Smith, went with precision through their final checks.

All seven astronauts locked their helmet visors in place. They rechecked their seat harnesses one final time. Every man and woman was strapped in securely. Commander Scobee told his crew, "Welcome to space, guys."

In Launch Control, NASA commentator Hugh Harris reported the countdown's final moments. His words spoken into the microphone that carried his official report to every media outlet worldwide. He watched the numbers shining brightly before him. Green and flashing numbers: They gave him an update with each passing second of the count while a television monitor showed him *Challenger* looming high on its icy launch pad.

But the NASA commentator wasn't that comfortable relying on elec-

tronic vision. He found himself turning often in his seat to peer at the shuttle through the huge glass window trusting only his own eyes that all continued smoothly toward that critical moment of engine ignition.

Hugh Harris had been the "voice of Launch Control" for most of the previous twenty-four shuttle flights. As chief of information for the Kennedy Space Center, he knew the drill by heart and felt comfortable with the routine.

Last-second events kept Harris busy, providing a steady stream of information to the outside world. Through the news outlets carrying his running commentary, Harris's microphone was the public's link to the event.

"T-minus four minutes and counting . . . "

As the countdown rolled, the astronauts' families were hurried from their VIP suite to an observation deck on the roof of Launch Control.

Ignition began as a flash of coruscating fire.

"T-minus ten, nine, eight . . . we have main engine start . . . "

Challenger came to life.

Searing orange light appeared in a swift rippling of unleashed power. This was the moment of the Shuttle's savage fire birth. The light was so intense it forced tears to the eyes of many of the onlookers. Three engine bells, now lost in the controlled tornado of burning rocket fuel, cascaded their violent fire down the curving flame tubes. White clouds snapped into being as fire and water begat shrieking steam. *Challenger* shook, vibrating its flanks. A blizzard appeared about the huge fuel tank as thunderous vibration ejected the ice storm that had gathered on the outer-skin of the fifteen-story-tall external tank.

The main engines screamed in a hoarse bellow, waiting for the computers to sense that all three engines were running properly and had built to the required liftoff thrust.

They had. Relays clicked. Computers gave the signal to ignite and release the hold-down bolts of the two giant solid rocket boosters.

Two enormous fire plumes snapped into existence, gushed downward, and spattered away in every direction, raging, uncontainable.

"Five, four, three, two, one," the words rolled strongly from the voice of Hugh Harris.

Challenger: A Disaster | 231

The giant spaceship kicked free of its launch pad and spread its flame in a visible blast, burning ever brighter, ever fiercer.

"Liftoff! We have a liftoff of the twenty-fifth Space Shuttle mission and it has cleared the tower."

Hugh Harris's words were now barely audible over *Challenger's* thunder, over the screams and shouts of the thousands of onlookers crying the prayer of the astronauts, "GO, GO! GO, GO!"

Almost at the same instant Harris spoke those words, the shock wave from the running engines arrived at the press site and the VIP bleachers three miles distant. The deck trembled and astronaut family slammed against family on the roof observation deck. Sound crashed and rolled, tumbling and shaking ground and water and air. . .

On board *Challenger*, the seven astronauts felt the Space Shuttle come alive as its three main engines swiveled in a final pre-ignition check and then erupted in fire. Crew commander Dick Scobee shouted, "There they go, guys!"

"Allll riiight!" came the shout from veteran astronaut Judy Resnik.

"Here we go!" laughed pilot Mike Smith.

Christa McAuliffe shouted personal words into her tape recorder for her students. She gripped her seat tightly, heard the booster rockets roar to life, and felt *Challenger* leap from its pad.

While back on the roof deck of the Launch Control Center, the astronauts' spouses and children stood stunned and awed, their bones vibrating from the mighty energy of *Challenger*. Sound engulfed and embraced them, a sonic juggernaut heralding a magnificent birth. They reached out, faces wet with tears, and sought each other's hands. Fingers gripped tightly, unknowingly watching their loved ones permanently leave this Earth.

At the moment of solid rocket ignition, something sinister happened. Barely apparent beside the opening fiery blast, a puff of black smoke spat forth from the lower joint of the right booster. Almost as

quickly as it appeared, it was gone. Much later, examination of every frame of film and every inch of videotape would reveal that the smoke spewed forth from a sudden, tiny gap. It was a death warrant.

The freeze had robbed the critical O-ring of its ability to flex, to expand and seal, and when the joint of the booster rotated, it created that tiny but critical gap. Searing gases rammed through and rushed past the breach. For two-and-a-half seconds, black smoke jetted out. Then, instantly, it vanished. For within the curving flanks of the rocket, aluminum oxide particles created by the burning fuel miraculously plugged the leak. Flame no longer escaped.

Unaware they were in mortal danger the astronauts waxed enthusiastic, shouting with excitement as *Challenger* hammered its way higher and higher.

"Go, you mother!" Mike Smith shouted as the Shuttle charged ahead, heading faster into space.

"LVLH," Judy Resnik announced, reminding the two pilots to check *Challenger*'s ADI (attitude determination indicator) on the cockpit panel for the ship's local vertical and local horizontal attitude.

"Ohhhkaaaaay," Dick Scobee agreed, grinning.

Sound and fury washed through our studio windows at the press site. Lights, cameras, and anchor platforms shook as walls rattled and floors rumbled. Beyond the window, red became orange, leaving behind a dazzling trail of golden fire.

Something told me to grab my telephone and move outside.

No matter how many of these shattering launches you have seen, no matter how many times you have felt the body-shaking impact, the shock waves rippling your clothes and skin, you never feel at ease. I phoned editor Jim Wilson at the New York radio network desk. Space Shuttle launches had become so safe and ordinary that even with the first citizen passenger on board, the only broadcast news service covering it live were our friends at CNN. This made me uneasy. Something told me all was not well.

V eteran space reporter Mary Bubb of the Reuters News Agency sat in the press site's grandstands with tightened fists. She tilted her head slowly to keep the climbing Shuttle with its attached booster rockets in clear view. Unthinking, she groped for the hand of the reporter seated next to her.

Mary was an original. A pioneer female reporter, she had been ill for months, but she was dedicated, undaunted by her ailing body. She had been covering space from the time the first rockets tried desperately to lift from their pads and she would never be absent for any launch, especially a Shuttle.

Today, something felt different. It was not the chill of the morning's freeze that swept her body.

"I'm afraid," she said, her voice barely heard over the battering vibrations and crackling roar. "I'm afraid for them."

H igh above *Challenger's* launch pad, the wind howled, blowing horizontally with hurricane speed of eighty-four miles per hour—some of the fiercest ever recorded for a Shuttle ascent.

The big spaceship accelerated with determined power into the area of Max Q, where its building speed created shock waves from the resisting air through which it had to fly. Inside the Shuttle the astronauts felt the side loads, felt *Challenger* meeting the invisible forces.

Space Shuttles had flown through high winds before. "Yeah," Dick Scobee announced in recognition of the sudden shaking, "it's a little hard to see out my window."

It was a moment with far greater impact than anyone could have known, for this mission carried with it a terrible flaw.

When the side loads of the winds smacked into the right booster, they struck an already weakened rocket. The winds were physical impacts. They jarred loose the aluminum oxide particles that at launch had sealed the lower joint where the O-rings had failed. Now the aluminum oxides broke up and spat away from the booster.

There was nothing left to hold back the raging fire and enormous pressure. A tongue of dazzling flame burst through the joint opening, creating a fearsome blowtorch of immense power precisely fifty-eight seconds into the flight.

No one in the crew cabin knew what was happening.

"Okay, we're throttling down," Scobee called out as he began the reducing power of the main engines from 104 percent down to 94 percent, and then reduced power to 65 percent. This would safely diminish the howling thrust behind them as *Challenger* knifed its way through the combination of powerful shear winds and maximum aerodynamic pressure.

Then, as suddenly as they had entered, they were through Max Q and commander Dick Scobee went back to full power, throttling the engines to full thrust.

"Feel the mother go!" yelled Mike Smith.

"Woooooohooooo!" another crew member shouted, swept up in the acceleration.

"Thirty-five thousand going through one point five," Smith reported.

Challenger was now seven miles high and booming past one-and-a-half times the speed of sound.

"Reading four-eight-six on mine," Scobee acknowledged.

Smith agreed with the routine airspeed check. "Yep, that's what I've got, too."

Scobee heard Mission Control report his three main engines were again running fine at full throttle. Every instrument reading of the Shuttle's flight and power systems was transmitted automatically, in real time, to Houston.

Mission Control kept up its steady monitoring, telling the pilots everything was "Go!"

No one knew the fiery blowtorch far below the crew cabin was already ripping apart the right booster while the crew worked smoothly, flawlessly.

"Roger, go at throttle up," reported Scobee. His steady voice amazed the world audience.

Suddenly a sheet of intense flame swept swiftly over Mike Smith's window.

The pilot's seat was on the right side of *Challenger*, nearest to the disintegrating booster rocket. In whatever instant of time was available to Mike Smith, he knew something terrible was happening. He had just enough time to utter, "Uh-oh!"

What Happened?

Flames from inside the booster rocket had escaped through the failed O-ring seal. They enlarged the small opening and grew into a monstrous blowtorch. The torch then slashed through the lower half of the external fuel tank that stored the liquid hydrogen. The lower half collapsed, with the entire tank following in swift disintegration.

The bottom strut attached to the right booster had broken away. The blazing rocket had swiveled on its upper strut and had sent its nose crashing through the skin of the tank. That had freed liquid hydrogen and liquid oxygen to mix disastrously and ignite.

Where there had been only cold blue sky pierced by bright flame atop a climbing white smoke trail, there grew a hellish fireball. No explosion, just an instantly growing monster of fire where metal tore, where it shattered into burning jagged debris that would continue to climb before tumbling and cartwheeling through curving arcs until gravity commanded its downward fall.

Nearby, two corkscrew spears of white smoke spun twisting paths even higher, the rocket boosters flaming out of control. The instant fire in the sky continued to expand in a scattering of flaming debris, creat-

ing hundreds of burning and twisting fingers of smoke that appeared to be running from the terrible blast.

While eyes were focused on the burning chunks of *Challenger* fluttering and whirling toward the ocean, a hairline streak of red arched up and then over in a curving line. It would be long remembered. *Challenger's* crew vessel with its seven astronauts was fleeing the flames and devastation.

In this ghastly moment, the very air over America's spaceport burned. Thunder echoed and boomed downward. It kept echoing and booming for the longest minutes. We were hearing *Challenger* breaking and shredding itself into hundreds, then thousands, possibly millions of pieces while beneath this sky of ominous groans, thin wailing cries and screams rolled upward from Earth to where *Challenger* died.

Inside Mission Control near Houston, NASA commentator Steve Nesbitt followed his flight-mission script. He kept up his litany of progress, reporting the main engines were now burning at their full thrust of 104 percent. He continued to read his prepared notes to match flight times and progress. He was simply unaware of what had happened to *Challenger.*

"One minute and fifteen seconds, velocity two thousand nine hundred feet per second, altitude nine nautical miles, downrange distance seven nautical miles."

Nearby, a flight controller gestured frantically. Nesbitt turned to see where the controller was pointing with such agitation. He stopped reading, disbelief gripping him like a giant fist. He was staring slack-jawed at the expanding fire cloud on the huge television screen before him, at the twisting smoke trails and the flotsam of burning debris raining toward the ocean.

He slumped into his chair, embarrassed, and afraid for the crew. Most of them were his friends, and Steve Nesbitt was above all else a gentleman and a professional. He hurt as if the weight of Earth had been dropped in his lap.

Tears started crowding into his eyes, but he was on duty. Nesbitt still had his job to do. He shook off the helpless feeling, rallied his senses, and keyed his microphone. "Flight controllers here are looking very carefully at the situation."

He simply could not explain what had really happened. He had to report only what he knew for certain. "Obviously," he heard himself saying, "a major malfunction."

There was nothing left to do. He leaned forward and turned off his mike.

B ack in Launch Control at the Cape, Hugh Harris fared no better than Steve Nesbitt. He was stunned, in shock, staring vacant-eyed through the big window. Even as he searched the tumbling, burning debris and corkscrewing smoke trails for some sign the crew was still alive, the scene before him refused to penetrate his own reality, that there could be that much fury and destruction.

It was . . . unbelievable. So inadequate a word! What made it all the more terrible was the tremendous personal emotion he felt for *Challenger*'s astronauts. Harris had shared with these people a professional and personal alliance. He stood in his emotional cocoon of shock and kept asking himself how in the name of God this could have happened.

O n the roof observation deck of the Launch Control Center, in the brilliant sunlight beneath the pockmarked sky, NASA escorts were doing everything possible to move the distraught, sobbing families away from the horrifying spillage of charred debris raining downward to ocean waters.

The children of *Challenger*'s pilot Mike Smith stood rooted to where they had been when the blast split the heavens.

"I want my father!" they wailed as one voice. "I want my father! He told us it was safe!" Then they lost their voices in tears and choking misery.

In the bank where she worked in Cocoa Beach, my wife Jo and her colleagues stood watching Challenger's remains fall toward the ocean. No one had a clear understanding of what had just happened, but Jo had been around space flight long enough to know something was terribly wrong.

Family friend Loverne Holt drove her car up to the drive-in window and Jo waited on her. Loverne's car radio was blaring with an uninformed news type telling his listeners the astronauts had aborted the flight, and they had been ordered to return to the Cape and land.

"I don't think so," Jo said quietly. "I don't think so."

Harry Kolcum, veteran editor of *Aviation Week*, stood in front of the press site's bleachers, staring at something he knew he would think about, and have dreams about, for the rest of his life. He didn't really want to call the office, to talk to anyone about what had just happened, but he had no choice. He turned and started walking toward his phone in the press dome.

Harry was a gentle man, a religious man. "God, be merciful," he prayed quietly.

Reuter's Mary Bubb left the stands with that terrible image in her mind. She knew *Challenger*'s loss would be with her forever.

Along the way radio reporter Mercer Livermore came running up to her. "Did you see the faces? The faces, I'll never forget the faces."

Veteran ABC space reporter Bill Larson was driving through the streets of downtown Chicago. Suddenly his radio's program was interrupted with the following bulletin: "The space shuttle *Challenger* has exploded in the skies over Cape Canaveral. There's no immediate word about the fate of the seven astronauts on board. It's apparently a

major disaster." Immediately Larson's mind took him back to the *Apollo 1* fire, back to the loss of his friends Gus Grissom, Ed White, and Roger Chaffee.

He quickly drove his car to the curb, and in spite of the heavy traffic and blaring horns, he stopped. "Dammit!" he pounded his steering wheel and screamed. "Not again! Damn! Not again!"

I nside the Associated Press trailer, veteran aerospace editor Howard Benedict worked furiously to get out the story to the world as quickly as possible. He was dictating over the phone to the AP's New York desk. His first paragraph was already available as a news bulletin in every newspaper and network and magazine in the world, and he was into his second paragraph:

"There was no immediate indication on the fate of the crew, but it appeared that nobody could have survived that fireball in the sky."

Howard felt a chill pass over his perspiration-soaked body, and he paused for a long moment—a long moment he didn't have time to spare.

Howard Benedict needed to cry.

N ext door, inside the United Press International wire-service trailer, aerospace writer Bill Harwood was madly typing copy into his computer terminal. Harwood was fast and he was good, and his copy was speeding over his worldwide wire as quickly as possible when he suddenly stopped, fighting back tears. They're dead, he thought soberly; they're all dead.

I n the press site's broadcast studios, ABC, CBS, CNN, and NBC were all on the air live.

Tom Brokaw, just possibly the greatest of the network anchors, was in the nation's Capitol and he raced to our NBC Washington studios to anchor *Challenger*'s coverage.

I was on the phone with news editor Jim Wilson, and before we went on the air I told him to give me a couple of seconds. I pulled the phone down by my side and focused on the destruction in the sky above me. I kept looking for *Challenger*. I kept hoping it would reappear out of that growing fireball—hoping, just possibly, it could escape and make a pancake landing on the Atlantic. No *Challenger*. No miracle. They were gone. . .

I bit my lip, wiped the wetness from my face, and told Jim, "Let's go . . ."

Wilson sprung into action. He had never been better. He called the normally, unflappable Cameron Swayzee into the studio to anchor the hotline bulletin.

A nervous, out-of-breath Swayzee took his cue: "This is an NBC News Hotline Report. This is correspondent Cameron Swayzee at NBC News Headquarters in New York.

"There has been a major malfunction problem with the Space Shuttle *Challenger* which moments ago lifted off from Cape Canaveral. Details are not certain yet, but let's go to Cape Canaveral and try to bring in correspondent Jay Barbree, who's standing by.

"Jay, are you there, and what can you tell us?"

"Cameron, we're looking at a disaster in the blue skies above this spaceport—a major disaster. The Space Shuttle *Challenger*, only a minute or so after liftoff, exploded. We have nothing but fire and debris above us . . . "

It was obvious the astronauts were dead but in journalism, in reporting death, you wait. You must wait.

The disaster was only minutes old as thousands of journalists were seen running for planes, headed for the Cape, and NBC News was no exception. We were moving troops in from our Miami Bureau as well as New York City, and in the New York newsroom they were madly searching for material, new information, any kind of facts about what had burned in the Cape Canaveral sky, but NASA had simply slammed their information door shut, not one syllable of official information coming from anywhere.

All videotapes, film, and pictures of the disaster were being gath-

ered on news chief Hugh Harris's orders, and as the bucket of information ran lower and lower, NBC-TV decided they needed me on the air with Tom Brokaw. They needed to reach back into the history of the space program and I could take them there; more important, I had the sources that could reach through NASA's closed information door and tell NBC's viewers why *Challenger* was lost. This was the time when solid reporting counted; not capped teeth, good looks, slick vowels and consonants.

The out-of-breath television producer in the next studio, Kelly Rickenbacher, came bursting into the radio booth. "They want you on television," he said.

I stared back at him. "I'm on radio, Kelly, I can't leave my assignment."

The television producer could not believe what he was hearing. "But they want you on television," he shouted, his tone implying television was obviously more important than radio.

"Let me check with the radio desk," I said, turning to pick up the open line with New York.

"Hell, no, you can't leave radio for television," Jim Farley screamed the words down the line. "You're our man. We need you there."

Jim Farley was vice president of Radio Network News, and he went on to tell me he would take the heat for his decision. I explained this to Kelly, and the television producer left madder than a rained-on setting hen only to return two minutes later to tell me Larry Grossman, the president of NBC News, was ordering me to move to television. I told the radio desk I wasn't going to disobey Mr. Grossman and soon I was running back and forth between the radio and television studios, scouring every available detail from my sources. Tom Brokaw and I were beating the pants off the competition, and in spite of the major tragedy it felt good.

That evening, the executives in New York decided I had the best chance of breaking the story of what caused *Challenger*'s accident and they sent in all the help we could use. The next morning I hit the ground running.

I locked myself in my office and started making phone calls, talking

with the grunts that turned the wrenches on the launch pad as well as supervisors and management types. I kept getting the same. No facts. Nothing. Just opinion.

I kept getting the same until one source made an off-hand comment about a concern raised the day before the launch by a Morton Thiokol engineer in Brigham City, Utah.

Thiokol built the solid rocket boosters for the space shuttle, and after further research, I learned the concerned person was senior rocket booster engineer Roger Boisjoly. Boisjoly had raised questions about earlier problems with the joints between booster segments, and Thiokol managers decided to alert managers at NASA's Marshall Space Flight Center in Alabama. Marshall oversaw the booster's design and production, and Thiokol decided to tell NASA management that the cold weather could seriously affect the shuttle booster's joints.

Boisjoly's concern was with the synthetic rubber O-rings designed to seal the joints and prevent hot gases and flames from escaping. On several shuttle flights, the primary O-ring had suffered severe hot gas erosion, and in a few instances minor erosion was found on the secondary O-ring seals. The problem was simple: The lower the outdoor temperature, the greater the erosion.

I learned that five months before *Challenger*'s accident, on August 19, 1985, Marshall Space Flight Center and Thiokol officials briefed NASA headquarters for the first time on the history and potential of the O-ring problem. They had not recommended halting flights, saying that continuing to fly was an acceptable risk while the joints were being redesigned.

Acceptable risk?

I phoned Cecil Houston, Marshall Space Flight Center's manager at the Cape, and asked him what in the hell was going on.

Cecil told me he had chaired two teleconferences the night before launch, and everyone decided the O-rings would not be a problem. "Everybody signed off on it, including Thiokol," he said. "We agreed we should fly."

"With the freeze we had you guys didn't think the O-rings would be a problem?"

"Naw," he assured me. "It was one of the engines."

"You know that for sure?"

"No, not yet," he insisted, "but we're looking. Something came loose."

"Like a fan?"

"Could be," Houston agreed, but quickly added, "Don't go with that yet, Jay. That's what we think happened. I'll let you know when we've got something."

Cecil Houston was a damn good engineer and a devoted manager. I knew he would be the last person to deliberately put an astronaut at risk, but nevertheless I could not believe the lack of concern about the O-rings.

I thanked Cecil and decided to phone a longtime friend who'd been brought to the space program by Gus Grissom before any astronaut crawled into a spaceship:Sam Beddingfield, the man who had retired only a couple of weeks before as deputy director of Shuttle Projects Management—the same Sam Beddingfield who told Gus Grissom he didn't need a parachute because he wouldn't have time to put it on. The same Sam Beddingfield who Gus told, "Put the parachute in my Mercury capsule anyway. It'll give me something to do until I hit."

Sam Beddingfield's experience and contacts were definitely what I needed. If anyone could find out what the brass on headquarters' fourth floor was up to, it was Sam.

I grabbed the phone, dialed, and listened to the rings. "Hello."

"Sam, this is Jay Barbree."

"Yeah, Jay, what's up?"

"I was sitting here wondering what's going on down at Headquarters this morning. Especially with senior management on the fourth floor?"

"I know what they're doing," Sam grunted. "They're running around, pointing fingers, protecting their asses."

"Most likely," I laughed, quickly adding, "Why don't you go down there and check it out?"

"I could," he smiled. "I still have a senior management badge."

"You want a job?"

"Doing what?"

"Working for NBC News as a news analyst."

"That sounds good. It'd keep me outta the pool halls."

"It would at that," I said, laughing. "Take a drive down to the fourth floor, check out what all your old buddies are talking about, and swing by the press site. If you'll work for us through the *Challenger* coverage, I'll clear it with Don Browne."

"Who's he?"

"Our Miami bureau chief. He's in charge."

"I'll think about it, Jay, and I'll take a drive by my old office."

"Do that, Sam. Keep in touch."

I put the phone down, suddenly feeling I was making progress. This just could work!

For the next twenty-four hours Sam Beddingfield parked himself in the executive offices at NASA headquarters, visiting old friends, listening to everything being learned about the accident. Most of the NASA managers simply thought Sam was still on the job and in the middle of the afternoon, January 30, 1986, two days after *Challenger* disintegrated nine miles above the Atlantic surf, Sam called me.

"I've got it," he said flatly.

"The cause of the failure?" I asked anxiously.

"A rupture in a field joint splice."

"An O-ring leak?"

"Right."

"That's for sure?"

"For sure."

"How do they know?"

"They have pictures."

"Whatta you mean?" I asked, my heart now racing.

"Pictures of the leak," Sam explained. "They can see the flame blowing out of the sucker like a blowtorch."

"Where did the pictures come from?"

"From a fixed engineering camera north of the pad."

"Away from our cameras? Where we couldn't see?" I asked.

"That's it."

"What did the torch do, burn into the tank?"

"Yep," he said. "They think it burned through the insulation and everything blew."

"We can't see it on our launch tape?"

"No way."

"Can you get your hands on a copy of that tape?"

Sam laughed. "You trying to get me shot?"

"This is great, Sam," I told him. "Great work."

I asked Sam to educate me on the booster segments, on the O-rings and the booster joints called "field joint splices," and he told me how they were stacked here in the Vehicle Assembly Building. Once I was comfortable with what I needed to know, I thanked Sam again and told him to come by the NBC building when he could.

I phoned a confidential source at the Marshall Space Flight Center and he confirmed what Sam had said. This was what we call in journalism a firm, second source, and I looked at my watch. It was 4:00 P.M. Eastern time, two-and-a-half hours to my buddy Tom Brokaw's *Nightly News*, and suddenly I was playing mind games. I wanted Tom to have the story, but the next NBC newscast was the 5:00 P.M. radio network hourly, and, dammit, I thought, should I go with it now, before someone else breaks the story?

I was obviously sitting on the biggest story of my life, and I knew I had to dump it in Don Browne's lap.

I left my office and went in to see Don. He sat talking on the phone, pretty obviously just chatting, and I held a finger before his eyes.

Annoyed, he looked up. "Just a minute, Jay."

Not now, play big shit another time, Don, I thought to myself, and moved right into his face. "Now," I said. "Get off the phone."

Don Browne was temporarily in shock. He couldn't believe I had spoken to him in that manner. He scanned my face, suddenly realizing I had something important to tell him. "I'll call you back later," he said, hanging up the phone.

I moved to within a foot of his face. "I got it."

"Got what?"

"The story, the cause of the blowup, dammit."

Don took a deep breath. "Let's go somewhere else to talk," he ordered, standing up and heading for the door.

Outside, I laid it out for him. "Let's go into the radio booth and lock the door," Don said. "We'll call New York in private."

Once out of earshot of everyone, Don phoned Executive Vice President of News John Lane and Vice President Joe Angotti. We filled them in, and Lane asked, "Who are your sources, Jay?"

Disbelieving that anyone in journalism would ask another journalist to reveal his or her sources, I took a couple of seconds, and answered: "With all due respect, Mr. Lane, I do not reveal my sources."

"Well," he said, "we have a policy, we have to know who the sources are before we put something of this magnitude on the air."

I was stunned. Was I witnessing the death of journalism here? I stood firm. "Mr. Lane," I began my answer, "I've been with this company for nearly twenty-eight years. I have broken my share of exclusives on NBC. I have never put any story on this network that wasn't gathered under the guidelines of solid journalism. You have my reputation. If that's not good enough, let me break it on radio's 5:00 P.M. hourly newscast. I'm sure Jim Farley will be most happy to put the story on the air."

"No," he said, "we want the story on Brokaw's show, but we have to be sure."

"Dammit, John, I'm sure," Don Browne spoke up. "Jay has the best sources here. He's proved it time and again. Now let's get Brokaw's people on the phone and let's break it."

I put the phone down. "You argue it out with them," I told Don. "When you have their decision, call me."

Don Browne argued and won. Tom Brokaw and I broke the story, the biggest of my life, and I did it with the *New York Times*'s reporter Bill Broad standing at my feet, taking notes.

The *Challenger* disaster would later be voted the number-one story of 1986 and I received a write-up in the *New York Times*, in the *Washington Post*, in *Newsweek*, in *Time* magazine, and on all the wire services. Larry King in his *USA Today* column wrote, "Jay Barbree of NBC News is arguably the best correspondent to ever cover the space program."

I could not help but notice that the breaking of the *Challenger* story failed to bring me a single nomination for any journalism award—a nomination generally entered by one's company, and, even though the great news producer Jim Kitchell had gotten our unit an Emmy for the Apollo landings in 1969, in 1986 no grunt in the field was to be nominated for anything. Our industry was obviously on a slippery slide into show business. Journalism was an afterthought. Our future was the star system, where the greed of the world's multimillion-dollar news anchors would suck a network's news budget dry.

Two months later I was selected as one of the semifinalists in the Journalist in Space Project. Our number was 1,769 at the beginning, and those of us who were left in the final stages had to go before a selection board made up of six journalism professors and five peers. We were questioned by a live TV interviewer, and when it was over, there were eight of us left in the Southeast—five in the Washington Press Corps, two in Florida, and one in Virginia. My boss Jim Farley was proud. He was the one member of NBC News's senior management who had been helping me pull the Journalist-in-Space wagon down the road.

In March 1986, I settled in for what was ahead. There would be two-and-a-half years of covering NASA's recovery from the *Challenger* accident and "return to flight," and all the while I had to keep mind and body in shape for the Journalist-in-Space project.

It was a time of little sleep and many frustrations. Only minutes after *Challenger*'s remains tumbled into the sea, the largest naval search-and-salvage operation ever was launched. Six thousand people, fifty-two aircraft, thirty-one ships, three submarines, and five robot subs were used. The real pressure began the day civilian divers discovered the astronauts' remains. They were in *Challenger*'s crew cabin in one hundred feet of water seventeen miles northeast of the Cape. Every news editor in the world wanted to know if and when *Challenger*'s crew had been recovered, and the American public wanted to know when each astronaut had been reclaimed from the sea for interment by their family.

It was a time your best simply wasn't good enough.

An Eternity of Descent

The water was murky, swirling from surface winds, keeping divers Terry Bailey and Mike McAllister from seeing more than an arm's reach in front of them. They had been diving for days, recovering *Challenger*'s debris, and, now, on this dive, they had only six minutes left in their tanks.

They were about one hundred feet down, moving across the sea floor, when they almost bumped into what at first appeared to be a tangle of wire and metal. It was nothing that unusual, nothing they hadn't seen on many dives before. Then, they saw what was different: a spacesuit, full of air, legs floating toward the surface. There's someone in it, Bailey thought.

No, that's not right, he admonished himself. Shuttle astronauts do not wear pressurized spacesuits during powered flight. They wear jumpsuits. They carry along two pressure suits if they should be needed for an emergency spacewalk.

He turned to his partner. They just looked at each other and thought, "Jackpot!"

They had found the crew cabin but they were low on air, so the two divers made a quick inspection, marked the location with a buoy, and returned to their boat to report the find.

E arly the next morning, the USS *Preserver* recovery ship put to sea. The divers began their grim task of recovering the slashed and twisted remains of *Challenger*'s crew cabin and its seven occupants.

On first inspection, it was obvious the crew vessel had survived *Challenger*'s fiery demise and its descent to its watery grave. A two-year-long investigation into how the crew cabin, and possibly its occupants, had survived was begun.

Veteran astronauts Robert Crippen and Bob Overmyer, along with other top experts, sifted through every bit of tracking data. They studied all the crew cabin's systems down to the smallest, most insignificant piece of wreckage. They learned that at the instant the external fuel tank was breached by the rotating right booster, igniting 500,000 gallons of fuel, when a sheet of flame swept up past the window of pilot Mike Smith, there could be no question Smith knew—even in that single moment—that disaster had engulfed them. Something awful, something that had never before happened to a shuttle, was upon them.

Mike Smith uttered his final words for history, preserved on a crew cabin recorder: "Uh-oh!"

Immediately after, all communications between the shuttle and the ground were lost. At first, many people watching the blast, and some in Mission Control, believed the astronauts had died instantly—a blessing in its own right.

But they were wrong.

NASA's intensive, meticulous studies of every facet of that explosion, comparing what happened to other blowups of aircraft and spacecraft, and their knowledge of the forces of the blast and the excellent shape and construction of the crew cabin finally led some investigators to a mind-numbing conclusion. The seven astronauts survived *Challenger*'s breakup.

Rob Navias, UPI's outstanding radio voice who would later take a job with NASA, tracked the fate of *Challenger*'s crew intently. Navias, also a semifinalist in the Journalist in Space Project, told me NASA's

own forensic medical report, released July 6, 1986, concluded the crew most likely survived *Challenger*'s blast but was unconscious at impact.

Investigators found the explosive release of fuel that dismembered the wings and other parts of the shuttle were not great enough to cause immediate death, or even serious injury, to the astronauts. *Challenger* was designed to withstand a wing-loading force of three g's (three times gravity), with another 1.5 g safety factor built in. When the external tank was ruptured and separated the two solid boosters, rapid-fire events, so swift they all seemed of the same instant, took place. In the shortest of moments, all fuel was gone from the big tank.

Navias said, "The computers still functioned and, right on design plan, dutifully noted the lack of fuel and shut down the engines."

It was a supreme exercise in futility, because by then *Challenger* was no longer a spacecraft. One solid booster broke free, its huge flame a cutting torch across *Challenger*, separating a wing. Enormous g-loads snapped free the other wing. *Challenger* came apart—but the crew cabin remained essentially intact.

The explosive force sheared metal assemblies, but was almost precisely the force needed to separate the still-intact crew compartment from the expanding cloud of flaming debris and smoke. The best data told the experts that *Challenger* broke up 48,000 feet above the Atlantic. The undamaged crew compartment, impelled by the speed already achieved, soared to a peak altitude of 65,000 feet before beginning its curve earthward.

It was only when the crew compartment smashed into the sea's surface, and like a speeding bullet drilled a hole from the surface down to the ocean floor, that the impact crumpled the crew vessel into the tangled mass found by divers Bailey and McAllister.

Other experts argued that even with the crew cabin intact, wouldn't the violent pitching and yawing of the cabin as it raced toward the ocean create g-forces so strong as to render the astronauts unconscious?

But that was before the investigation turned up the key piece of evidence that led to the inescapable conclusion that they were alive: The commander and pilot's reserve oxygen packs had been turned on by

astronaut Judy Resnik, seated directly behind them. Furthermore, the pictures, which showed the cabin riding its own velocity in a ballistic arc, did not support an erratic, spinning motion. And even if there were such g-forces, commander Dick Scobee was an experienced test pilot. His body was trained and accustomed to such violent forces of flight and most likely could have handled the g-forces as did the bodies of Neil Armstrong and David Scott during the violent spinning of *Gemini 8* if, and this is the big IF, *Challenger* still had power, pressure, and oxygen.

The evidence led most experts I've interviewed to conclude that the seven astronauts did not have power, pressure, and oxygen, and lived for only a short time after the blast.

Some dispute this conclusion, and the truth is there is no way of knowing absolutely at what moment the *Challenger* Seven lost their lives.

NASA made this official admission: "The forces on the Orbiter (shuttle) at breakup were probably too low to cause death or serious injury to the crew but were sufficient to separate the crew compartment from the forward fuselage, cargo bay, nose cone, and forward reaction control compartment." The official report concluded, "The cause of death of the *Challenger* astronauts cannot be positively determined."

The man arguably the closest to the investigation, and in my mind the best of the lot in shuttle pilots, veteran astronaut Robert Crippen, is convinced *Challenger*'s seven survived only a short time after the breakup.

Why?

Because of the three facts stated before: power, pressure and oxygen.

"Without pressure and oxygen at those altitudes, you don't stay awake very long," astronaut Crippen said flatly.

Challenger broke apart at 48,000 feet and its crew cabin climbed to 65,000 feet before gravity grabbed it and brought it back to Earth. During that two-minute-and-forty-five-second flight, Crippen feels, all members of the crew surely would have lost consciousness.

Dr. Gene McCall, recently retired chief scientist of the air force's Space Command, agrees with Crippen. Dr. McCall told me, "Pressure is

only 20 percent of normal at 48,000 feet where the *Challenger* breakup occurred, and the pressure at 65,000 feet, the crew cabin's highest altitude, is only 7.5 percent of normal. At those altitudes the time it would take to lose normal brain function is nine to twelve seconds, and at these very low pressures even 100 percent oxygen will not keep you alive. These altitudes and pressures and times in the *Challenger* accident would have rapidly caused loss of consciousness and the crew would certainly have been unconscious, even if alive, at impact."

The bottom line and most accepted and informed conclusion?

Challenger's seven were asleep at the end.

Sudden Death

The recovery of *Challenger*'s debris and its seven astronauts' remains ended sixteen months of high-stress and flat-out competition. It ended with me satisfied I had done my best. I had broken the cause of the *Challenger* accident, as well as filing some seventy *Challenger* recovery stories on Tom Brokaw's *Nightly News* and the *Today Show*. My body felt like it had aged sixteen years instead of sixteen months and despite having to cover out-of-town stories while NASA redesigned the Space Shuttle's boosters, I still needed to train for the Association of Schools of Journalism and Mass Communication's Journalist in Space Project. For eleven years, jogging had been my answer to keeping in shape, and the hard sands of Cocoa Beach offered the perfect place to run.

May 28, 1987, was a typical late spring day. The temperature was in the mid-80s, and I had wrapped myself in the comforts of being home. Since *Challenger*'s loss, I had spent my working hours at the press site and on other assignments. It was time for some serious jogging, time to reintroduce my lungs to the cleanliness of the salt air.

I hurried over our home's sand-dune walkover to the beach, submerging myself in the ocean breeze. The brilliant white surf was just that, brilliant, and I squinted to stare across the ocean blue. A distant cruise ship

hung like a slow-moving cloud on the horizon and I stopped just short of the water. It was great to dig my jogging shoes into the wet sand where I began my series of warmup stretches. I was fifty-three years old, but I was trying to be thirty-three. Most of the semifinalists to be the first journalist in space were younger, one of the few exceptions being the man himself, Walter Cronkite. When it came down to it, I was confident I could do at least one more pushup than the trusted network anchor.

America was blessed to have such network news anchors as Cronkite and Tom Brokaw. They had been entrusted with their anchor chairs by such names as Murrow, Huntley, Brinkley, and Chancellor, and as my thoughts return to my jog, I knew they both fit nicely in those chairs. My fast-paced walk continued my bodily warmup. I felt the ocean breeze in my face. It smelled wonderfully clean, and I grinned widely, remembering Cronkite. He's just a hell of a fellow. He and Mercury astronaut Wally Schirra were some team covering the Apollo landings. Even today, Wally loves telling the story about what Cronkite said on the air when Armstrong and Aldrin touched down on the moon.

Walter Cronkite tells Jay Barbree, "I hope they get the Shuttles' plumbing fixed so we can fly before our plumbing stops working." (Barbree collection).

Schirra, the worrier, kept bugging Cronkite. "Whatta we gonna say when they land on the moon? It's gotta be historic, right?"

"Don't worry about it, Wally," Cronkite assured the astronaut. "I'll have something to say. It'll be fine."

Yep, it was.

After fighting off computer problems, *Eagle* landed softly on the moon's Sea of Tranquility. Millions were listening to what the *New York Times* called Walter-to-Walter coverage as Neil Armstrong reported: "Houston, Tranquility Base here. The *Eagle* has landed."

Capsule communicator Charlie Duke answered, "Roger, Tranquility. We copy you on the ground. You've got a bunch of guys about to turn blue. We're breathing again. Thanks a lot."

The first humans were on the moon. It was Cronkite's job to string profound words together—words for the history pages. Viewers listened intently. The master wordsmith sighed and said, "Oh, boy! Whew! Boy!"

I laughed aloud. Walter Cronkite was simply the greatest. We all did our best to emulate this genuine and loved man. The truth was, we did no better than he. You'll not find our words in print recording the century's most historic event.

S uddenly I was back to the present. I moved my jog into a perfect rhythm—running with the wind, matching my speed with the sea gulls flying and darting overhead. Stress had fled. The "runner's high" would soon be flooding my body.

I let my mind drift into the future. What if I should be selected as the first Journalist in Space? A magnificent obsession. My listeners would hear a commentary of absolute candor. That was a given. They would hear my reports of fears, of sensations, of exuberance, of wonder. I would take them along for the thundering and rattling ride through clouds and sky, through the heavens themselves, into orbit. Together, we would tumble as softly as a falling snowflake into weightlessness. There we would experience the thrill of swift sunrises and sunsets, of the whirling galaxies, the dancing nebulas, and the stars—so many, we so few.

To soar through space was indeed a magnificent obsession, and jogging was a minor price for me to pay for so much promise.

Running was not only a time to dream. It was also a time to think, to reflect and give thanks. I'm not a staunch religious man, but I feel there is something more—something beyond this life.

My wife, Jo, and I had a son born five weeks premature November 22, 1964. The local hospital failed to take proper precautions. Our baby developed Hyland's Membrane Disease a day after his birth, and we were doing everything we could to see he survived his underdeveloped lungs.

I had to visit longtime friend John Rivard, and during our conversation I received a thought message that our son had died. I visualized my wife sitting up in her hospital bed, crying. She needed me. I repeated the message I was receiving to John and headed for the hospital. We had named our son Scott, and when I arrived I found the scene precisely as I had received it in my mind.

"Scott's dead, Jay," Jo cried.

"I know," I answered, "about ten minutes ago."

We comforted each other, and, as John Rivard and I have agreed many times, my experience was real. I had in fact received the message by thought. Was it mental telepathy? Was it heaven sent? Whatever, it happened, and as my friend Dr. Gene McCall, the Princeton physicist told me, "There is much that cannot be explained by science. Perhaps, one day," he added, "but not today. Just be grateful you had such an experience."

I wiped the wetness from my face and turned my thoughts back to my run. I was growing tired. I was aware of the increasing strain on my body, but there was no cause for alarm. I felt the strain was due to the extra pounds I had gained the previous eight days covering the arrival at Jacksonville's Mayport Naval Station of a destroyer that had been hit by an Iraqi missile. Nevertheless I could feel the heavier air. My breaths were increasing in rapidity. My lungs were burning but I reminded myself, no pain, no gain. Ahead I could see the finish line. I was tired, more tired than on any run I could remember, but I was determined to finish. No giving up . . . no quitting. If I was to be the first Journalist in Space,

I must be willing to pay the price.

I was not aware of what was going on inside my chest. There was no pain. Only exhaustion. I was collapsing tired and I looked up at our house, at the gray walkover above the sand dunes leading to the backyard. Suddenly, there was a rocking flutter inside my chest. It was there . . .

Blackness . . .

Only blackness . . . a pure, deep blackness, absent of dreams.

Doctors call it "sudden death."

The little girl stared at my stilled body. She snickered as she watched the surf wash foam around my jogging shoes.

Her name was Christy. "Look at the funny man, Mommy," she said. "He's getting his shoes all wet."

"Come on, Christy," her mother ordered, grasping her little girl's hand. "He's drunk, honey. Stay away from him."

I was later told that others near my lifeless body paid little notice. It wasn't all that unusual to see a person lying on the crowded sand. Puzzling, but not alarming to most who made it a practice not to get involved.

David Frank, an engineer for RCA, was well into his daily walk as he approached my lifeless form.

"My God," he spoke to no one. "That guy just jogged by me."

He hurriedly knelt down and felt for my pulse. There was none.

Frank had spent many years on the Eastern Missile Range, assigned to island tracking stations where CPR was a necessity learned—where doctors and trained medical personnel were a scarcity. He knew what had to be done.

Quickly he began CPR, pumping my chest and blowing air into my lungs, and he would later tell me I coughed, tried to breathe on my own. But there was no luck. The breathing stopped again. Frank turned, looking for help. "Call the Rescue Squad," he shouted to passersby.

One block north Pat Sullivan, a college student, was at work at the restaurant Coconuts. He was carrying supplies into the dining room when he noticed the small group of people standing around my body.

"What's going on down there?" he yelled to a man on the beach.

"It looks like a drowning to me," the man replied.

Sullivan turned to his fellow workers. "Any of you know CPR?"

None responded.

He quickly ran the block to where David Frank was on his knees.

He stared at my lifeless body and froze. "My God," he shouted. "It's Mr. Barbree."

"You know him?" David Frank asked.

"I sure do," the young man responded. "His daughter Karla and I are friends," he said as he turned and pointed. "They live right up there, that house on the ocean."

My attempted revival was taking place within the shadows of the Park Place Condominiums. There, Debi Hall was busy preparing dinner, annoyed with her detective husband for leaving the police radio on. The constant 10–4s and law-enforcement chatter were getting on her nerves.

She paid scant attention to the call that a man was down on the beach and the Rescue Squad was rolling, until she heard the location. Then she ran to the balcony, looked down, and saw two men working on a lifeless body.

On her way out the door, she stopped only long enough to turn off the stove.

Debi Hall had been trained as an emergency medical technician to react quickly to any life-threatening situation. Her job was to take care of workers on the nation's spaceport, including the astronauts.

Within seconds she was on the beach, moving Pat Sullivan and David Frank aside. First she checked for my pulse. There was none. Then she resumed CPR. She knew it was critical to keep oxygen and blood moving to the brain and other vital organs.

She completed her first sequence and shouted in my ear. "Don't go to the light! Don't go to the light! You're gonna be all right."

She kept the rhythm going tirelessly. "Where the hell is that Rescue Squad?" she yelled.

Ed Clemons and Lee Proctor were busy with firehouse maintenance duties when the call came in. They both stopped and looked at each other. Clemons, a paramedic, had seen it all too often before, and the outcome was all too predictable. But they had to do what they could. Once in a great while they did get lucky, and maybe this call would be the rarity.

One thing in my favor is that I was lucky enough to drop dead within a block of the Cocoa Beach Fire Station and the city's Rescue Squad.

The rescue unit screamed out of the firehouse and headed for the beach. Clemons hit the ground first.

He stared at me dressed in jogging shoes, dry shorts, and a shirt wet with sweat. "This guy didn't drown," he protested to his partner. "He's a jogger."

"That's right," Debi Hall told them. "He went into v-fib while jogging."

Her eyes darted back and forth between the two firemen. "Did you bring a defib pack?"

"No," Clemons said. "The ambulance is on its way with that gear."

He read the disgust in Debi's face but let it pass. He and Proctor took over, first checking for a pulse. It still wasn't there.

"Don't go to the light," Debi screamed again in my ear. "Stay here with us."

"What's wrong with this woman?" Clemons mumbled as he instructed his partner, Proctor, to resume CPR chest compressions, manually moving the blood through my stilled heart into my lungs to pick up the fresh oxygen and send it to my brain and other organs.

My color began to return and occasionally I would attempt to breathe, what medical people call agonal respiration.

The rescue work continued until the ambulance arrived with the defibrillators.

Emergency medical technician Chris Bedard leapt from the vehicle with the defibrillator pack and immediately checked for my pulse. Still there was none.

He reached for my eyelids and checked my pupils. Good, he thought. They haven't dilated.

Bedard and his partner hooked leads to my chest and checked the monitor. The screen displayed what appeared to be chicken scratchings. It told the medical team my heart was in ventricular fibrillation, disorganized electrical patterns causing the organ to quiver instead of pumping normally.

"Stand back," Bedard ordered as he removed my shirt and placed the defibrillator's paddles on my chest.

Bedard set the equipment for two hundred joules shock, and the two hundred newtons of electrical energy lifted my body several inches above the sand.

The jolt did nothing.

Bedard set the equipment for a heavier force—three hundred joules shock. Again the electrical energy jolted my body off the ground.

Nothing.

The equipment was reset for a third shock, more energy, 360 joules.

Again my body was jolted into suspension above the sand.

Still nothing.

Bedard looked at the others. "Continue CPR," he ordered, moving to get an IV needle in one of my arms.

He started heart-stimulant drugs into the bloodstream as fresh oxygen continued to flow into my lungs. The CPR moved the drugs and fresh blood into the heart muscle itself.

While the medics worked feverishly to revive me, life in my home only one hundred yards away continued unaware that I had fallen victim to sudden death.

We had moved into the seaside house only four months before, and Jo was still busy decorating. She was painting in the garage when Pat Sullivan, face white, banged on the window.

"Mrs. Barbree," he called. "Your husband has fallen on the beach."

Jo's mind was suddenly numb. She paid little attention to what Pat was saying. All she could think about was that Jay had had a heart attack, just like his brother Larry, just like all of his family. The Barbree curse, she thought.

She started over the dunes overpass; to her left she could see the crowd, the fire department's rescue vehicle next to the county ambulance.

Jo watched as they loaded me into the ambulance, and she felt someone's hand on her shoulder. "I'll take you to the hospital, Mrs. Barbree," Sergeant Duane Hinkley said.

T he medics continued the procedures inside the ambulance to keep my brain and other organs enriched with fresh blood and oxygen as the vehicle, sirens screaming, raced from the beach and down A1A toward the hospital.

"Let's hit him with the paddles again," Chris Bedard said.

Bedard kept the defibrillator set at 360 joules, and with everyone clear, he sent another shock of electrical energy through my chest.

They stared at the monitor. A HEARTBEAT! Not perfect, but a heartbeat!

The medics stared at each other. Their lips stretched into economy-size grins. "I don't know who you are, buddy," Chris Bedard laughed, "but the sonofabitch didn't win today. You are one lucky sucker."

The sonofabitch referred to by Bedard was death, and Ed Clemons said quietly, "Welcome back from the dead, Mister. This is one time we guys won."

"We're not outta the woods yet," Bedard reminded them.

"Nope, but it's a hell of a start," Clemons grinned.

They sat quietly for the rest of the ride, tracing the restored heart-

beat across the monitor. Each knew if it had not been for the CPR efforts of David Frank, Pat Sullivan, and Debi Hall before their arrival, there was no way they would have won this day.

The odds simply were not with them. Only 25 to 30 percent of "sudden deaths" are brought back with the immediate attention of trained emergency medical technicians. But by the time they reached the Cape Canaveral Hospital, I was fighting back.

M y worried wife waited anxiously outside. She turned to Sergeant Hinkley. She had to know. "You think he's dead?" she asked flatly.

The veteran police officer, who would within months be brought down by a suspect's bullet and have his own battle to hold onto life, somberly looked into her worried face. "I'll see what's going on," he said.

Sergeant Hinkley moved to the door of the emergency room, looked in, and a smile crossed his face.

He turned back and walked to where Jo was sitting. "Hell no, he's not dead," he laughed. "They're having trouble holding him down on the table."

Jo leapt to her feet and threw her arms around the big police officer. "That's my man," she cried. "That's my man!"

I nside the room I twisted, turned, and fought, trying to make sense of my predicament.

Where did all the fog come from?

That's not fog, you idiot!

The hell it isn't! It's too cold not to be fog.

Why don't those people shut up?

There. That's better. The fog is moving away.

Look at the stars. Aren't they beautiful? Jo would love them. But, my God, they are so bright! Well, I'll just look at the blackness. Now, that's black. I've never seen night like this before. Never stars so bright.

I turned toward the light.

But it's not night over there. Over there it is beautiful. If I could go over there I could get away from the noise.

I struggled for a moment, struggled against the restraints before lying back. I was exhausted.

I fell back into the dark pit, back into the sleep without dreams, only to be awakened again by the noise. . .

To hell with those loud people! I turned to the beauty. The grass reached out, beckoning to me. The earth itself was alive and it flowed to me, and the trees were living creatures, green-golden-silver, swaying into a canopy through which there shone a glorious golden light.

Was I moving closer to . . .

To what?

I could *feel* life draining from me, but it was being replaced, and the thought whispered through my mind that nothing in life, nothing between heaven and earth, is really lost, and there was comfort in that when the light appeared as a tiny speck in the darkness, a light swelling in size and in brilliance, filling an endless globe of darkness, yet translucent and becoming a cross to fill the world and the universe beyond. A never-ending universe before me, shining from within, and I thought of God.

But I was alone.

Drifting in space.

Alone?

Where was God, I asked, and suddenly, out of the light, out of its magnificent brilliance there appeared a darker form, a bed—that's what it was, a huge bed being pushed by two white shadowed forms, two nurses, and I heard the gallop of their feet, the high-pitched squeal of wheels needing oil . . .

The brilliant light vanished. It was gone.

There was only the huge bed, the nurses taking tremendous strides, crashing through the darkness, the squealing wheels. . .

An invisible hand grasped me, swept me like a leaf in a high wind after the fleeing nurses.

Instantly the bed and the nurses stopped, and I suddenly realized

there was someone in the bed. A man. A familiar man, and he turned his head to face me.

Me. Hell, it was my own body. I was in the bed, but I wasn't. How could this be?

Where are we going? I asked in my silent voice.

"We're going to CIC."

"What's that?" another voice asked.

"Cardiac Intensive Care."

I moved into the huge bed, into my body, into a body strapped to the railings with arms loaded with IVs, with a mouth filled with tubes.

Suddenly we were moving down a long hall, moving by people, by equipment, and in step with disassociated sounds.

Sleep—I drifted into sleep. Welcomed sleep. . .

Sleep.

I spent the first two days in the hospital, my body inhabited by tubes, fighting restraints, trying to remember. I kept waking up, writing on a pad one question: *What happened?*

My wife would tell me and I would promptly forget.

My brain was literally swollen. The minutes it had been deprived of oxygen-rich blood had caused it to swell, and the doctors said I wouldn't be fully conscious until the swelling went down.

The question was how long would it take me to remember, and whether I would ever really recall any of the events surrounding my "sudden death."

The answer was yes; I was recalling them, but slowly. There was confusion between the real and the unreal. But after two days I'd come far enough back that they removed the restraints, removed the tubes from my throat. It left me more alert—and hungry.

The longer I lay in the hospital bed connected to the heart monitors, the clearer my thoughts grew. I was coming to realize just how fortunate I was.

I had being moving through life with the goal of pleasing everyone I met, most of all that beautiful woman sitting in my room's corner chair.

"You are in a good mood today," Jo smiled. "It's good to see you laugh."

I looked at Jo, watched as she rubbed a shoulder muscle, knew her neck must ache from sitting in the hospital chair for the past three days.

Some spend their lives searching for a mate. Some are looking for love. Some are looking for devotion. Others are looking for a friend. Most are looking for beauty. Well, I grinned, I found them all July 4, 1958.

That was seventeen days before I went to work for NBC and I was working for local radio station WEZY. I had been assigned to cover the Miss Brevard County beauty pageant, an annual celebration with plenty of food, bands, speeches, and a bevy of beauties dressed in all-white bathing suits to accent their Florida tans, moving gracefully across a stage before the judges, and when the contest was over, I was having difficulty pronouncing the winner's name, Jo Reisinger.

She was a raven-haired beauty cut from the same bolt of cloth as Elizabeth Taylor and Ava Gardner, and her first name was no problem.

"It's pronounced rye, like rye bread—rye-singer," another reporter told me, and I went on the air without the slightest hint I had just filed a report on my future wife.

The coming months would find me covering other beauty contests— Miss Space, Miss Orbit, Miss whatever—and Jo Reisinger kept winning, but not with just her looks and her figure. She was winning with personality and fairness to others, and when it came time for the senior class to elect a homecoming queen, Jo was elected.

Jo and I dated for a couple of years, long enough to know we were a solid fit, and on September 3, 1960, she got me drunk, drove me across the state line to Georgia, and married me before I could sober up. Well, that's the lie I tell. I've never gotten the first person to believe it.

Three weeks passed and finally we were back home, on the road to recovery.

Mrs. Jay Barbree, Mrs. Alan Shepard, and Mrs. Deke Slayton are seen here plotting against their husbands. (Barbree Collection).

NASA was still in the middle of redesigning the space shuttles' boosters, but a crew had been selected to fly the all-important "Return-to-Flight" mission.

NASA managers were hitting on all cylinders. They had selected as commander of the first post-*Challenger* flight Frederick H. "Rick" Hauck, a Space Shuttle veteran who was not only a seasoned naval test pilot; his skills as a gentleman were on equal par.

Years before as a naval test pilot, Hauck had flown a jet that blew up underneath him. The jet was an RA–5C Vigilante. The objective of the test flight on July 23, 1973, was simple: Verify the Vigilante's response to commands sent by an automated carrier-landing system on the ground. Shortly after takeoff from the Patuxent River Naval Air Station in Maryland, Hauck climbed to twelve hundred feet and turned downwind. He was ready. He set himself up for a hands-off approach. It was one of those lazy summer days with haze, with no definable horizon, and as you looked straight down, you could barely see the ripples on the surface of the Chesapeake Bay. Shortly after lowering the landing gear and flaps, Hauck heard and felt an ominous shudder. Seconds later, he heard another shuddering sound. The Vigilante shook, and on his

cockpit panel he saw a "RAMPS" warning light flash on, then off. This confused him. The light indicated that the engine inlets were somehow out of configuration, but at subsonic speed, the inlet ramps should not be moving at all. Then the left-engine rpm gauge started unwinding rapidly, signaling a flameout.

Hauck looked up. The Vigilante's nose had pitched down. The Chesapeake Bay waters were racing toward him, and the surface waves were in sharp focus. Hauck grabbed his seat's ejection handle and pulled. His seat's rocket blasted him away, free from the flames beneath his feet. Rick Hauck had just ejected from an exploding fireball and lived.

Now he would command the most important flight in the Space Shuttles' history—a flight that would result in the either space planes' rebirth or their demise.

I wasn't the only one ready to get back to work.

How High Is Up?

September 29, 1988.

Space shuttle *Discovery* sat on its launch pad.

Five seasoned astronauts waited.

They had been hand picked to fly the rebuilt ship after seven of their number were lost in the *Challenger* fires.

Two hundred-fifty thousand other souls had surrounded the spaceport to lend their support. Twenty-four hundred members of the news media had settled on the press site. They would witness NASA's comeback from its worst disaster.

At 11:37 A.M. Eastern time, *Discovery*'s main engines roared. Seconds later the twin solid rockets fired. The assembled thousands crossed fingers and gritted teeth. The two rebuilt solid rockets lifted the five astronauts skyward—boosting the space plane and rocket combination straight and true. Two minutes later the huge assemblage broke into wild cheers as the boosters, blamed for the *Challenger* accident, burned out and peeled harmlessly away from the Shuttle and its human cargo. Six minutes later, the main engines shut down and the five seasoned astronauts sailed safely into Earth orbit. Cheers erupted from the Launch Control Center at the Cape and in the Mission Control Center near Houston.

President Ronald Reagan opened an awards ceremony in the White House Rose Garden with the announcement, "America is back in space."

NASA had spent thirty-two months fixing the O-ring seal and other Shuttle problems, but to make sure they drove down the road of caution, *Discovery*'s mission was designed to be as benign as possible. Six hours into the "Return-to-Flight," astronauts Mike Lounge and Dave Hilmers released from the Shuttle's cargo bay a $100 million tracking and data relay satellite. The huge communications spacecraft was the replacement for the TDRS lost in the *Challenger* accident. The new satellite's onboard rocket motor fired and the new tracking and data relay satellite raced to a stationary orbit 22,300 miles above the equator. There it could cover a third of the Earth as it joined the first TDRS, launched earlier.

Discovery's astronauts poignantly remembered the five men and two women who died aboard *Challenger* before gliding to a landing on a dry lake bed at Edwards Air Force Base in California. Four hundred thousand grateful were there to meet them.

Discovery's veteran crew sport Hawaiian shirts given to them by its Cape Canaveral launch team. Front left: Dick Covey, pilot, and Rick Hauck, commander, center. Front right: John "Mike" Lounge. Back left: George "Pinky" Nelson. Back right: Dave Hilmers. (NASA).

The comeback continued two months later when the space shuttle *Atlantis* soared into orbit on a secret mission solely for the Defense Department, and then opened the door for science to dominate America's space efforts. The crew of *Atlantis* deployed the Space Shuttle's first planetary probe. A Magellan planetary ship was sent streaking away to Venus with radar to look through the thick Venusian clouds and map the planet's steamy surface. A second Shuttle planetary mission began October 18, 1989, when astronauts launched a three-ton Galileo spacecraft on a six-year, 2.4 billion–mile journey for up-close photographs of Jupiter. Other major planetary craft that were sent racing from shuttle cargo bays included Ulysses, to orbit and study the sun, and the Gamma Ray Observatory, to measure space radiation.

NASA entered the final decade of the twentieth century fully recovered from the worst accident in space flight history, and I entered the 1990s recovered from a coronary bypass operation at Emory University. My friends were amazed at how lucky I had been not only with my health, but with the Space Shuttle launch schedule itself. None of my health problems caused me to miss a single space flight, but living on the ocean in 1990s had become a serious problem.

No longer was Cocoa Beach the quaint little seaside village with its main beachside drive lined with swaying Australian pines. No longer were the easygoing villagers enjoying the slow pace of Florida living. It had become what many had predicted, another Fort Lauderdale, lined with one condominium after the other. There were now twenty times the number of people stacked on every inch of its once pristine sand.

Jo and I looked at each other and nodded. It was time, definitely time to move to Merritt Island—an island bordered on its east side by the Banana River lagoon and on its west side by the Indian River estuary, an island separating the beaches from Florida's mainland where low-lying hills on its southern tip host Honeymoon Lake, a body of water dug by mound-building natives four thousand years ago, a tropical winter sanc-

tuary today for geese and ducks from the north, and an equal sanctuary from greenback-laden tourists.

We managed to secure a piece of the lake's north shore and my wife began drawing up plans. By the time it was time for the most important Space Shuttle mission of the 1990s, the launch of the massive Hubble space telescope, we had moved into our new island home.

H ubble was set free in Earth orbit by a crew aboard *Discovery* and was hailed as the most advanced telescope ever built for astronomy.

The massive observatory, the size of a city bus, was a dream started in 1946 by Princeton astronomer Lyman Spitzer. Spitzer had urged our government to build an orbiting space platform with revolutionary instruments to probe the universe. No matter how powerful the astronomical telescopes on Earth were, they would never see clearly through the planet's thick and pollution-muddied atmosphere. A telescope orbiting above Earth's atmosphere could survey the heavens with unmatched clarity.

But once in orbit, Hubble was sidetracked by flawed vision. Two months after its fiery ascent from Cape Canaveral in April 1990, embarrassed astronomers admitted Hubble's goals were seriously compromised. Some systems worked well, but not the telescope's ability to see deep into the universe—back to near the beginning of time.

The most celebrated telescope since Galileo assembled his first optical instrument was sending Earth blurred images. Hubble's primary mirror worked dismally; the observatory electronics sent back pictures that were fuzzier than snapshots taken by the unsteady hands of a child. The precious eight-foot primary mirror, which it had taken five years to grind and polish to supposed perfection, was flawed.

The mirror was ten-thousandths of an inch too flat.

That sounds insignificant. It is only one-fiftieth of the diameter of a human hair, which means it's invisible to the human eye. But in the optical world of mirrors and lenses built to see twelve billion light years across the universe, that amount of error was enormous. So Hubble be-

came instant grist for late-night television comedians and a butt of ridicule for American science.

In Arizona State University's astronomy program, scientists were hard at work to come up with a fix for the myopic observatory. The result was COSTAR (corrective optics space telescope axial replacement), a box the size of a telephone booth. On Earth, it weighed 650 pounds, and it contained ten mortised mirrors. It was about as close to technical magic as astronomers and engineers could get. Each of its ten mirrors was no larger than a man's thumbnail!

The plan was for spacewalking astronauts to fly a Space Shuttle to an orbiting rendezvous with the massive telescope, grasp Hubble tightly with the Shuttle's robotic arm, and move the large observatory to within their reach in the Shuttle's cargo bay. There the spacewalkers would begin their "save the Hubble" week in space.

Among their repairs, the spacewalkers would slide COSTAR in place within the main structure, where the mirrors would shorten the beam of light images captured by the flawed edges of the primary mirror. By shortening the beam of light exactly two-millionths of a meter, Hubble would be able to focus accurately. Once the ten mirrors were in place, astronomers in ground control would transmit instructions for focusing COSTAR's mirrors by tipping them into thousands of different positions.

But more than COSTAR was necessary to bring Hubble back to pristine performance. New forty-foot solar panels would replace those that shook when the ship passed between day and night, through temperature changes of 500 degrees Fahrenheit. Two magnetometers that had lost their precision attitude control would be removed to make way for new ones. A series of critical gyroscopes that pointed Hubble on command had either failed or were failing; new gyros would be installed. COSTAR would be eased by the spacewalkers into its housing. A new computer would be added to Hubble to eliminate "electronic memory lapses" and increase the space telescope's reliability. And finally, the spacewalkers would repair flawed relays in the spectrograph that scanned the radiations of the universe.

Space Shuttle *Endeavour* departed Earth at 4:27 A.M. Eastern time on

The centuries-old technology that built Christopher Columbus's three sailing ships passes the twentieth-century Space Shuttle Endeavour, *awaiting liftoff on its launch pad. The replicas of the* Santa Maria, Nina, *and* Pinta *were part of the Spain '92 Foundation tour of American ports to celebrate the five hundredth anniversary of Columbus's voyage to the New World. (NASA)*

December 2, 1993, with astronauts and fifteen thousand pounds of precious tools, equipment, and supplies. No sooner than *Endeavour* had settled into orbit with its veteran crew, I was in the air headed for Mission Control in Houston. The Hubble repair mission had captured the public's imagination like no space mission since the days of Apollo moon landings, and Tom Brokaw, along with master producers Phil Griffin and Jeff Gralnick, wanted my experience reporting Hubble's repair on the *NBC Nightly News.*

When *Endeavour* reached Hubble's orbit, the astronauts found and seized the observatory with the Shuttle's robotic arm as planned, and then the spacewalkers, equipped with pressure suits and working in pairs, went through an astonishing week of giving the crippled telescope new life and sparkling accuracy.

Floating a constant 375 miles above a curving horizon, looking like living snowmen, the spacewalkers performed weightless ballets to make their repairs. It was a feat unparalleled in history, surgeons of

the new age operating beneath a star-filled theater. There had not been so much attention paid by billions of people since astronauts walked on the moon. With producer Phil Griffin running interference for us in New York, Tom Brokaw's viewers, as well as those of NBC's early-morning *Today Show*, were looking over the spacewalkers' shoulders. Live television cameras followed their every move. We from NBC were sleeping in two shifts. The crew and I were up at 4:00 A.M. to take care of *Today* and then back to bed, then up again at 2:00 P.M. to take care of

Floating on the end of the shuttle Endeavour's *robotic arm at the top of the mammoth Hubble space telescope, spacewalkers Story Musgrave and Jeffrey Hoffman are seen above the west coast of Australia. (NASA).*

Tom Brokaw's *Nightly News*. A couple of times we came close to meeting ourselves coming when we were going.

For the spacewalkers, performing microsurgery on Hubble's systems, as well as moving bulky and cumbersome equipment into the right slot at the right speed and with perfect aim, was like trying to weave a frond basket wearing thick mittens. The astronauts performed eleven major repairs while Hubble managers on the ground sweated out every move. One misstep could wreck the mission and damage Hubble beyond repair. Yet, from changing fuses to sliding the refrigerator-sized COSTAR into the telescope's bowels with less than an inch of room to spare, they pulled it off, against terrible odds, with nonstop perfection.

Finally the nerve-racking mission was nearing its end. The old solar panels were removed from their mountings. Spacewalker Kathy Thornton, with her five children on the ground clinging to the family's television set, had her feet secured to the end of the Space Shuttle's long robotic arm. Thornton held the twisted panels in her hands and pushed them away in tantalizing slow motion. Commander Dick Covey aimed the Shuttle's rocket motors at the old solar wings. Streaming rocket thrust struck the golden panels, and they flapped eerily up and down, looking like mankind's first space bird. Kathy's children jumped up and down before the television, screaming, "Mom is Superwoman," as the discarded solar panels began falling back toward Earth's atmosphere to disappear in a burst of flame.

K athy Thornton and her crewmates returned to Earth and Hubble managers began chewing their nails. They now had to wait to determine whether the orbital telescope surgery was as successful as they dared hope.

Power was fed to Hubble's controls. The space observatory accepted its checkout commands with a thumbs-up. The orbiting telescope was alive. Astronomers gathered before the huge television screen monitoring Hubble's cameras in the Space Telescope Science Institute in Baltimore, Maryland. The control center was bathed in the same tension as a busy maternity ward.

The master television screen flickered, then its picture steadied, and there it was—the first image from the rebuilt Hubble. *Star AGK +81 D226* . . . clear and sharp. It was perfection, and those in the room stared at one another until the tension was gone and applause, cheering, and backslapping began. Astronomers hugged one another fiercely, and NASA's top scientist, Ed Weiler, told those of us in the media, "It's beyond our wildest expectations." From nearsightedness to super vision, this was the new Hubble, and NBC space correspondent Robert Hager quipped, "It's amazing what you can do with a $629 million pair of contact lenses."

Before the astronauts' rescue-and-repair flight, Hubble could see out to four billion light-years from Earth. Now the massive space telescope's "vision reach" had tripled to twelve billion light years. Its new clarity would fulfill the promise of the massive orbiting telescope—its lens peering almost to the beginning of time.

H ubble fired the most doubting imaginations, because in the space telescope's twenty-year lifetime it would answer many eager questions.

Were there other planets outside our solar system? Hubble answered yes as it showed astronomers hundreds in our galactic neighborhood.

How old is the universe? Hubble says 13.9 billion years.

Is the speed of light really the ultimate velocity? Or will we find unanticipated matter and energy that travel faster? What exactly is dark matter? Does it really make up most of the universe? And what happens to the trillions of tons of matter that vanish into the maw of black holes? What are the white gushers in space pouring vast amounts of subatomic particles into our universe—with no identifiable source or known reason? And is the universe expanding? Hubble says yes as it observes exploding stars in galaxies whose light was emitted when the universe was half its present age, and the space telescope reports the universe's expansion is accelerating—being driven by an unknown force.

With Hubble still marching into the future, with astronauts planning one more maintenance-and-repair mission in early summer 2008

so the magnificent space telescope can study and photograph the first stars and galaxies formed twelve billion years ago, will we come to understand our place in the order of being? And of most importance, will we every answer the small child's question, "How high is up?"

Stay tuned.

As the Century Turned

One of NASA's oldest dreams was to build a permanent space station. It would, in some minds, be the beginning of an orbiting space city, a gravity-free outpost where earthlings could multiply, raise families, live longer, and produce the stuff and foods needed for self-sufficiency in orbit.

NASA had a small taste of operating its own space station in 1973. That's when it used rockets and spaceships left over from canceled Apollo missions. The agency launched three separate crews of three astronauts each to spend up to nine months aboard the station named *Skylab*. The astronauts proved humans could live and work in space for periods up to eighty-four days with few ill effects.

The Russians, after losing the moon race, used their workable rockets to build their own versions. They launched a series of *Salyut* laboratories with two and three cosmonaut crews staying in space for months at a time. It was from this experience that Russia sent a larger and, to many space engineers' way of thinking, the first real space station into orbit. It was called *Mir*, and cosmonauts stayed aboard their home in the sky for up to a year.

Spurred by Russia's success, the United States signed an agreement with Japan, Canada, and the member nations of the European Space

Agency to jointly develop an international orbiting complex. The United States would maintain the leadership role and provide the major elements of the future space city, with the Europeans and Japanese building research modules and Canada developing a mobile service center, a maintenance depot, and a large robotic arm.

By having to compete with the financial weight of America's Strategic Defense Initiative (called "Star Wars" by some), the Soviet Union broke apart and ceased to exist. Officials of the cash-strapped Russian Republic began vigorous international marketing of the still-to-be-built larger station called *Mir 2*. The most interested party was the United States. Meanwhile the International Space Station survived by only one vote in Congress. This spurred NASA to negotiate a deal making the former Soviet Union the newest partner in the international dream.

With Russia adding its *Mir 2* sections and rockets and Soyuz spacecraft to the program, the International Space Station grew by a fourth; its crew would now increase from four to six. The addition of the Russians reduced America's overall costs, and both houses of Congress smiled as the first of a series of international cooperative missions got underway. Cosmonaut Sergei Krikalev boarded a Space Shuttle and became the first of many cosmonauts who would ride into orbit on America's Space Transportation System.

Cosmonaut Vladimir Titov was aboard the shuttle *Discovery* when it flew to within thirty-seven feet of Russia's *Mir* and began "station keeping," a technique where each spacecraft orbits side by side with another, separated by a small distance. It was the first meeting of American and Russian spaceships in orbit since the *Apollo-Soyuz* linkup in July 1975, and it was a rehearsal for a series of Space Shuttle and *Mir* dockings.

From February 1994 to June 1998, NASA racked up eleven flights to the large orbiting complex. Seven American astronauts spent a total of 977 days, 2.7 years, in residence aboard Russia's *Mir*. It was on-the-job-training for the time when the International Space Station would become reality—not only for Russia and America but for thirteen other partners in the international project as well.

Between March 22 and August 26, 1996, Dr. Shannon Lucid began America's continuous presence on *Mir*. The veteran astronaut set an

Astronaut Alan Shepard (left), America's first man in space, and astronaut Robert "Hoot" Gibson (center), the commander of the hundredth American mission, recognize NBC correspondent Jay Barbree as the only journalist to have covered all one hundred American flights. (NASA).

American single spaceflight record with her 188-day stay, and those who followed enjoyed uneventful visits until astronaut Jerry Linenger arrived for his residency. The good doctor became the first American to take a spacewalk outside of the Russian outpost, but he also became the first astronaut to fight fire in orbit. At 10:35 P.M. Moscow time, February 23, 1997, cosmonaut Sasha Lazutkin activated a backup oxygen canister. It was needed because the station was supporting an overlapping six-person crew. Soon after the canister was activated, the master alarm erupted and Linenger's eyes went wide. A four-foot flame shot across the *Kvant 1* research module.

Warm air doesn't rise in a weightless environment. Fire cannot spread as it does on Earth. But this one had a built-in oxygen supply. The blowtorch-like flame rendered the *Mir's* water-based extinguishers useless and the flames blocked access to one of the two Soyuz emergency escape vehicles. This meant only three of the six people on the station could leave.

Unable to put out the fire, the cosmonauts and astronauts had only one choice: They had to let the fire burn out. Station commander Valeri Korzun aimed his extinguisher at the far wall to keep it from melting. The extinguisher acted like a rocket thruster, and Linenger had to hold the cosmonaut steady. Others brought in new extinguishers when the old ones ran out. The rest of the crew shut down equipment and powered up the accessible Soyuz. Fourteen minutes later, the canister had no fuel left to burn. The fire disappeared as quickly as it had ignited.

A second emergency happened on June 25, 1997, during astronaut Mike Foale's stay. A manual docking system could have cost him and his crewmates their lives. A Russian Progress supply ship ran into the station, knocking a hole in the *Mir*'s Spektr module. The result was rapid depressurization and the crew closed the hatch to Spektr. The station's air pressure stabilized, and after a few flight adjustments, *Mir* was back in operation.

My colleague covering spaceflight in those days was Robert Hager. Called the "rabbit" by those of us who admired him, Hager would hop from one story to another, and just to fire up our competitive juices, he covered them all superbly.

Robert Hager is a decent, warm, and most likable fellow, and he convinced Tim Russert, another decent, warm, and most likable fellow who is NBC's Washington bureau chief, that we needed a detailed model of *Mir*. We needed it if we were to continue covering fires and wrecks and such on the Russian space station. But the main reason was Hager's belief in models. He used them on most of his stories, including on his wedding night. Remember, a picture is worth a thousand words, and he told Tim Russert it shouldn't cost more than a couple of hundred dollars.

Russert, being the supportive manager he is, said, "Fine. Do it," and Hager was off to model factories seeking the best at the craft.

To cut to the chase, he had this detailed *Mir* model built at a cost of thousands of dollars. *Mir* never suffered another accident, and we never got to use the model. I'm told Russert moved it to the center of the bureau to use as a coat rack. Hager retired quietly to a farm in Vermont, where the senior country squire dresses smartly Saturdays and drives

his tractor to the better square dances. His wife, Honoré, standing on the back between the two large tires, seems just a bit unseemly.

B ack on Earth, trips into space were running like a well-oiled clock, and another senior was getting restless. John Glenn, the first American to orbit our planet, decided he'd had enough of Washington politics, and he retired from the United States Senate with the hope of returning to the pursuits of his youth. John had a hankering to prove a seventy-seven-year-old senior could handle modern spaceflight.

Most agreed it would be difficult for the average septuagenarian. Disregarding any ills, the slow movement of bodily joints and the re-duced strength of bodily functions alone would be enough to keep the average senior citizen out of orbit. But John Glenn was anything but average, and NASA was quick to recognize the public-relations value of welcoming back the senator.

But there was another problem. Lingering like a houseguest who refused to leave was a NASA promise. After the *Challenger* disaster, the agency announced that when it was ready to fly citizens again, the first person would be teacher, Barbara Morgan, who had been Christa McAuliffe's backup. But a fast-thinking NASA moved quickly to nullify its promise. The agency decided to make Morgan an astronaut instead. She would attend the same astronaut-training program as the others. She would be trained to fly and to pull regular astronaut duties; then Senator Glenn could go fly again and everyone would be happy.

Happy, my Aunt Hilda's petunias! What the hell about the Journal-ist-in-Space Project? NASA had promised a journalist would follow the teacher. When I asked, NASA decided, in the tradition of Scarlett O'Hara in *Gone with the Wind*, it would think about that another day . . .

It was clear that no matter how well I had recovered from my health setbacks, I could never be more than an "earthbound" astronaut. There would never be a "Journalist-in-Space"! Instead, there would be those going for political value. The Russians would soon be flying tourists at $20 million a pop!

There are many times in life one must accept the inevitable. I filed

the dream away in the "what could have been" drawer and refocused on my job.

I was pleased for my friend John. With a wink and a nod here and there, Glenn, national hero, passed all of NASA's physical and mental requirements, and the agency loaded up the septuagenarian former astronaut and test pilot with a series of assignments. He was to go into orbit and do research on aged bodies. Well, John Glenn sure had one of those, and he slipped his aged body into his bright orange spaceflight suit and helmet and marched off to join the STS–95 crew.

Curt Brown and Steve Lindsey were the aviators for the mission and they welcomed the old marine fighter pilot with open arms. The question of what citizen flew first in space was quickly forgotten, and all other critics and whiners and complainers were herded off into the nearby Florida swamps, where they were lost for days.

Mercury astronaut Scott Carpenter, who had been John Glenn's backup for his first launch on February 20, 1962, flew down to the Cape to join Tom Brokaw, Brian Williams, Matt Lauer, Katie Couric, David Bloom, Robert Hager, and me for NBC's launch coverage. Scott Carpenter was there to re-create his famous good-luck goodbye. At the precise

White House correspondent David Bloom (left) is seen here with field producer Dan Shepherd (right) covering John Glenn's return to space for the Today *Show. (Shepherd Collection).*

Seventy-seven-year-old John Glenn relaxes among his experiments on his second space flight. (NASA).

same moment, Carpenter was to say "God speed, John Glenn" as he had before, and Tom and Brian wanted me around for a little aged experience.

The event had grown into a massive homecoming week at the Cape. The spaceport swelled with gray-haired folks falling off buildings and out of trees, and we seniors were all just tickled to our toes to see John Glenn climb aboard another spaceship. We prayed and wished him luck, and on October 29, 1998, at 2:19 P.M. Eastern time, the space Shuttle *Discovery* headed into a blue and happy sky. Those of us who had admired Glenn and appreciated his friendship for forty years were never more proud, and we spent nine days watching this seventy-seven-year-old never miss a step. He proved to be the champ we all knew he was by taking care of his assignments, having fun in orbit, and doing a little rocking and singing.

On Saturday, November 7, 1998, at 12:04 P.M. Eastern time, *Discovery* touched down on its Florida landing strip.

An hour or so later, after all the housekeeping chores on board the shuttle were over, John Glenn strolled off *Discovery* seemly without a care in the world.

Now you may say, "Why not?"

The why not is that the lack of gravity in space weakens the arms and legs, and it takes some thirty-something astronauts hours, sometimes even days, to get their land legs under them again. Most doctors felt Glenn would need a wheelchair—possibly for days.

Well, forget about it! John walked by me and winked, and I hit a smart salute and hid a couple of tears, and the hope he'd just brought all us gray-haired "keep on going-ers" was the tonic we needed to keep dreaming and planning, to keep goals out there, marching through life with purpose to the end.

We celebrated John Glenn's second flight with some pretty hard partying, and my friends Bill Harwood from CBS, Hugh Harris from NASA, Bill Larson from ABC, Colonel Bill Coleman from Fighter Pilots 'R Lonely, Michael Cabbage from the *Orlando Sentinel*, Diana Boles from Cats Unlimited, Eddie Harrison from Sailors 'R Us, and many other spaceflight vets wanted to keep the party spirit going. New Year's Eve 2000 was approaching and such a special New Year deserved to be celebrated in a special place, so we rounded up all the old folks from the Mercury days we could find and pounded on the air force's door. We wanted to welcome 2000 with a New Year's Eve party on John Glenn's historic Mercury launch pad. All the little naysayer lieutenant colonels trying to make bird colonels threw up their hands in total disbelief. ("These drunks will kill themselves on air force property. They'll drive into the ditches, into buildings, it'll just be awful, and I will not have this on my record.") But a sharp and bright and fun-loving commanding brigadier general by the name of Randy Starbuck said, "Let them have Glenn's pad," and picked up his cap, walked through his office door, and with a knowing grin quickly left town.

The little naysayer lieutenant colonels were forgetting that our generation had always been responsible. As Americans, we didn't take a backseat to anyone. We sent the first astronauts into orbit and to the moon and we sure as hell weren't about to destroy something as sacred as John Glenn's launch pad.

Our buddy Ken Warren of the Cape's public affairs office put on his cleanest and brightest Dallas Cowboys jersey and ran interference. Ken kicked and stomped and shoved the traffic-cop mentality aside, and five hundred old Mercury and Gemini and Apollo vets showed up along with a 1950s big band from Disney World, and we danced to the oldies, saying our goodbyes to the 1900s and throwing our arms around the 2000s without dropping a single soiled napkin on historic ground.

When it was over, and the year 2000 was firmly in place, we drove off the military site without driving into a single ditch, singing, "We'll always love you, General Starbuck."

A s the century turned, construction was getting underway on the International Space Station. The orbiting outpost was to be as large as two football fields set side by side, with Russia's Zarya control module launched first atop one of that country's huge Proton rockets. The second part followed two weeks later aboard America's Space Shuttle *Endeavour.* The crew captured Zarya with the Shuttle's robotic arm and mated it with part two, called the Unity Node. Another Space Shuttle delivered and outfitted the infant station with logistics and supplies, and yet another crew readied it for the arrival of its main segment, Russia's Zvezda service module.

On July 12, 2000, Zvezda launched atop a Russian Proton and docked with Zarya and the Unity Node. Two more service flights were flown before the first crew to live and work aboard the International Space Station arrived on October 31, 2000.

Within weeks, astronauts and cosmonauts were in the swing of things and the construction flights were jumping off American and Russian launch pads without a hitch. Mission after mission was building the station that would, when finished, include eight large cylindrical sections called modules.

The modules were carried from Earth separately in the cargo bays of America's Space Shuttle fleet and on the nose of Russia's Proton rockets, and construction spacewalkers connected each section in orbit. Eight giant solar panels were needed to supply enough electricity to power a

small city after being mounted on 360 feet of metal framework. The first of four sets of solar arrays, and the backbone truss to support them, were carried to the station November 30, 2000. The heart of America's operation aboard the station, the Destiny Laboratory, was attached to the station in February 2001, and Canada's big robotic arm that would be used as a construction crane arrived the following April. More truss and backbone sections for the huge orbiting platform were sent up in 2002, and construction spacewalkers—astronaut engineers and trained construction people were humming. The International Space Station

The space shuttle Atlantis *is seen here streaking through orbit behind the International Space Station under a Texas moon. (Scott M. Lieberman).*

was about half-built, and more and more people were spotting this strange object moving across the predawn and early-evening skies.

My grandson Brian and his friends in Illinois spotted the station early one evening and freaked out. "Papa Jay," Brian phoned me excitedly. "We just saw this thing that looked like the biggest and brightest star ever moving across the sky. It was way up there . . . It was . . ."

"Brian," I interrupted, laughing, "You just saw the International Space Station. It travels 52 degrees above and below the equator, and you guys are about 42 degrees."

"Man, Papa Jay," he said out of breath, "that thing's bright."

"Yep, son, it sure is," I said, enjoying his excitement. "Once it's built, it will be the second brightest object in the early-evening and predawn sky."

"Why's that, Papa Jay?"

"Because in the early evening, and during a couple of hours before sunrise, the space station will be lit by the sun while it's dark here on Earth."

"Oh."

"Computers are your thing, right?"

"Yes sir."

"Just go to NASA's home page, Brian, to the space-station section, and type in your city and it'll tell you when the space station will be passing over your location."

"That's great, Papa Jay," Brian said with excitement. "We'll keep a log up here and we'll let you know when we see it, okay?"

"Sure, buddy," I smiled. "You guys will be my official space-station watchers in Illinois."

As time passes, the more time one finds to spend with family. Between the Shuttle flights putting more sections of the International Space Station in orbit, the more I found myself on football fields with my oldest grandson, Bryce.

Bryce is the kind of young man most find likable. He is easygoing, with a grinning personality that gets him just about whatever he wants

from his grandfather. Not really because of his grin, but because he was a pretty fair country football kicker and his foot earned him a handful of college scholarships.

The first was from the University of South Carolina, but he decided to play at East Carolina and Shenandoah University in Virginia, where he was voted first-team all-conference two years in a row. He even won Most Valuable Player in Special Teams and until you have experienced it, it's hard to match the pride you have in chasing a family member around college football fields.

In a way Bryce and I found more humor in football than we did sincerity, and at the end of the 2002 football season an unusual Space Shuttle launch was calling. I was suddenly focusing on a break in the Shuttle launch team's space-station construction flights. NASA was preparing the original Space Shuttle for a mission most wished would go away.

Columbia was the first Shuttle and therefore the oldest. It was lovingly called the fleet's "Hangar Queen," and most felt there it should stay. The launch team knew that like the senior citizen it was, *Columbia* was hard to get out of bed, but once it was on its feet, it was vintage dependability.

NASA had promised to fly an Israeli astronaut, and he and six others were going up for sixteen days of science. *Columbia*'s flight was set for January 16, 2003. The launch team smiled and said, "One more time."

Columbia:
Had They Only Looked

I guess those of a superstitious bent could say, "I told you so."

All the signs were there. *Columbia's* STS–107 launch was the 113th Space Shuttle mission. It had slipped into the second half of January, the same general time period as its doomed predecessors, *Challenger* and *Apollo 1*.

But there was another sign. It was much more ominous and much less obvious. There had been eighty-seven relatively successful Space Shuttle missions flown since the *Challenger* accident January 28, 1986, and once again, an aura of what might best be called arrogant complacency pervaded the ranks of the agency's senior management. As was the case before *Challenger*, they had become less tolerant of dissenting views when they believed they had valid data to support their position.

Shedding foam from the Space Shuttles' external fuel tanks had been a major concern during the early missions, but by now it had become a fact of life. It was considered an acceptable risk and more of a post-flight maintenance problem than a threat to flight safety. Space Shuttle managers had come to believe that it was somewhat like hitting your car bumper with the cover of your Styrofoam cooler.

Columbia's was the first mission to fly in three years that did not

have the International Space Station as its destination. The station, of course, can serve as a safe haven for the crew of a crippled ship. The Shuttle's mission was a planned science flight with more than eighty experiments during its sixteen days in orbit, an ambitious around-the-clock agenda with more than seventy scientists involved worldwide. On board were commander Rick Husband; pilot Willie McCool; mission specialists Dave Brown, India-born Kalpana Chawla, Mike Anderson, and Laurel Clark; and Israel's first astronaut, Ilan Ramon. Husband, Anderson, and Chawla had flown once before.

Following an almost flawless countdown, America's oldest and most storied Space Shuttle rumbled off its launch pad at 10:39 A.M. Eastern time on January 16, 2003. Weather was ideal with a temperature of 65 degrees Fahrenheit, calm winds, and scattered clouds at four thousand feet.

The launch appeared to be normal to us at the press site, and these observations were backed up by early reports from Mission Control. But ground cameras later revealed that 81.7 seconds into the flight, at an altitude of 65,000 feet, one large piece and at least two smaller pieces of insulating foam broke away from the external tank's left bipod ramp, one of the connection points between *Columbia* and the tank.

Additional photographic analysis the next day revealed that the larger piece, traveling at more than five hundred miles per hour, struck *Columbia*'s left wing's leading edge. The chunk had an estimated weight of 1.67 pounds and was one by two feet in size. It was the seventh known time in Space Shuttle history that foam had fallen from the left bipod ramp—but this time it was fatal, because unknown to *Columbia*'s astronauts or anyone on the ground, the collision had caused a six-inch breach in the reinforced carbon-carbon panel in the middle leading edge of the left wing.

Once in orbit, *Columbia*'s crew went to work on their two shifts while on the ground, the Mission Management Team, with the responsibility for resolving outstanding problems outside the scope of flight directors in Mission Control, gave *Columbia*'s flight cursory notice. Linda Ham, an up-and-coming former flight director who was the Space Shuttle Program integration manager at the Johnson Space Center near Houston, served as chairwoman.

Because of its size, the strike was considered to be "out of family," and a debris assessment team was established to analyze the problem. They relied on a mathematical modeling tool called "Crater," developed by the Boeing Corporation to predict the penetration depth of debris impact, but the system was stretched beyond its designed limits because of the large size of this particular piece of debris. By flight day nine, after extensive analysis, the team came to the conclusion that there was no flight safety risk, and reported their results to the Mission Management Team.

During that time, three requests were made to get Department of Defense spy-satellite enhanced imagery of the wing. Two of the requests were turned down and the third never came to the attention of the Mission Management Team because of a communication breakdown. There were numerous e-mail exchanges about the foam strike between concerned structural engineers at NASA's Langley and Johnson centers, but their concerns never reached the proper channels. To compound the situation, three days before the mission was to conclude, former astronaut and then NASA associate administrator Bill Readdy accepted a Defense Department offer to provide spy-satellite coverage, but because the Mission Management Team had concluded that this was not a safety-of-flight issue, the imagery was to be gathered only on a low-priority non-interference basis. No imagery was ever taken.

The Mission Management Team brushed aside further discussions of the foam. The Columbia Investigation Board also noted that the management team met only five times during the course of the mission, not every day as required by Shuttle program rules.

Ironically, on flight day eight of the mission, Mission Control sent up a message to Rick Husband and Willie McCool informing *Columbia*'s pilots about the foam hit on the left wing. The message stated there was no concern for reinforced carbon-carbon or tile damage, and because the phenomenon had been seen before, there was "absolutely no concern for reentry." It was a heads-up for the crew in case the media asked about the incident during an upcoming in-flight news conference.

On the morning of that fateful Saturday, the first day of February 2003, the *Columbia* crew, justifiably proud of its accomplishments over the past fifteen days, prepared its ship for the landing at its Florida launch site.

Touchdown was set for 9:16 A.M. Eastern time and I took my place before my microphone. On the main NBC network, *Weekend Today* hosts David Bloom and Soledad O'Brien were moving through their show with little or no interest in *Columbia*'s landing. After eighty-seven post-*Challenger* touchdowns without a hitch, this landing was routine. NBC News's plan was for the *Today Show* to cut in with a brief video of the landing while I did a play-by-play of *Columbia*'s return for MSNBC's Saturday-morning viewers.

On *Columbia*'s 255th trip around Earth in sixteen days, commander Rick Husband was given the "go" to put on his brakes and leave orbit. The senior pilot was flying *Columbia* backward and tails-up when he ignited the ship's two orbiting maneuvering rockets. Twelve thousand pounds of thrust pounded against *Columbia*'s forward speed for two minutes and thirty-eight seconds. The burn was "right on the nose," and it slowed the big Shuttle's forward motion just enough to drop it out of orbit and onto an hour-long flight path to its Florida landing site.

Entry interface came over the Pacific Ocean at an altitude of 400,000 feet. This is when the spacecraft skips along the upper surface of the planet's air, much like a stone skipping across a lake. The first effects of reentry heat can be felt when the Shuttle penetrates the atmosphere. Its surface grows hotter and hotter as it ploughs deeper and deeper into the thickening air. The plasma sheath around the Shuttle is hotter than the molten lava pouring from Hawaii's Kilauea volcano.

In physics, plasma is a highly ionized gas containing an approximately equal number of positive ions and electrons. The super-hot plasma is the product of friction created by a fast-moving object through air. It first appeared to *Columbia*'s astronauts as a faint salmon glow. Nearing the California coast, *Columbia* was dropping like a rock. Its nose-up attitude was focusing the plasma's super heat on its reinforced carbon-carbon panels covering the Shuttle's nose and the leading edges of it wings.

"This is amazing," Willie McCool said. "It's really getting, uh, fairly bright out there," he added, staring at the growing intensity of the outside fire.

Rick Husband grinned. It wasn't his first reentry. He knew this was only the beginning of the blast furnace that was yet to come. "Yeah, you definitely don't want to be outside now," he smiled at his pilot.

Moments later, *Columbia* crossed the California coast at 8:53 A.M. Eastern time, twenty-three minutes from its Florida touchdown. Below, two news photographers had set up their cameras to photograph the returning Space Shuttle—a man-made shooting star leaving a long plume of fiery plasma trailing in its wake.

But instead of seeing a perfect plasma trail as expected, the photographers saw a big red flare shoot from underneath *Columbia*.

The two stared at one another. Was that thing coming apart?

Inside Mission Control the reentry appeared normal until 8:54:24 A.M. Eastern time, when the Maintenance, Mechanical and Crew Systems officer informed entry flight director LeRoy Cain that four hydraulic sensors in the left wing were indicating "off-scale low." At 8:59:15 A.M., the same crew systems officer reported that pressure readings in both left landing-gear tires had been lost.

Suddenly, *Columbia*'s commander, Rick Husband, was calling. He hadn't talked to Mission Control since entering Earth's atmosphere fifteen minutes earlier.

"And, uh, Hou . . . " he began, only for his transmission to be lost in the middle of the word "Houston." This was not unusual. Such communications dropouts happen frequently during reentry when the Shuttle is banking and rolling as planned. Its huge tail assembly blocks signals between itself and the TDRS satellite 22,300 miles above the western Pacific. It is the TDRS satellite network that relays transmissions between the Shuttles and Mission Control.

LeRoy Cain told CapCom Charles Hobaugh to alert the crew about the sensors and tire-pressure losses.

Husband attempted to respond to Hobaugh with, "Roger, uh, buh—"

Those were the last words from *Columbia* at 8:59:32 A.M. Eastern time as the storied Space Shuttle sped over north central Texas at an altitude of slightly less than forty miles.

What followed was inevitable. The super-hot plasma sped freely through the six- inch hold into *Columbia*'s left wing, melting the ship's inner structure. America's first Space Shuttle was instantly ripped into more than 84,000 pieces that would be recovered later, and its dedicated crew of seven, without a hint of their doom, died so swiftly they blessedly never finished their final thought.

I sat straight up in my chair, pulled my microphone closer, and told MSNBC control we should go on the air *NOW!*

The MSNBC anchor came to me and no sooner than I was reporting, "Mission Control has lost communications with the Space Shuttle *Columbia*," I heard a strange click on my interrupted feedback line from New York. The voice of David Bloom was instantly in my ear along with Soledad O'Brien's, and we were on all NBC networks with live coverage.

At the Shuttle landing strip itself, *New York Times* reporter and friend Stefano Coledan told me, "The first hint was the silence." The countdown clock ticked down to touchdown time. No sonic boom rolled through the Florida swamps. Something was desperately wrong.

I brought our viewers up to date and Mission Control kept calling *Columbia*, and, of course, the Space Shuttle crew did not answer, and soon one of our affiliate stations in Texas had video of the remains of *Columbia* streaking across the Lone Star state.

David Bloom, who would lose his own life a little more than two months later during the Iraqi invasion, came to me, and as soon as I saw the video I knew: "It's *Challenger* all over again, David," I said. "We've now lost *Columbia.*"

By mid-afternoon, NBC had flown Tom Brokaw to the Cape from his vacation in the Virgin Islands and we were well into our coverage of the loss of a second Space Shuttle and its crew.

In Texas, a massive search-and-recovery undertaking involving more

than 25,000 people from 270 different federal, state, and town emergency agencies was underway. In all, the searchers found over 84,000 individual pieces of *Columbia* from Fort Worth, Texas, to Fort Pork, Louisiana, an area the size of Connecticut covering 2.3 million acres.

By an amazing stroke of luck, there were no reports of injury and little property damage caused by the raining debris. NASA officials crossed themselves, and *Florida Today* space reporter Todd Halvorson wrote an investigative story stating that if the instant breakup of the Space Shuttle had occurred only one minute earlier, the bulk of the wreckage would have fallen on south Dallas.

The recovered debris played a significant role in the investigation, as Space Shuttle launch director Mike Leinbach and his engineers were able to use parts of the wreckage to build a three-dimensional reconstruction of *Columbia*'s left wing at Florida's Shuttle Landing Facility.

After a comprehensive seven-month investigation, the *Columbia* Accident Investigation Board, chaired by retired navy admiral Harold W. Gehman, Jr., issued a scathing report, confirming without a doubt that "the foam did it" and indicting NASA as a co-conspirator, stating that "the NASA organizational culture had as much to do with the accident as well as the foam." The board cited eight missed opportunities to detect the problem during the flight and identified schedule pressures and communications breakdowns as contributing factors.

I had been on television for months asking blunt questions: "Why didn't you look? Why didn't the Mission Management Team act responsibly and identify the damage?" In fact, my questions were so pointed, lifelong associates came to me and said, "Jay, you're losing a lot of friends. You're unfair." And I said, "Remember *Apollo 13*?"

I told the associates and our NBC viewers, let's rewind the tape back to *Columbia*'s flight day three. Let's do a little what-iffing.

Suppose after reviewing the tapes of the foam hit, the Mission Management Team accepted the recommendation of the Inter Center Photo Working Group to get more imagery. Suppose chairwoman Linda Ham had then called the Defense Department with an emergency request to use America's spy satellites. The spy satellites' powerful cameras would surely have revealed the damage to *Columbia*'s left wing. While

she most likely would have had to call the White House for immediate use of the recon-satellites, President Bush surely would have responded and the Mission Management Team could have gotten pictures of *Columbia*'s damage. NASA would have exhausted all its resources to bring their comrades back. Flight directors and Shuttle engineers would have inventoried every item on board *Columbia* to determine if they had materials that could be used to plug the hole. At the same time, the Shuttle launch team would begin around-the-clock processing of the shuttle *Atlantis* to prepare it for the earliest possible rescue launch.

The astronauts would be directed to conserve on-board consumables such as oxygen and water, and by modifying crew activity and sleep time, carbon dioxide could be kept to acceptable levels until flight day thirty, February 15—fifteen days beyond the day they perished.

To make the repair, the crew members would hang onto a makeshift ladder from the cargo-bay door and plug the six-inch hole with heavy metal tools, small pieces of titanium, or other metals scavenged from *Columbia.* These heavy metals could help protect the wing structure and would be held in place for reentry by a water-filled bag that would turn to ice in the void of space, possibly restoring leading-edge geometry, preventing a turbulent airflow over the wing. and keeping the heating and burn-through levels low enough for the crew to survive reentry.

A different reentry profile could have been flown to lessen the heating on the left wing, and the astronauts would be prepared to bail out if the wing structure was predicted to fail on landing. NASA called the repair option "viable" but a high-risk long shot.

The rescue mission appeared to be the better alternative. Of course, the Mission Management Team would first have had to weigh the odds of another devastating foam hit as *Atlantis* roared into orbit. At that time, *Atlantis* was being readied for a March 1 launch.

If the decision was to "go," working around the clock *Atlantis* could have been prepared for a February 10 launch without taking any shortcuts. That would provide a five-day launch window to reach *Columbia*'s astronauts before time ran out.

Seven commanders, seven pilots, and nine mission specialists trained

in spacewalking were available. The rescue mission would have required a crew of four—a commander, a pilot, and two mission specialists.

In February, launch weather is traditionally great at the Cape, and looking back, it was beautiful for a launch during the February 10–15 time period.

The plan called for *Atlantis* to rendezvous under an inverted *Columbia* and station keep with the cargo doors of both Shuttles open, facing each other. Using tethered ropes, the *Columbia* astronauts would have been brought on board *Atlantis*. After the successful rescue, Mission Control would have configured *Columbia* for a de-orbit burn that would ditch the crippled Shuttle in the Pacific.

To NASA, the rescue option was considered "challenging but feasible." And, despite NASA management shortcomings in the loss of *Columbia*, the great majority of NASA employees are still imbued with *Apollo 13*'s "can do" spirit. For every Space Shuttle launch, a rescue shuttle is standing by. The space station is a safe haven, and rescue crews stand in deep lines ready to fly to the aid of their fellow astronauts.

That's a Wrap!

Following the loss of *Columbia*, it would be two-and-a-half years before another Space Shuttle would fly. NASA needed an attitude and cultural adjustment, and the agency also needed a fix for the problem of foam falling off a Shuttle's external fuel tank. Ignoring the foam hazard for twenty-two years and 113 Space Shuttle flights had killed seven astronauts and destroyed a $2 billion space machine.

At 10:39 A.M. Eastern time on July 26, 2005, the Space Shuttle *Discovery* roared into orbit. It was the first return-to-flight mission following *Columbia*, and at the controls was a gutsy shuttle commander named Eileen Collins. She was about to show the boys how it was done.

With her years of well-honed skills, Colonel Collins flew a textbook flight. Her rendezvous was perfect, and she flew *Discovery* through a smooth 360-degree backflip so inspection cameras could photograph the Shuttle's thermal protection system—the system with the hole that brought *Columbia* down. She docked, unloaded supplies, and sent two astronauts outside on space-station repair assignments. When *Discovery*'s stay at the station was over, Collins ended the two-week mission with a predawn landing at California's Edwards Air Force Base.

Later at the Cape, Colonel Collins looked at me and whispered, "I landed a little short, but it was black out there."

I smiled at her and nodded. "No one noticed."

Her command had been superb but there was one problem, not of Eileen Collins's making. During her climb into orbit, more potentially damaging foam dropped off her Shuttle's external fuel tank. The foam debris did no harm, but it could have, and it was back to the drawing boards.

Another year of fix-it work dominated the space centers across the country. Little by little, NASA convinced itself the foam shedding had been reduced to an acceptable minimum. The shuttle *Discovery* lifted off once again, this time on Fourth of July 2006. Colonel Steve Lindsey took his crew to the space station on another textbook flight. The mission set the stage for the Space Shuttle trips needed to complete the construction of the international outpost—an orbiting complex that would grow to the size of a small city block.

Once again, America's spaceports were humming with happy workers. The Space Station Processing Facility at the Cape was packed with

Chris Jansing and Jay Barbree report live on Discovery's Return to Flight *for MSNBC.*
(Shepherd Collection).

NBC's Cape Canaveral crew. Seated, left to right: Specials' producer Brian Cavanaugh, Atlanta bureau chief Frieda Morris, producer Martha Caskey, and producer Dan Shepherd. Standing, left to right: correspondent Jay Barbree, cameraman Dan Beckmann, production coordinator David Molko, and senior Today Show producer Javier Morgado. (Barbree Collection).

complex pieces of the orbiting international outpost. One by one, the Space Shuttle fleet hauled each part that would form the final station upstairs. The challenge was to complete the "city in the sky" before the Space Shuttles were to be retired by presidential order September 30, 2010. NASA took a deep breath and went to work.

All the while, America's spaceport was getting ready for the future. A new fleet of Ares rockets and Orion spaceships were coming off the drawing boards for return trips to the moon. I smiled. Damn, it felt good. The visionaries had return to the sands of Cape Canaveral.

The International Space Station grew and grew, and as the fiftieth anniversary of *Sputnik* approached, we learned that Pluto was no lon-

ger a planet, that the universe was bigger than we'd thought, and that we were probably not alone. Because I was the only reporter on the job for all of its fifty years, I was often asked what I considered the most important event in space. My answer startled and confused the questioners. I didn't say the Apollo moon landings. But for the sake of clarity, permit me to qualify my judgment. I'm hard put to set anything above the achievement of sending twelve astronauts to walk on the moon. I'm all for sending astronauts back to build a lasting lunar base. But when it comes to the salvation of the human species, the achievement of the Strategic Defense Initiative was unequaled. Only providence knows the millions, possibly billions, of lives it most likely saved.

Yep! I'm talking about "Star Wars," that project many academics and members of the media mocked and ridiculed at a time when earthly foes had some thirty thousand nuclear warheads aimed at each other— enough destructive fire and shock waves to destroy civilization.

My trusted friend Dr. Gene McCall was in the thick of it. He was a senior scientist at the Los Alamos National Laboratory working on nuclear missile defense, and a senior advisor to the chief of staff of the U.S. Air Force. He recently wrote me: "There are still a few learned people who attempt to deny the importance of the United States Missile Defense Program to the ending of the Cold War. Those who have analyzed the history in detail, though, generally agree that the Strategic Defense Initiative was intimately connected to the fall of the Soviet Union."

Dr. Michael Griffin, presently NASA's administrator, who was then the deputy for technology of the Strategic Defense Initiative, echoed what Dr. McCall said. Dr. Griffin added, "Many feel the technological successes of SDI to stop nuclear strikes against the United States overwhelmed the Soviets' ability to compete."

As Dr. McCall, Dr. Griffin, and others have explained, operating SDI was something like trying to keep up with your neighbor. First you both build the best house and pool and garden and deck your money can buy, and then, suddenly, you decide to build an elaborate guesthouse. Your neighbor has had a series of failed economic setbacks and poor leadership. In other words, the Soviet Union was fresh out of rubles

and could no longer match America weapon for weapon financially or technically.

Dr. McCall went on to write: "If we ask whether SDI were the cause of the fall of the Soviet Union, we can only answer that it was an important factor in all the events of the 1980s. While there were serious doubts about the chances of success of SDI expressed in the West— even in the U.S. Congress—the Soviets appear to have had no doubt that it would eventually work. The beginning of the development of SDI was surely the beginning of the end for the Soviet system. Given the intransigence of Ronald Reagan and his willingness to pursue missile defense—even in spite of objections from allies—SDI, or The Strategic Defense Initiative, finally caused the Soviet rulers to throw up their hands and surrender."

Referring to the money spent on weapons during the four-decade standoff, Soviet chairman Mikhail Gorbachev said, "We all lost the Cold War."

But the United States was still standing when the Soviet Union collapsed on President George H. Bush's watch, and the weapons of the West had performed well. None had been fired. No one had been killed by nuclear strike. From America's point of view, given the outcome, the price of the Cold War was a bargain—monies well spent for a war we never fought.

As a father of four and a grandfather of six, it gave me a warm, fuzzy feeling to see the size of our nuclear arsenal reduced to a logical level of threat. I have tried explaining this to my grandchildren. Bryce, Michelle, Bethanie, Brian, and Nicole are more rooted to the ground with logic while Jake, the five-year-old, is still easily taken in. Often while I'm trying to explain something, or giving the grandkids history, Nicole simply reassures her younger brother by telling him, "Don't worry, Jake, Papa Jay is just telling another one of his whoppers!"

I was laughing and driving home from another day of covering the construction of the space station. Telling whoppers, I suppose, is fuel for writers and, once again, I reminded myself there was nothing more

important than family. Family is simply the continuation of life, and we inhabit a stirring, surging, moving, living planet. It is our spaceship *Earth,* where we see the beginning of life, its present, and its end. But more important, we recognize that our spaceship's bounty is finite. Its supply of energy, foodstuffs, clean atmosphere, and pristine waters will be depleted.

Astronomers have already identified more than 150 planets within reach of future rockets. These new Earths will be needed desperately when our planet's wells run dry, its fields turn to dust, and our agitated sun turns it to a cinder.

Those entrusted with power should heed the words written more than a century ago by a Russian teacher of science, Konstantin E. Tsiolkovsky, who was the first known human to envision and draw up concepts for the use of rockets in space travel. In a simple but wonderfully elegant turn of words, Tsiolkovsky surveyed the future and saw what the human race must do and where it must go.

"Earth is the cradle," wrote the self-taught man reaching for tomorrow, "but one cannot live in the cradle forever."

I was suddenly aware of the cradle around me as I drove. A cold front had passed through earlier in the morning and left behind a sky of rare clarity. There were the whitest of puffy clouds floating against a rich, clean blue, and beneath this portrait of a perfect day were stands of pine and palm lost in a mass of green.

I followed sun reflections leaping along the surface of marsh ponds—familiar landscape to me. I had first driven this same land many years ago when I moved to Cape Canaveral, where I would meet my wife Jo, raise a family, build a life and a career with NBC.

Where do you find such a wife and such a place to work?

I'm convinced you don't unless you are blessed.

Somebody up there definitely likes me!

I was feeling the same renewal as the morning rains had brought the flora surging to life along my drive. Azalea and bougainvillea and oleander blossoms and palms and saw grass created a never-ending savanna,

and I suddenly realized, after fifty years reporting from this place, I did not want it to end.

I laughed at the impossible and thought about the future—a future where the fog was beginning to clear on NASA's next generation of rockets and crafts to replace the Space Shuttle. First, the International Space Station's construction was to be completed to give Earth an orbiting outpost for habitation by humans. This truly could be the first step out of Tsiolkovsky's cradle, where humans could, if they chose, use the station as the cornerstone for an orbiting city. Where families could work and grow and prepare for deeper journeys into the solar system.

The plans had long been on NASA's drawing boards.

Many had been approved, and in the coming months, the building and testing of the rockets named Ares and the spaceship named Orion that will replace the Space Shuttles will be underway—sleek rockets and a reliable spaceship that are scheduled to carry astronauts back to where they last walked on lunar soil in 1972.

Four are to go in the space capsule Orion that is in fact a larger, modern version of Apollo. They will not be going for national prestige, as Americans had gone before. This time, they will be going for science and survival and, most important, to stay. They will build outposts and pave the way for eventual journeys to Mars and possibly beyond.

And once that lunar outpost is built, humans will remain on our only natural satellite. Planners are already looking at the moon's south pole for a colony candidate, where NASA expects to find large concentrations of hydrogen in the form of water ice and an abundance of sunlight to provide power.

These plans give NASA a head start on getting to Mars. A lunar outpost just three days away from Earth will give space travelers needed practice of "living off the land" before starting out on the long road to the fourth planet from the sun.

The good news is NASA has a devoted and strong man at its helm in Dr. Michael Griffin. He told my NBC colleague Tom Costello, "The space station is on the footpath towards becoming a space-faring nation. If we're going to go to Mars, if we're going to go beyond to live on other planetary surfaces and use what we find there and bend it to our will

just as the pilgrims did, we must take all these steps to become a space-faring nation. I want that for the American people—I want that for my grandchildren."

I find myself chomping at the bit to go. It's the excitement of Columbus's voyage, of the wagon trains west. The crossing of the space ocean to younger, more promising planets is the future of humankind if our species is to survive. The only foundation that will not sink beneath our feet is knowledge.

After fifty years on the job, I find myself satisfied and grateful and pleased with a life well spent. Life is indeed good and we should all cherish it. Knowing that my days are numbered, I find myself missing all those good friends and loved ones that have gone on before. You have found their stories in these pages and in a way, I'm looking forward to following, meeting up with them again. But I am sad that I won't be shouting into an NBC microphone about the building of a lunar colony or the start of a months-long journey to Mars.

God, what exciting times they will be!

What a future for those who will live it—those who will be going and those who will be staying as the flotilla sails for the fourth planet. How I would like to be there!

And don't count me out just yet! Astronauts are to return to the moon in this century's second decade. If my flesh makes it, I will be in my eighties. If not, my spirit won't be far away.